Ettore Sottsass: Architect and Designer

Ettore Sottsass: Architect and Designer

Ronald T. Labaco

with contributions by **Dennis P. Doordan, Penny Sparke, James Steele, Emily Zaiden**

Los Angeles County Museum of Art

MERRELL
LONDON · NEW YORK

First published 2006
by Merrell Publishers Limited

Head office:
81 Southwark Street
London SE1 0HX

New York office:
49 West 24th Street, 8th Floor
New York, NY 10010

www.merrellpublishers.com

in association with
Los Angeles County Museum of Art
5905 Wilshire Boulevard
Los Angeles, California 90036

Published on the occasion of the exhibition
Ettore Sottsass, Designer
organized by the Los Angeles County Museum
of Art and made possible by Max Palevsky.

This publication was supported in part by
the LACMA Decorative Arts Council.

DAC

Exhibition dates
Los Angeles County Museum of Art
March 12 – June 11, 2006

For the Los Angeles County Museum of Art
Exhibition curator: Ronald T. Labaco
Project supervisor: Emily Zaiden
Project coordinator: Christel Guarnieri
Project assistants: Lindsey Rossi, Laura Verlaque
Editor: Wendy Kaplan

British Library Cataloging-in-Publication Data:
Labaco, Ronald T.
Ettore Sottsass : architect and designer
1. Sottsass, Ettore, 1917– – Exhibitions
2. Design – Italy – History – 20th century – Exhibitions
I. Title
745.4'092

A catalog record for this book is available from the
Library of Congress

ISBN 1 85894 320 5

Produced by Merrell Publishers
Designed by John Morgan
Design assisted by Michael Evidon, John Morgan studio
Edited by Christine Davis and Anthea Snow
Proofread by Barbara Roby
Indexed by Hilary Bird

Printed and bound in China

Note on the illustration captions
Captions that relate to objects included in the
accompanying exhibition are shown in bold. The date
in each caption refers to the year when the object
was produced in its final form. The dimensions indicate
height followed by width followed by depth.

Jacket front: *Lapislazzuli* teapot, from the
Indian Memory series, 1972 (see fig. 41)
Jacket back: Jasmine Hill, Singapore, 1996–2000
(see fig. 23)
Jacket background and binding: *Bacterio* pattern for
high-pressure laminate, 1978 (see fig. 59)
Page 2: Portrait of Ettore Sottsass, photographed
January 24, 2005

Contents

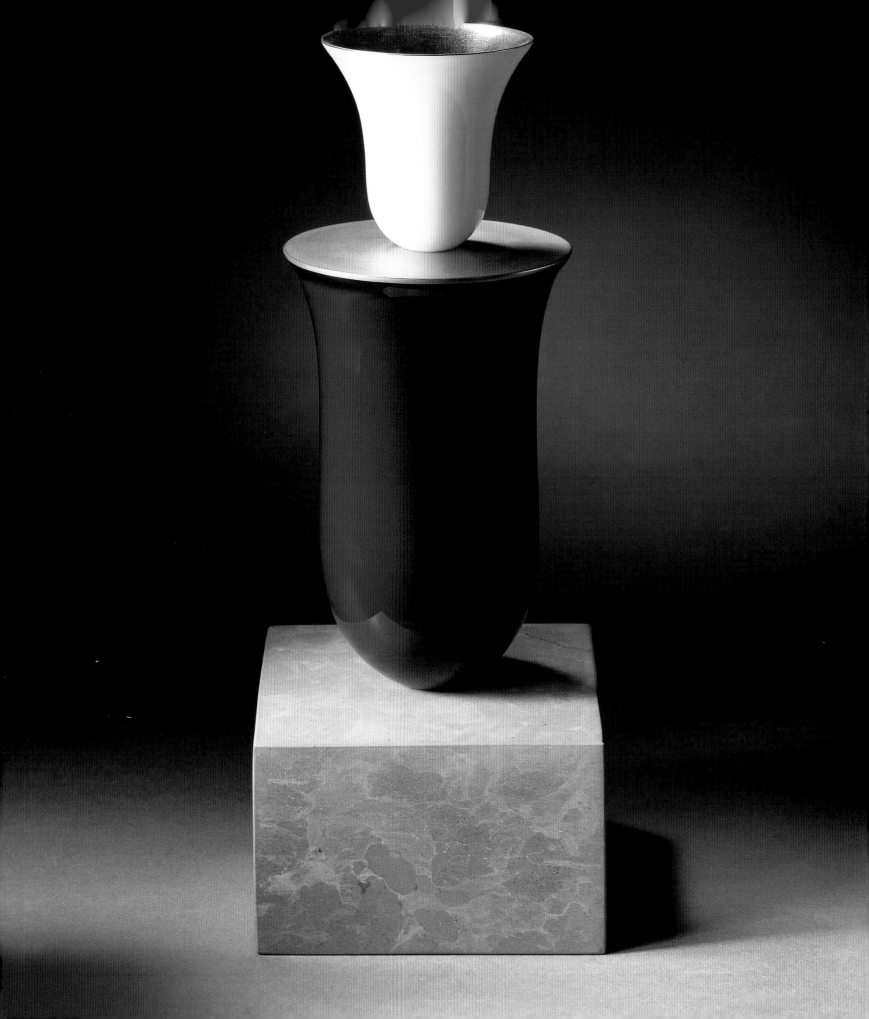

Sponsor's Statement

I first met Ettore Sottsass at his exhibition at the Israel Museum, Jerusalem, in the spring of 1978. It was there that I became fascinated not only by the variety and depth of the work on display but also by the man and his ideas. As our friendship grew over the years, I came to realize that underneath Sottsass's intensely serious intellectuality was a profound interest in humanity and a terrific joie de vivre, qualities that come up repeatedly in his work. Sottsass infuses his designs with both individualism and universality, goals of early Modernism that were somehow lost in the ensuing ethos of uniformity and mass production.

Sottsass is most commonly identified as the founder of the Memphis design collaborative. Memphis defined the look of the early 1980s, with its characteristic bold use of color and its pastiche of different materials and historical styles. As a longtime follower of Sottsass's career and collector of his work, however, I feel that he transcends this restrictive association. It is Sottsass's pluralistic approach to design and his philosophy about the intimate relationship between design and the individual that I find most compelling and rewarding.

Sottsass does not fit into any neat category of mainstream Modernism. Perhaps this is why the primary arbiters of modern design and the keepers of its history in the United States have largely ignored his contribution. I am gratified that the Los Angeles County Museum of Art has had the foresight to rectify this by organizing Sottsass's first one-person exhibition in the United States. This exhibition provides a timely opportunity for the previously uninitiated, much as the Israel Museum exhibition did for me long ago, to appreciate the indelible mark that Sottsass has left on architecture and design of the twentieth and twenty-first centuries.

Max Palevsky

Foreword

Ettore Sottsass examines the career of one of the most important and versatile artists of the past century. Architect of both public spaces and private refuges, designer of mass-produced objects as well as those for a privileged few, painter, photographer, sculptor, and social critic, Sottsass has been interpreted in light of almost every "ism" since the 1950s. Stubbornly resistant to characterization, his work of the last sixty years is explored anew in this outstanding overview.

Once again, LACMA's decorative arts department is indebted to philanthropist Max Palevsky. His passionate advocacy of Sottsass's work and remarkably generous donations have given LACMA the opportunity to present these designs in all their exuberant variety and breathtaking scope—a first for any museum in the United States.

Ettore Sottsass was organized by assistant curator Ronald Labaco, one of the most creative scholars of post-mid-century design. His commitment and unerring eye have resulted in a truly innovative perspective on Sottsass's role in the development of modern art and design.

Working on this project has been a great adventure, especially since my own studies have seldom ventured beyond the early decades of the twentieth century. And having Ettore Sottsass as a guide to this uncharted territory has been the greatest privilege of all. I am also deeply grateful for the collaborative spirit of the entire decorative arts department. The contributions of each staff member, our volunteers, and the board of the Decorative Arts Council have been invaluable to the success of the project.

Wendy Kaplan
Department Head and Curator, Decorative Arts
Los Angeles County Museum of Art

Fig. 1
Lucrèce vase, 1994
Made by Manufacture Nationale de Sèvres
(Sèvres, France)
Glazed and gilded porcelain, stone
12 x 4⅝ x 4⅝ in. (30.5 x 11.8 x 11.8 cm)
Collection of Max Palevsky

Preface

While Ettore Sottsass has made remarkable contributions to architecture and design, and is recognized in both his native Italy and throughout Europe as a monumental figure, he remains far less known in the United States. The exhibition that accompanies this book is his first one-person show at a major American museum, and the publication itself marks the first major assessment of Sottsass as an architect and a designer in over a decade.

Born in 1917, trained as an architect at Turin Polytechnic, and working since 1939, Sottsass first garnered international acclaim outside of architecture and design circles in the early 1980s as the founder of Memphis, the Milan-based design collaborative. As a harbinger of Postmodern design, Memphis—and soon Sottsass himself—became the subject of widespread attention. Of the numerous publications engendered by his fame, the following were particularly invaluable sources for this project: Penny Sparke's *Ettore Sottsass, Jnr.* (1982), Jan Burney's *Ettore Sottsass* (1991), Barbara Radice's *Ettore Sottsass: A Critical Biography* (1993), Hans Höger's *Ettore Sottsass, Jun.: Designer, Artist, Architect* (1993), and the Centre Georges Pompidou's *Ettore Sottsass* exhibition catalogue (1994). Building on the work of the past two decades, this book emphasizes the diversity of his talents in all media over the course of his sixty-five-year career, including furniture, glass, ceramics, architecture, industrial design, "radical design," and jewelry. The LACMA exhibition and book not only affirms Sottsass's major artistic contributions but also provides an innovative assessment of his professional life up to the present.

In the first essay, Penny Sparke challenges the widespread notion of Sottsass as a leading advocate of Postmodernism. She recasts him as a "late Modernist" designer who has succeeded in extending Modernism into a new era by renewing its message. In the second essay, I correlate Sottsass's modern-day humanism with that of Leon Battista Alberti during the Renaissance. By examining the importance of color and form in Sottsass's work, I aim to show that the designs serve as vehicles for personal expression and communication with the user. Dennis P. Doordan then examines Sottsass's use of materials. He discusses how Sottsass refutes the design world's pro-Modernist bias toward material innovation and technology by sometimes embracing but equally often rejecting traditional associations with particular materials. James Steele explores Sottsass's architectural portfolio. This aspect of Sottsass's career, which has become prominent over the past twenty years, is discussed in the context of other twentieth-century architectural movements. Emily Zaiden's interview with Ettore Sottsass illuminates his design philosophy. Sottsass's unique point of view emerges as the culmination of a long personal campaign against a rigidly ideological Modernism.

These essays and the interview address principal themes in Ettore Sottsass's career as well as the history of Modernism and Postmodernism in twentieth-century architecture and design. In addition, a selected list of short profiles on Sottsass's many collaborators over the course of his career offers a context for his creative output, and a brief biography/career chronology provides an overall framework by which to navigate the narrative.

Ronald T. Labaco
Assistant Curator, Decorative Arts
Los Angeles County Museum of Art

Note on the illustration captions
Captions that relate to objects included in the accompanying exhibition are shown in bold. The date in each caption refers to the year when the object was produced in its final form. The dimensions indicate height followed by width followed by depth.

Fig. 2
Untitled, 2003
Made by Bottega d'Arte Ceramica Gatti
di Dante Servadei (Faenza, Italy)
Edition of three
Ceramic, acrylic paint
4 x 20 ½ x 13 in. (10 x 52 x 33 cm)
The Gallery Mourmans, Maastricht,
The Netherlands

Ettore Sottsass, a Modern Italian Designer

Penny Sparke

By dint of walking among the areas of the uncertain (due to a certain mistrust), by dint of conversing with metaphor and Utopia (to understand something more) and by keeping out of the way (certainly due to an innate calmness), we now find we have gained some experience; we have become good explorers. . . . We can do—nearly—anything because, dear friends, as we were saying, we are old and skilled navigators on wide open seas.[1] Ettore Sottsass

The architect-designer Ettore Sottsass has been working in Milan since 1945 creating architecture, interiors, furniture, craft objects (glass, ceramics, and jewelry among them), industrial products, and items of office equipment for the internationally renowned Olivetti firm. Also, throughout that half-century, he has pursued a personal search for a new language of modern design. One of his best-known, and most publicized, experimental projects was undertaken in 1981 when, at the age of sixty-four, he founded the design group Memphis, exhibiting a collection of "radical" prototype designs for furniture pieces and decorative art objects which he created with a team of young collaborators, including Michele De Lucchi, George Sowden, and Nathalie du Pasquier. So radical were the designs that their brightly colored, patterned surfaces and unconventional forms shook the international design establishment to its core (figs. **3, 4, 5**). In spite of his age at the time and his breadth of experience in design, Sottsass was represented as an enfant terrible in the show's unprecedented international press.

Today the name of Ettore Sottsass is still widely associated with what was seen in 1981 as a deliberately provocative event, as his biographer and companion, Barbara Radice, described it, a "coup de théâtre."[2] Memphis was held responsible for what was described at the time as a dramatic paradigm shift in the world of design. For the international design community of the 1980s the experiment was perceived as a daring act of defiance and anarchic exuberance that marked an abrupt end to the authority of Modernism—that architecturally dominated movement which, with "form follows function" as its creed, sought to reject the historicism and eclecticism of nineteenth-century design—as the dominant design movement of the

Fig. 3 (above)
Carlton room divider, 1981
Made by Memphis (Milan, Italy)
Wood, plastic laminate
77 ⅛ x 74 x 15 ¾ in. (195.9 x 188 x 40 cm)
The Gallery Mourmans, Maastricht,
The Netherlands

Fig. 4 (opposite)
Ashoka table lamp, 1981
Made by Memphis (Milan, Italy)
Painted and chromed metal
35 x 32 ½ x 3 ¼ in. (88.9 x 82.6 x 8.3 cm)
Collection of Max Palevsky

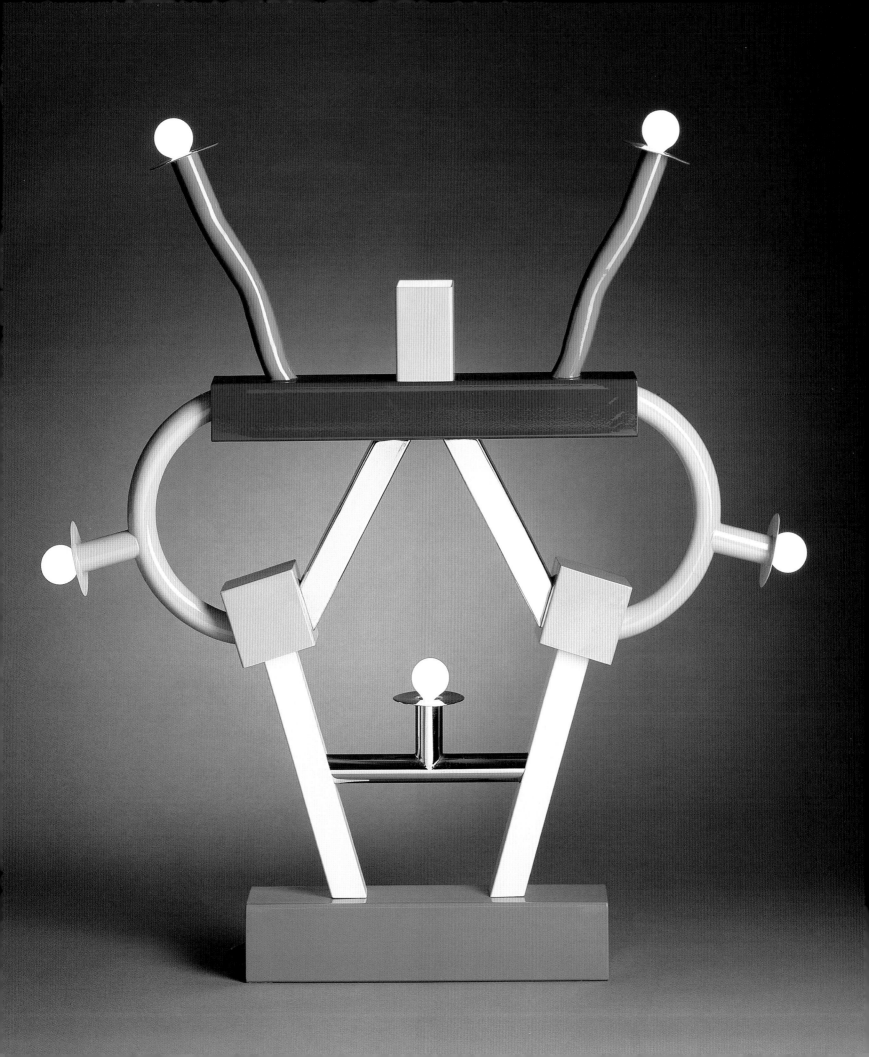

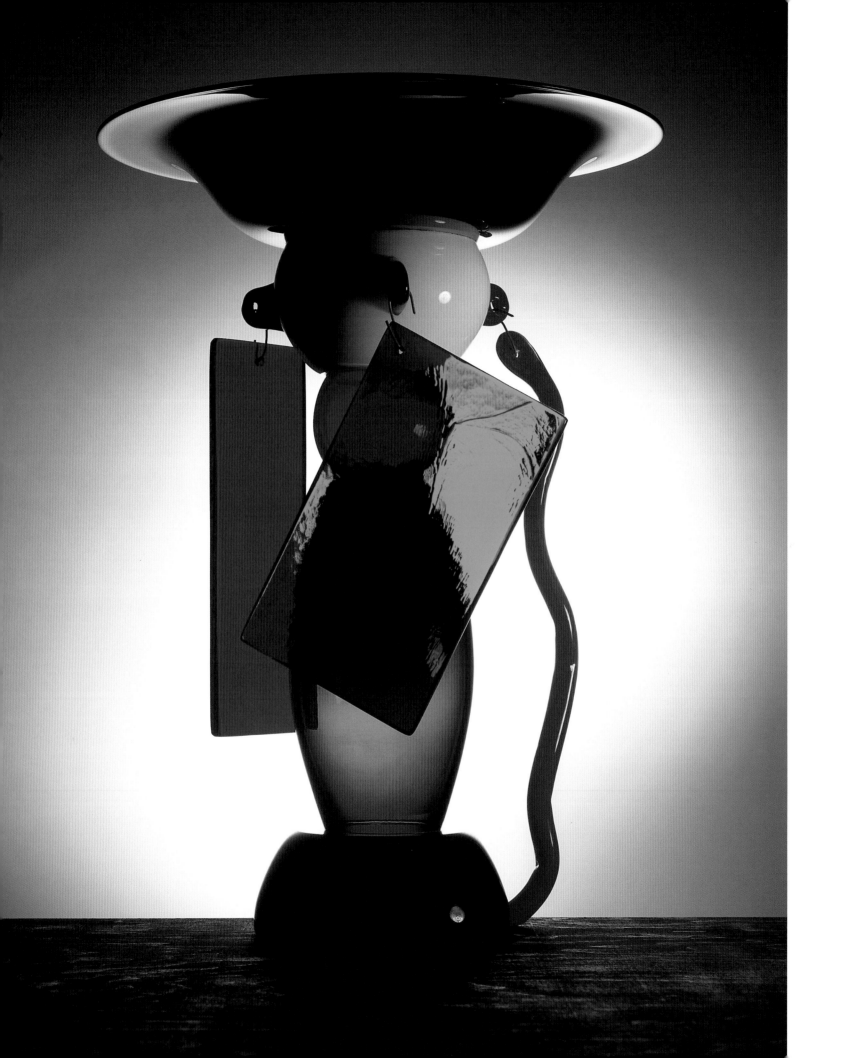

twentieth century. In its place, the work of Sottsass and his colleagues exemplified, for the 1980s community, a new "Postmodern" approach, characterized as embracing irony, pluralism, pastiche, nostalgia, and historicism, and asserting the superiority of "meaning" over formal values.

It is perhaps only now, with the advantage of hindsight, that this highly publicized moment of international visibility in Ettore Sottsass's long career can be properly assessed and understood not only in terms of rupture but also, perhaps more importantly, in terms of continuity. In the context of the extensive body of work that led up to it, Memphis can now be seen less as a bolt out of the blue, transforming the direction in which late twentieth-century design was heading, than the culmination of the intellectual and emotional journey that Sottsass had begun nearly forty years earlier. Viewed from this perspective the project becomes just one of the many negotiations with architectural and design Modernism that Sottsass initiated in the context of Italy as a modernizing nation in the years following World War II. It is this extended and continually reworked negotiation that lies, I would suggest, at the very heart of his important contribution to twentieth-century design.

An account of Memphis's prehistory will serve to recontextualize and reposition it appropriately within Sottsass's career. For the young designer, trained in architecture at Turin Polytechnic, the journey that led to Memphis and beyond began with an instinctive need to establish some distance between him and the previous generation of Italian architects, in particular the group linked to the movement known as "Rationalism," Italy's version of European Modernism. From the late 1920s into the 1930s the individuals associated with Italian architectural Rationalism—Piero Bottoni, Luigi Figini, Gino Pollini, and others—had been deeply committed to the international language of, and the democratic ideology underpinning, the white, flat-roofed, concrete and glass, metal-framed, geometric buildings created by such European Modernist architects as Le Corbusier in France and Walter Gropius in Germany. The Rationalists' mission had been to transfer that movement to Italian soil, thereby linking the country with international Modernist activity and minimizing its isolation.[3] The fact that

Sottsass's father, the Austrian architect Ettore Sottsass, Sr.,[4] who had trained in Vienna under Otto Wagner, worked in Innsbruck and moved to Turin in 1928, had been linked to this movement, gave the younger man a personal reason to want to break out from within its boundaries. From the outset of his creative journey Sottsass felt uncomfortable with what he saw as Rationalism's mechanistic approach to architectural form, and he devoted his energies, instead, to experimenting with color in the context of the interior and to seeking links between painting and architecture. A series of examination drawings executed by Sottsass at Turin Polytechnic demonstrated his strong "painterly" preoccupations at that early stage in his creative career (fig. 6; see also figs. 24, 99, 100).

Although Sottsass never rejected the idealism underpinning European Modernism, he was to push and pull it in new directions and challenge what he saw as its limitations—especially what he perceived to be its overdependence upon a Western concept of rationality and its minimal recognition of the role of human emotion in the relationship between people and their material culture—throughout his career. In nearly all of his work he chose, however, to reflect Modernism's optimistic belief in the future, its faith in new technologies and new materials, and its commitment to internationalism. In his early years as a designer he also

Fig. 5
Efira fruit bowl, 1986
Made by Toso Vetri d'Arte (Murano, Italy)
for Memphis (Milan, Italy)
Edition of seven
Glass
19 ⅝ x 14 ¾ x 14 ¾ in. (50 x 37.5 x 37.5 cm)
The Gallery Mourmans, Maastricht,
The Netherlands

Fig. 6
Drawing for Interior Design examination,
Faculty of Architecture, University of Turin, 1938
Tempera and ink on paper

acknowledged a debt to its aesthetic. In 1946, for example, he created an exhibition installation intended as a room for a young girl, the rectilinear forms of which, like those of a wooden and metal chair he designed for the 1947 Milan Triennale (an exhibition established before the war and dedicated to international design), clearly owed much to Rationalism. A number of architectural projects from these years also showed signs of the same influence. Designs for workers' houses in Iglesias, Cagliari, for example, created in 1950, on which Sottsass worked with his father, were characterized by the simple aesthetic of their unadorned concrete structure (fig. 7).

Sottsass began his own professional career in 1945 in Turin in the office of Giuseppe Pagano, an architect who designed both buildings and interiors in line with Rationalist ideals, but the image of the "bourgeois" architect, complete with an office, a secretary, a telephone, and a car, clearly suggested by his father, was anathema to him.[5] "To be an architect," Sottsass wrote later, ". . . is a luxury job. . . . I thought at that time that it was really possible to be a craftsman."[6] He chose to work directly with materials, to be in touch with his emotions and sensations, and to make things with his hands. Suspicious of the middle-class, socially respectable image of the architect, he preferred to be positioned, like a craftsman, nearer to the margins of society. Other architectural projects from the same period, including a 1950 design for a housing scheme in Arborea, demonstrated his strong desire to link craft and architecture. The project in question incorporated a colorful ceramic grill created by Andrea Cascella.

The imperatives of post–World War II Italy included the need to develop a new, humanistic approach to architecture and design, as well as a fresh visual and material identity for the post-Fascist republic. They encouraged the young designer to search for innovative ways of working that questioned some of the assumptions underpinning prewar architectural Modernism. In search of an alternative path he studied contemporary European (and later American) avant-garde painting and sculpture, as well as traditional Italian crafts. In both of these areas Sottsass discovered models of creativity that openly embraced human emotions and visibly demonstrated their

dependence upon them. As a result of his research he began to develop a language of modern design that was all his own.

Sottsass's years as a young professional architect-designer coincided with those of Italy's transformation into a newly industrialized, democratic country. The social and cultural agendas of Italy, which included the need to embrace democracy, raise general standards of living, house the homeless, and bring material goods within the reach of everyone, heavily influenced the direction he took in his work. From the late 1940s onward, his practice was defined by an attempt to refresh the language and potency of Modernism by adding a new dimension to it—that of human emotion and sensation. At the same time, Modernism's essential utopianism, progressivism, and belief in the power of the designed object to bring about social, cultural, and behavioral change crucially underpinned all his activities. The years 1945 to 1950 witnessed a new generation of Italian creative individuals (many of them, like Sottsass, trained as architects in the prewar years and now establishing practices as professional architect-designers) seeking ways to express the values of the new democracy in material form and to work with the revitalized Italian industries that were emerging in the north of the country, especially around Turin and Milan. Corradino D'Ascanio's *Vespa* motor scooter for Piaggio of 1946, Gio Ponti's coffee-machine

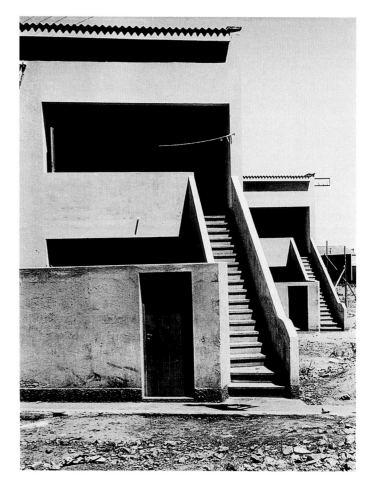

Fig. 7
Workers' housing, Iglesias, Cagliari, Italy, 1950
Architects: Ettore Sottsass, Jr., and Ettore Sottsass, Sr.

for La Pavoni of the following year, Marcello Nizzoli's office machines for Olivetti, and the modern furniture items designed for apartments in Milan by such architects as Vico Magistretti and Marco Zanuso for the new furniture manufacturers—Azucena, established in 1947, for example—were among the artifacts to leave Italy's newly formed production lines in these years. They were more than just novel additions to the everyday environment, however. Their sensual organic forms and materials—metals, processed wood, and plastics among them—actually embodied the aspirations of the emergent nation. These strikingly modern products rapidly became potent symbols of the culture of optimism, technological utopianism, and democratic idealism that characterized Italy's postwar democracy. These aspirations were clearly expressed in the words of the architect, and member of the architectural team BBPR, Ernesto N. Rogers, in the first postwar copy of the journal *Domus*, which he edited, in 1946. "It is a question of forming a taste, a technique, a morality," Rogers wrote with feeling, "all terms of the same function. It is a question of building a society."[7] (Devoted to architecture and the decorative arts, *Domus* had originally been founded in the 1920s, edited by the architect Gio Ponti, but it ceased publication for a few years during World War II. Through the 1940s and 50s it acted as a vehicle for disseminating Italian architecture and design both inside and outside the country.)

Sottsass aligned himself enthusiastically with this forward-looking culture. It rapidly became an intrinsic part of him, determining both his intellectual and, more importantly, his emotional commitment to the cultural role of design, as he would later recognize when recalling the profound impact of seeing *Vespa* motor scooters "buzzing" through the streets of Milan, and of drinking in the new coffee bars.[8] When, in the late 1970s, he produced a number of plastic-laminated, 1950s-inspired objects for the Italian radical design group Studio Alchymia, he was to revisit this earlier era remembering (and still believing in) the utopian dreams he had shared with his contemporaries. Typically, however, the later project proved not to be a nostalgic journey but one that sought an appropriate expression for the era in which it was undertaken. As Sottsass pointed out, a living "memory" of that earlier utopian era was still visible in the 1970s

suburbs of Milan, where 1950s coffee bars still proudly displayed their "banal" materials and patterns. "It is," Sottsass later wrote in 1982, "a place where there is no culture, in the bourgeois sense, so the imagery is fresh and not yet catalogued. . . . The outskirts of Milan is the most elegant environment that I personally can find at the moment."[9]

The optimistic spirit of Italy's post-1945 modernity was so deeply embedded in the psyche of its designers that it followed many of them throughout their subsequent careers.[10] During the 1950s and 60s Sottsass was conscious that this spirit, inherited from prewar Rationalism, continued to define postwar, post-Fascist Italy, but that other characteristics of that earlier architectural and design movement—specifically its austere machine aesthetic, its refusal to embrace human emotion and the role of its user, and its prioritization of form over meaning— could not survive the ideological shift. Confronting this challenge head-on he initiated a program of research that has lasted for more than half a century, focusing on ways to usher Modernism into a new era and make it appropriate for that new context. Unlike many of his contemporaries, however, who were content to work within the late capitalist context of postwar Italy, in which the alliance between design and the burgeoning manufacturing industry inevitably transformed their postwar Modernist objects into fodder for conspicuous consumption, Sottsass openly resisted this pull and consciously pursued an "alternative" path.

In its enthusiasm to embrace the democratizing possibilities of joining hands with mass manufacturing, prewar Modernism had, in Sottsass's view, ignored the "user." His emphasis on the role of the user as an active participant in the design process, rather than a passive consumer, lay at the core of his renewal of Modernism. To this end he experimented with a number of ways of bringing users into the picture while avoiding transforming them into "consumers." By borrowing ideas from contemporary fine artists, revisiting craft in order to create another kind of communicative bridge with users, investigating the way in which non-Western cultures have integrated artifacts into their spiritual rituals, thereby empowering their users, referencing popular culture in order to provide a metaphorical continuum between

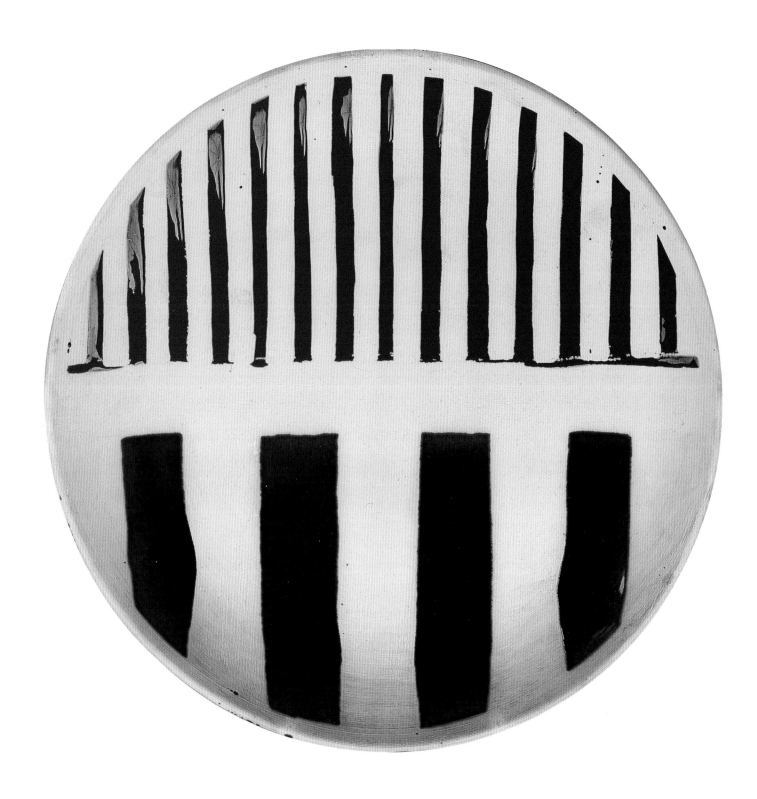

Fig. 8
Plate, 1958
Made by Bitossi (Montelupo Fiorentino, Italy)
Unique
Glazed earthenware
11 ⅞ x 11 ⅞ in. (30 x 30 cm)
Musée National d'Art Moderne, Centre Georges
Pompidou, Paris

objects and the mass of users, and designing objects that allowed their users freedom of movement rather than determining their lifestyles, he set out to renew the language of design. Most importantly, all these strategies were articulated in the context of a sensorial, rather than an exclusively intellectual, relationship between objects and people. By these means Sottsass intuitively aimed both to correct an imbalance within early Modernism and to extend the relevance of that movement into the era of late capitalism. He focused on reforming the relationship between the material world and human beings by offering the world a radically new definition of modern design. Although the international community only became aware of Sottsass's efforts in the early 1980s, when the Memphis experiment was brought to its notice, the designer had been working on his new formulation for a language of modern design for many years.

Sottsass first introduced an overtly communicative element into his designs for furniture and ceramics objects in the late 1950s. Ideographic signs, inspired by such contemporary American Abstract Expressionist painters as Arshile Gorky and Jackson Pollock, featured on a series of ceramic plates that were covered with multiple handmade marks, such as circles, grids, and stripes (fig. **8**; see also fig. **54**). The two plates illustrated here demonstrate the spontaneous way in which he applied signs to their surfaces, in the manner of the abstract painters. His signs were intended to communicate with the plates' "users" through a direct appeal to their senses, and no attempt was made to link them to the plates' utilitarian function. Other objects—trays, furniture objects, and textiles—were treated in a similar way, while in a number of interiors from the same years he exploited the spatial properties of color. The links with American painting were clear, recognized by Sottsass himself in an article for *Domus* magazine, in which he described one interior as emanating from "an attitude linked with modern painting."[11] Grids, both two- and three-dimensional, were also featured in a number of interiors from the mid-1950s, recalling the work of Josef Hoffmann and other members of the Wiener Werkstätte from the early twentieth century—early modern designs that still valued the power of patterns and motifs to contain and express modern meanings (fig. 9). There was also a strong

Japanese element visible in these designs, evidenced in an interior for a home in Genoa from 1958 featuring open-grid screens that acted as space dividers, and an interior for a home in Milan the following year that included a rug and a painting by Sottsass that helped to emphasize the repeated rectilinear forms within the space (figs. 10, 11). A later interior from 1965, for a bedroom, reinforced the importance of the grid for Sottsass, this time used to offset shapes that he had borrowed from Indian culture.

The references to designs by Hoffmann and others suggested that Sottsass was searching within early Modernism to discover features that had subsequently been rejected but that could now potentially contribute to its revitalization.

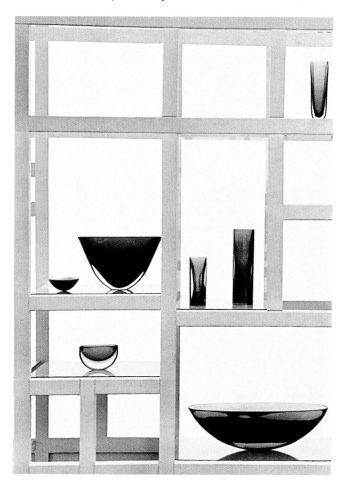

Fig. 9
Detail of shelving for glass exhibition
at the 11th Milan Triennale, 1957

A piece of furniture created for the interior of his friend Roberto Tchou's home, for example, exhibited Werkstätte-like features, while its black and white "target" cupboard handles (fig. 12), possibly inspired by the paintings of Jasper Johns, anticipated the Pop-inspired pieces the designer was to produce in the 1960s.[12] Later, in 1982, Sottsass revealed how the work of the Werkstätte had inspired him. "My father," he wrote, "was an architect and studied in Vienna, because the region of Italy he came from was under Austrian rule. As a child I would look through Viennese books of furniture, and this early influence meant that I never hesitated about what I wanted to do."[13]

Surface signs, abstract patterns, and color continued to characterize Sottsass's work throughout his career. In the mid-1960s his radical furniture designs for Poltronova featured brightly colored patterns, inspired by Pop and Op art as well as by such banal objects in the everyday environment as traffic signals and bank safes. The rounded forms and "traffic light" imagery of his *Barbarella* desk of 1964–65, for example, transformed it into an element within a sign system (fig. **13**). Its potency as an object was reduced while its primacy as an image was enhanced. The fact that all the sides of his wardrobes (later known as *Superboxes*), designed in 1966–67 and made in 1968, were covered with laminate, however, meant that they could stand in the middle of the room rather than just being propped against the wall (fig. **14**). The inspiration for these brightly colored, striped objects came, once again, from the world of fine art, this time from the work of Frank Stella, Sol LeWitt, Donald Judd, and others. Sottsass described his laminated wardrobes in *Domus* magazine, emphasizing their environmental quality, "isolated in the middle of the room and banded with colors, they eliminate, as it were, the presence of walls. They make reference to no other wardrobes and exist only in function of the mutual relationship between object and environment."[14] The furniture from these years prefigured many of the later Memphis pieces, a fact that Sottsass later acknowledged: "The beginning of Memphis in many ways was a series of pieces I designed in 1965." "They were," he explained, "very strange. They were made for an exhibition originally, but they were all sold and subsequently went into production."[15]

Fig. 10 (top)
Interior of an apartment in Genoa, Italy, 1958

Fig. 11 (middle)
Interior of an apartment in Milan, Italy, 1959

Fig. 12 (bottom)
Desk/cabinet/bookcase for Tchou apartment,
Milan, Italy, 1960
Made by Renzo Brugola (Milan, Italy)

Fig. 13
***Barbarella* desk, 1964–65**
Made by Poltronova (Agliana, Italy)
Wood, anodized aluminum
51 ¼ x 43 ⅜ x 15 ¾ in. (130 x 110 x 40 cm)
The Gallery Mourmans, Maastricht,
The Netherlands

Ceramic designs from these years—the *Ceramiche delle tenebre* (*Ceramics of Darkness*) created in 1963, the *Offerte a Shiva* (*Offerings to Shiva*) of the following year, and the large-scale ceramics exhibited in Stockholm in 1969—featured patterns and colors that complemented the ancient material of which they were made. The *Ceramics of Darkness* were created a year after Sottsass had been very ill, following a trip to India. He exhibited seventy pieces in the Il Sestante gallery in Milan. Their colors were somber and they had mandala-like shapes on their surfaces (fig. **15**; see also fig. **42**). The *Offerings to Shiva* ceramics, designed to celebrate his return to health, displayed brighter colors and were covered with shapes that were vaguely reminiscent of the patterns on Indian depictions of cosmic rhythms (see figs. **43**, **55**). Sottsass described them as examples of "design as memorandum for the mental and psychic operations necessary for liberation."[16] In 1967 he created an exhibition of giant ceramics, shown at the Sperone gallery in Milan. Sottsass entitled the show *Menhir, Ziggurat, Stupas, Hydrants, and Gas Pumps*, thereby reinforcing his sense of continuity between the deep past and contemporary popular culture (fig. **16**). He followed this in 1969 with an exhibition of ceramics in Stockholm, where he created a "Mandala altar" of brightly colored terra-cotta objects (see fig. **53**).

These objects extended Sottsass's evolving language of form and philosophy of design in other ways as well. His use of terra-cotta, for example, represented his conscious use of a material that belonged to Italy's past, and demonstrated his commitment to combining the past with the present. Some of the Shiva pieces resembled sixteenth-century majolica items, revealing the designer's interest in that exciting moment in Italian ceramic history. In bridging these distant periods he was echoing Italy's approach to industrial modernization, which combined traditional manufacturing methods with new production techniques. It was a modernizing strategy that minimized the trauma of a sudden rupture with the past and built on the country's traditional strengths. In a similar vein, when Sottsass and his colleagues were searching for a name for their radical experiment, "Memphis" was chosen because it combined the past (the ancient capital of Egypt and "site of the great temple of the god, Ptah, artist among gods")[17] with the present

Fig. 14
Wardrobe (also known as *Superbox*), 1968
Made by Poltronova (Agliana, Italy)
Unique
Wood, plastic laminate
80 ¾ x 31 ½ x 31 ½ in. (205 x 80 x 80 cm)
The Gallery Mourmans, Maastricht,
The Netherlands

Fig. 15
Vase from the *Ceramiche delle tenebre*
(*Ceramics of Darkness*) series, 1963
Made by Bitossi (Montelupo Fiorentino, Italy)
Unique
Glazed earthenware
9 ¼ x 6 ¼ x 6 ¼ in. (23.5 x 16 x 16 cm)
Collection Bischofberger, Zurich

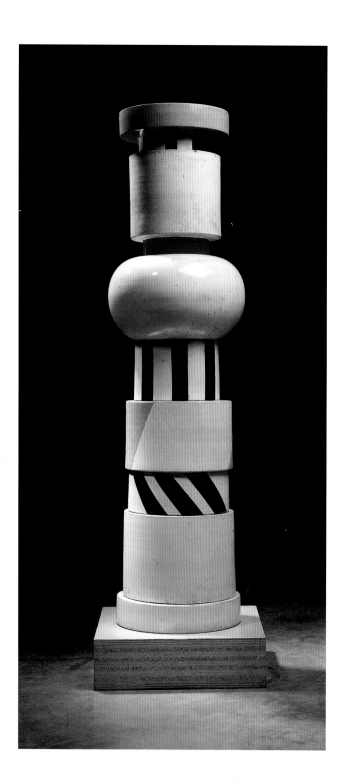

(the birthplace of Elvis Presley, the father of rock 'n' roll). Once again this debt to the past was not expressed nostalgically but through a commitment to the present and the future.

Sottsass's experiments with ceramics in the 1960s revealed another of his key strategies for updating and extending Modernism. At this time he felt the need to move outside Europe —the home of the eighteenth-century Enlightenment—in order to distance himself completely from Western rational thought. He first traveled to India in 1961 and returned several times in order to discover alternative ways of integrating objects into everyday life. His exposure in that country to a role for objects that was not linked to conspicuous consumption represented a turning point in his career. India opened his eyes to a cultural role for the object, which could encourage "users" to reflect on themselves; his experience there taught him how to "raise the object to the level of concentration so as to release it from its lesser functions."[18] Applying signs and symbols derived from Indian religion to the surfaces of his pieces, he created what he called "spiritual diagrams . . . capable of stimulating by their presence the awareness of our own gestures."[19] This dramatically different approach was utterly consistent with Sottsass's desire to develop a language of design that linked people to objects not through their role in the creation of social status but through the more liberating activity of "contemplation." This, he believed, allowed the users, or rather the "contemplators," of objects to avoid the materialistic relationship with them that was unavoidable when objects were only there to be "consumed." It was his way of "de-commodifying" the object.

The *Ceramiche tantriche* (*Tantric Ceramics*) of 1968 and the *Yantra di terracotta* (*Yantras of Terra-cotta*) ceramics of the following year extended Sottsass's bond with Indian religious philosophy, but this time he blended it with references to Art Deco forms from the 1930s, another manifestation of his interest in positioning the past alongside the present. His designs were, he explained, inspired by "Aztec sculpture and jazz-age radio receivers."[20] The *Tantric* pieces (he borrowed the term from Ajit Mookerjee's book *Tantra Art*) were geometrically rooted, the ziggurat form, rediscovered in Art Deco, much in evidence (fig. **17**; see also fig. **44**). *Yantras of Terra-cotta* consisted of forty

Fig. 16
Grande vaso afrodisiaco (per conservare pillole anti-fecondative) (*Large Aphrodisiac Vase [for Conserving Contraceptive Pills]*), 1966
Made by Bitossi (Montelupo Fiorentino, Italy)
Unique
Glazed earthenware, wooden base
64 x 19 ¾ x 19 ¾ in. (162.5 x 50 x 50 cm)
The Gallery Mourmans, Maastricht,
The Netherlands

Fig. 17 (opposite bottom)
Vase from the *Ceramiche tantriche* (*Tantric Ceramics*) series, 1968
Made by Nanni Valentini or Franco Bucci, at Laboratorio Pesaro (Pesaro, Italy)
Glazed earthenware
20 ⅛ x 15 ⅛ x 15 ⅛ in. (51.1 x 38.4 x 38.4 cm)
Courtesy of Barry Friedman Ltd

pieces that, according to Sottsass, "represented a particular force whose power or energy increased in proportion to the abstraction and precision of the diagram."[21] The forms he found in Art Deco once again suited his purposes ideally (see figs. 45, **52**).

Sottsass's borrowings from non-Western culture allowed him to extend the concept of function beyond the narrow utilitarian definition of the term, which had underpinned prewar Modernism, to one that included objects' sensorial relationships with their users. In order to stretch the language and meaning of design and discover ways in which to empower it he consistently looked (and continues to look) beyond Europe, the home of Modernism. His ultimate aim remains to enable people to engage directly with designed artifacts through their senses and to avoid the sad fate of the designed object in the context of conspicuous consumption.

The lessons that Sottsass learned from non-Western cultures also influenced the work he undertook for the Italian typewriter and office electronics manufacturer Olivetti through the 1960s. Although the world he discovered there was radically different from that of his other designs—the workplace rather than the domestic environment, for example, provided the context for Olivetti's objects—he became aware that these items of office equipment were restricting the actions and lives of their

users, from computer operators to secretaries. Sottsass found ways of designing objects for Olivetti that paralleled his work on his more personal furniture and ceramic projects and which were intended to help to liberate their users. He was quick to realize, however, that Olivetti was an extraordinary company, interested in serving society as a whole rather than just making profits. His closeness to Adriano Olivetti allowed him to make a number of interventions that went beyond simply creating new forms for the company's office-based machines and, later, furnishings.[22]

The designer's first coup was the *Elea 9003*, a rethinking of the usual approach to the housing of electronic products. He undertook the project in 1958 and won the prestigious Compasso d'Oro award for outstanding design in the following year. One of his simplest refinements to the *Elea* computer was to lower the height of its room-sized set of components so that its operators could see each other for the first time. He treated the project as he would other formal exercises, focusing on the shapes of the units, the links between them, and the signs on their surfaces (fig. 18; see also figs. **30, 66**). As a result of his work with Olivetti, Sottsass increasingly came to see products as parts of larger systems. In a lecture he gave about his work there, entitled, "How to Survive with a Company, Perhaps?" he explained that

Fig. 18 (top)
Elea 9003 mainframe computer, 1959
Made by Olivetti (Milan, Italy)

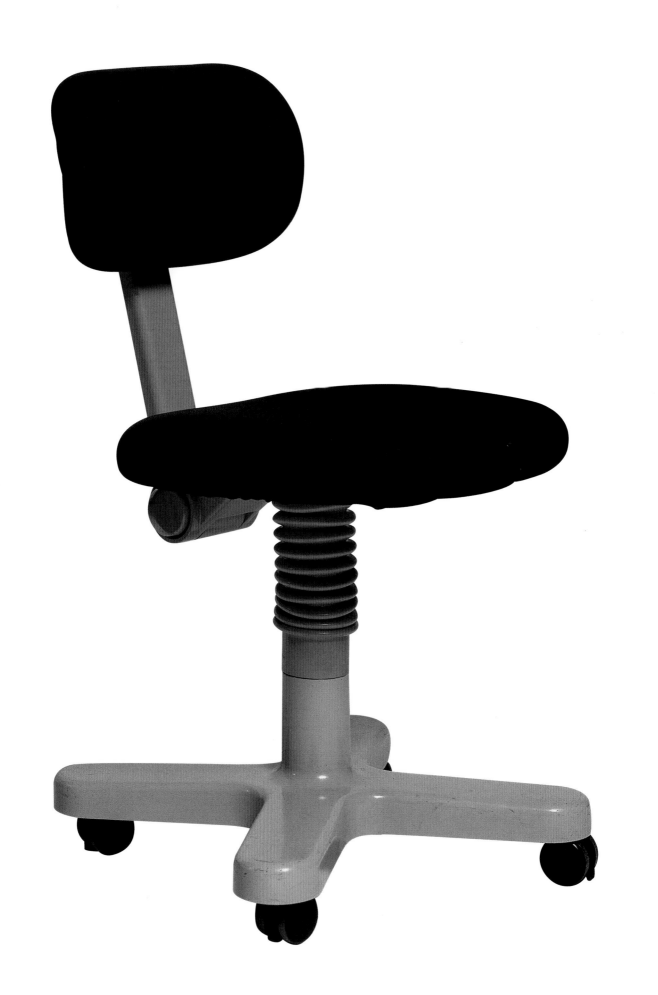

designing a typewriter involved thinking about the entire process that defined a secretary's daily work-related activities, from her metro ride in the morning to the chair on which she sat.[23] With this in mind a little later he created a typist's chair for Olivetti, the cartoon-inspired base and bright plastic frame of which distanced it from the familiar context of the working office (fig. **19**). The red plastic *Valentine* portable typewriter he created in 1969 reflected this same ambition (see fig. **32**). Covered with a sleek red plastic case with a carrying handle, it could be pulled off a shelf like a book, thereby avoiding a typewriter's usual destiny of being tied to an office desk. Advertising for the typewriter placed it in a variety of different, non-office-bound environments, thereby emphasizing its portability and the user's control of its function. Just as the *Shiva* ceramics had encouraged their "contemplators" to become aware of their own responses and gestures, so the *Valentine* typewriter allowed its user an unprecedented amount of freedom.

By the late 1960s, Sottsass had developed and implemented a range of complex and sophisticated strategies to extend the Modernist project, respond to Italy's special postwar model of modernity, and search for ways of avoiding the inevitability of Modernism becoming just one more style in the marketplace. In contrast, by the end of the decade, an internationally disseminated concept of Italian design had emerged—a chic, luxurious, modern, domestic aesthetic epitomized by expensive leather-clad sofas and smoked-glass and metal coffee tables. This "Neo-Modernism," as it was frequently dubbed, was extensively illustrated in many of the glossy interior magazines of the day.[24] Such an élite image of Italian high style and glamor was far removed from the optimistic, democratic idealism that had been expressed by Italy's material culture in the early postwar years. The ideological gap between Sottsass's aspirations to renew the language of Modernism in order to establish a new relationship between objects and users— one not determined solely by the logic of late capitalism—and the modern image of material domesticity that had become linked with the idea of "Italianness" through the dissemination of Italian design, had widened significantly in the years between 1950 and

1970. While he worked with Olivetti to create a series of objects with the power to liberate the user from the daily tedium of routine work patterns, other Italian manufacturers had, to his dismay, used design, and designers, to create a new modern language rooted in the concept of conspicuous consumption and recognized by its sumptuous forms. He was not alone, however, in his critique. The "revolutionary" years of the late 1960s witnessed the emergence, in Italy, of an architectural resistance to the mainstream that was directly inspired by the innovative designs—both the radical furniture pieces and the ceramics—that Sottsass had exhibited in Milan in the middle of the decade. A number of young, avant-garde architectural groups—Archigram, Superstudio, Gruppo NNNN, and others—began to work alongside Sottsass and formed a movement that came to be known as "Radical Design."[25] They rejected the idea of working with manufacturing industry, seeking instead to make their interventions from the margins.

Ironically, just at the moment when his influence was finally being acknowledged, Sottsass entered a period of extreme pessimism in which he almost lost his faith in the power of designed objects to make social and cultural changes to the status quo and to "free" their users from the tyranny of conspicuous consumption. Many of his projects of the early 1970s were two-dimensional—his lithographic series entitled *Il pianeta come festival* (*The Planet as Festival*), for example, which depicted utopian environments combining non-Western signs with cartoon imagery and which sought to reunite humankind

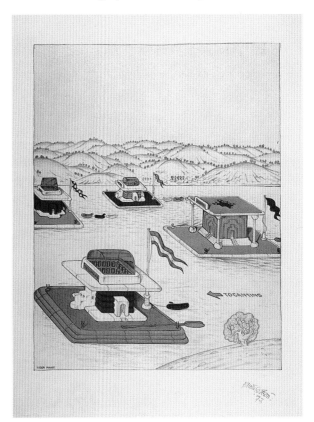

Fig. 19 (opposite)
Z9R typist chair, from the *Sistema 45* collection, 1973
Designed in collaboration with Perry A. King, Albert Leclerc, Bruno Scagliola, Masonari Umeda, and Jane Young
Made by Olivetti (Milan, Italy)
ABS plastic, polyurethane foam, synthetic fabric
32 ¾ x 17 x 22 ⅛ in. (83 x 43 x 56 cm)
Musée National d'Art Moderne, Centre Georges Pompidou, Paris

Fig. 20 (right)
Rafts for Listening to Chamber Music, from *Il pianeta come festival* (*The Planet as Festival*) series, 1973
Hand-colored lithograph

with nature by placing its utopian constructions in the natural environment (fig. 20; see also fig. 67). He also rejected bright color for a brief period, preferring to make his objects gray (fig. 21). It was "a color," he explained, "that will create some problems for anyone who would like to use it for advertising detergents, toothpaste, vermouth, aperitifs in general, Coca-Cola, *elettro-domestici* [electrical domestic appliances], deodorants and all that."[26]

This period of disillusionment with the positive power of three-dimensional objects came to an end, however, when Sottsass was invited to join Alessandro Guerriero, Alessandro Mendini, and others to participate in a project that was described by Mendini as "post-radical" or "post-avant-garde." Studio Alchymia, as the project was called, offered Sottsass the opportunity to develop the plastic-laminated furniture from the mid-1960s within a new, Postmodern context in which Modernism was challenged on a number of fronts.[27] He grasped the opportunity with both hands and created a series of radical furniture pieces that revealed a new energy and set of preoccupations, this time with the world of banal, suburban

imagery. The patterned "mosaic" surface of the base of a laminate-covered wardrobe, for example, was inspired by the floors of 1950s coffee bars (see fig. **61**). The fact that this Neo-Modern project was, importantly, informed by historical Modernism was reflected in the names of its collections, *Bau.Haus I* (1979) and *Bau.Haus 2* (1980). Simultaneously, Sottsass published his *Catalogue for Decorative Furniture in Modern Style*.[28] "It is an attempt," he wrote in the text, "to get back into design, bringing with me everything that has happened and maybe also everything that has not."[29] Designs, such as the *Le strutture tremano* (*The Structures Tremble*) table, were created by Sottsass to position Modernism within a (positive) critical framework (fig. **22**). In this example, the stability and solidity of the materials of that historical movement—tubular steel and glass—were challenged by the object's fragile structure. The overtly ironic and somewhat negative tone adopted by Mendini, which contrasted with Sottsass's more optimistic outlook and inner respect for Modernism, caused a schism to emerge between the two men, however. While the former saw his work as a form of critical commentary on modern design and what he

considered its limitations, Sottsass maintained a less ironic position, continuing to see his designs as a form of positive action seeking to extend the Modernist project rather than to reject it wholesale.

Sottsass's determination to let design act as its own cultural statement and extend Modernism underpinned the Memphis project. It was active, with Sottsass at its helm, between 1981 and 1985. The first catalogue—*Memphis: The New International Style*—acted as a manifesto making its leader's intentions clear at the outset.[30] In the text Sottsass explained that his use of the word "internationalism" was not an ironic reference to the past but rather part of a positive strategy to renew Modernism's aspiration to become a design movement that would transcend national boundaries. "The desire to design new things in Milan was by no means an isolated, Milanese one," he wrote. "There was also an extensive desire, a general spring of energy, seeing that all the architects and designers approached, world-famous or not, very young or not, immediately responded to the proposal to send in projects for a new line of furniture, for a new way of imagining houses and everyday objects, for a different outlook on life."[31] A little later he went on to explain that, unlike Studio Alchymia, Memphis was first and foremost a positive design movement. "All the Memphis projects are propositive, positive, non-critical acts," he claimed, "unlike the radical and conceptual philosophies that nevertheless served as incubators for these proposals."[32] Memphis represented a consolidation and a confirmation of the themes that had dominated Sottsass's career to date. In its commitment to functionality (albeit reduced to a minimum), internationalism, and the social and cultural potency of design—enriched now with the addition of color and decoration—it reinforced all the beliefs that the designer had been articulating since the late 1940s. Most significantly, it was a message that was no longer communicated from the margins as, by the early 1980s, the international design community and the mass media were ready to hear it.

In 1980, Sottsass formed his own architecture and design team, Sottsass Associati, with a group of young colleagues, Marco Zanini and Aldo Cibic among them. Since then he has continued to lead it in the realization of a vast quantity of diverse

Fig. 21
Pranzo aromatico (Aromatic Lunch) table and *Elledue (L2)* chairs, from *I mobili grigi (The Gray Furniture)* collection, 1970
Made by Poltronova (Agliana, Italy)
Limited production
Painted fiberglass
Table: 29 ⅛ x 54 ⅜ x 54 ⅜ in. (74 x 138 x 138 cm)
The Gallery Mourmans, Maastricht,
The Netherlands

Fig. 22
Le strutture tremano (The Structures Tremble) table, 1979
Made by Studio Alchymia (Milan, Italy)
Wood, plastic laminate, enameled metal, glass
The Gallery Mourmans, Maastricht,
The Netherlands

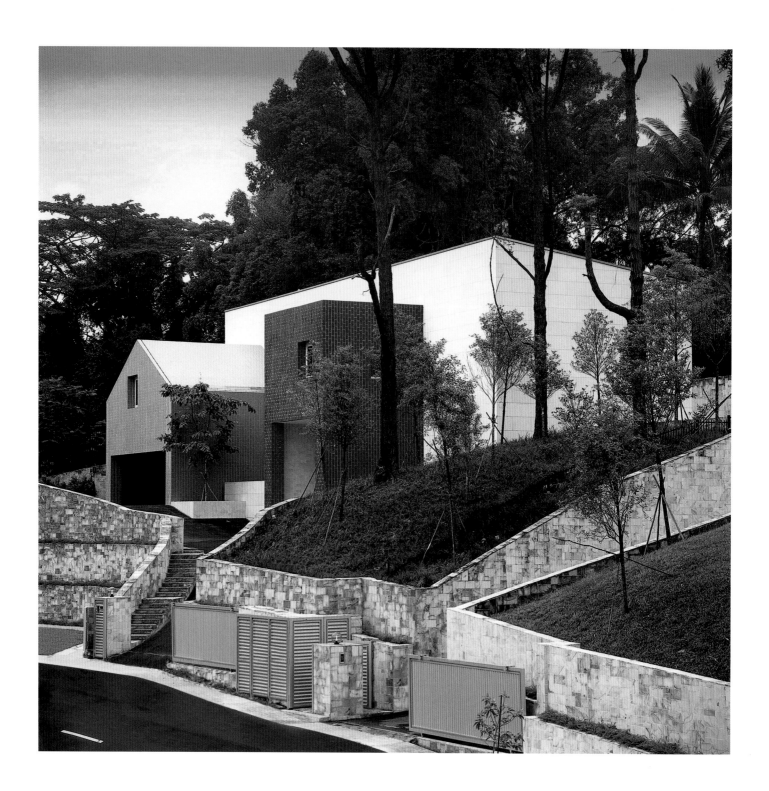

Fig. 23
Jasmine Hill, Singapore, 1996–2000
Architects: Sottsass Associati (Milan, Italy);
Ettore Sottsass and Johanna Grawunder,
principals-in-charge; Federica Barbiero and
Marco Polloni, project architects

projects undertaken in many different countries, for large numbers of private clients, and with many manufacturing companies.[33] Importantly, over the last two and a half decades the team has taken the reworked Modernism that Sottsass developed over a period of more than forty years back into the world of architecture, where it had originated. The Jasmine Hill project, created between 1996 and 2000 in Singapore, for example, shows how the lessons learned over these years served to revitalize both the aesthetic and the meaning of modern architecture (fig. 23; see also figs. 90, 91). In 2005, Sottsass is as committed as ever to modernity and to the seamless continuity that exists between the past, the present, and the future. He continues to live and work in Milan and to extend and elaborate his essential belief in the Modernist project, confident, still, that it is through the agency of design that the future will be formed. Although, given the changes in the nature of the marketplace, in technology, and in the world of manufacture and production, the era in which he is now working may be more properly defined as "Postmodern," Sottsass's positive, innovative, and utopian approach continues to derive from, and contribute to, the ideas and ideals of Modernism with which he was brought up. Barbara Radice's words of optimism, spoken in 1981 on behalf of Sottsass and the other members of the Memphis group, are as relevant today as they were then. "Our fear of the past is gone," she explained, "and so is our still more aggressive fear of the future."[34]

1. Memphis press release, Milan 1981, p. 4.
2. B. Radice, *Ettore Sottsass: A Critical Biography*, New York (Rizzoli) 1993, p. 216.
3. For an account of Italian architectural Rationalism see S. Dansi and L. Patetta, *Rationalisme e architecture en Italie*, Milan (Electa) 1976.
4. The family name was originally spelled many ways, such as Sot-Sas, and Sot Sas, but was changed by the young Ettore to Sottsass. G. Belli, *Ettore Sottsass Senior: Architetto*, Milan (Electa) 1991, p. 39.
5. Giuseppe Pagano (1896–1945) became a leading Rationalist architect in the 1930s. He was responsible for, among other projects, the Boccioni University in Milan (1936–42). Like Pagano, who had also begun his career in Turin, Sottsass worked for a while in the Fiat carriageworks. In the postwar years, many of Sottsass's early interiors (*e.g. An Interior for a Young Girl*, 1946), furniture designs (*e.g.* a chair for the 1947 Triennale), and architectural designs (*e.g.* one for a church for the 1947 QT8 competition) showed signs of his firsthand experience of Rationalism.
6. E. Sottsass, unpublished lecture delivered at Design and Industries Association conference, London, April 1979.
7. E. Rogers, "Editorial," in *Domus*, no. 84, January 1946, p. 3.
8. Conversation between the author and Ettore Sottsass, August 1979.
9. "Sottsass explains Memphis," in *Designer*, III, no. 3, February 1982, p. 7.
10. The work of such individuals as the Castiglioni brothers, Marco Zanuso, Vico Magistretti, and, a little later, Mario Bellini and Joe Colombo, drew from different stylistic roots in the years after 1950, but they shared a commitment to the "modern" and to the power of design to bring about cultural change.
11. E. Sottsass, "Interiors: Composition of Walls," in *Domus*, no. 358, 1959, p. 13.
12. This design is illustrated in M. Carboni (ed.), *The Work of Ettore Sottsass and Associates*, New York (Universe Publishing) 1999, p. 25.
13. *Designer* 1982, p. 6.
14. E. Sottsass, "Katalogo Mobili 1966," in *Domus*, no. 449, April 1967, p. 39.
15. *Designer* 1982, p. 6.
16. E. Sottsass, "Offerte a Siva," in *Domus*, no. 422, June 1965, p. 49.
17. Memphis press release, Milan 1981, p. 2.
18. E. Sottsass, "Ceramics of Darkness," in *Domus*, no. 409, June 1963, p. 45.
19. E. Sottsass, unpublished, undated lecture in Sottsass's private archive, Milan.
20. E. Sottsass, "Ceramiche Tantriche," in *Domus*, no. 478, 1969, p. 33.
21. Ibid.
22. *Design Process: Olivetti 1908–1983*, Milan (Olivetti) 1983.
23. E. Sottsass, "How to Survive with a Company, Perhaps?" unpublished, undated lecture in Sottsass's private archive, Milan.
24. *Domus*, *Abitare*, and *Casa Vogue*, for example.
25. For more information on this movement, which, like Modernism before it, had its roots in architecture, see P. Navoni and B. Orlandoni, *Architettura "radicale"*, Milan (Documenti di Casabella) 1974.
26. E. Sottsass, "Could Anything be More Ridiculous?" in *Design*, IV, no. 262, November 1970, p. 29.
27. Writings about architecture, in particular by Robert Venturi and Charles Jencks, had questioned the relevance of Modernism in a world increasingly dominated by a pluralist culture defined by the market and mass consumption.
28. *Catalogue for Decorative Furniture in Modern Style*, Milan (Studio Forma/Alchymia) 1980.
29. E. Sottsass, "Introduction," in *Catalogue for Decorative Furniture in Modern Style*, Milan (Studio Forma/Alchymia) 1980, p. 1.
30. B. Radice, *Memphis: The New International Style*, trans. Rodney Stringer, Milan (Electa) 1981.
31. Quoted in B. Radice, "Introduction," in *Memphis: The New International Style*, trans. Rodney Stringer, Milan (Electa) 1981, p. 5.
32. Quoted in ibid., p. 5.
33. See Carboni 1999.
34. Radice 1981, p. 7.

Humanist for the Modern Age

Ronald T. Labaco

Ettore Sottsass is not easily classified within the canon of twentieth-century Modernism. Over the course of a career that has spanned nearly three-quarters of a century, he has explored painting, sculpture, photography, journalism, art criticism, and philosophy, but he is best known, and internationally acclaimed, as an architect, a designer, and, among the cognoscenti, a theoretician. His furniture, ceramics, glass, industrial products, "radical design," jewelry, metalwork, interiors, graphics, and, most recently, his architecture, have substantially contributed to the domestic landscape, and only now in the twenty-first century can we begin to assess his impact on our world.

To label Sottsass as a Modernist or a radical designer or a Postmodernist would miss the complexity of his work, which incorporates his broader interests, ranging from Classical art to Eastern vernacular culture and modern painting and sculpture. Rather, Sottsass may be viewed as a throwback to the Renaissance, when artists incorporated the influences of other creative expressions including architecture, poetry, painting, sculpture, and even music. In this sense Sottsass shows a fraternity with the Renaissance artists of his native Italian past. And like a Renaissance artist, Sottsass takes a decidedly "humanist" approach to his work.

I use the term "humanist" as it was introduced in the late nineteenth century in reference to the revived interest in Classical culture that flourished in early fifteenth-century Italy. I will discuss Sottsass's design philosophy largely based on its affinity to the humanist approach of the fifteenth-century artist Leon Battista Alberti. It is easy to draw parallels between Alberti's definition of Renaissance humanism and Sottsass's modern take on this trope. Recognized as a philosopher, architect, musician, painter, and sculptor, Alberti was also considered a theoretician: he gave a scientific basis to works of art, elevated the status of the artist, and gave painting, sculpture, and architecture the same standing as literature and philosophy.

Renaissance humanists, many of whom were also men of letters interested in literary and scholarly pursuits, often wrote down their ideas on art and antiquity, and composed treatises on the subjects. Alberti is credited with establishing a theoretical foundation for Renaissance art with his three treatises on painting, sculpture, and architecture respectively. Beginning in 1937, Sottsass has written close to two hundred texts, documenting his thoughts on art, architecture, and design, in addition to his travel experiences. In 2002 many of his essays were compiled and published as *Scritti: 1946–2001*.[1]

According to art historian Charles Trinkaus, Alberti summarized the three necessary elements in painting in his 1435 treatise *Della pittura* as: 1) the evocation of spatial and historical actuality by a combination of artificial perspective and a system of proportion and scale based on the human figure; 2) the invention of a narrative; and 3) its elaboration through the use of appropriate color, light, proportion, composition, and affective movement in such a way as to communicate a living, moving visual drama that would edify, terrify, instruct, or please the viewer.[2] While Sottsass was training as an architect at Turin Polytechnic in the late 1930s, where he developed a passionate interest in art, the ideas of Alberti would have been a commonplace part of discussions in art class.

A review of Sottsass's designs will demonstrate that despite the seemingly eclectic nature of his body of work, his personal humanist outlook provides a philosophical fabric by which his work may be best appreciated. Just as the Renaissance humanists sought the revival of Classical literature and learning, Sottsass sees ancient, as well as non-Western, cultures as models for how we should relate to the objects of modern society. Whether it be office machines, ceramic vases, furniture, or architecture, Sottsass's humanist outlook serves as the framework for his designs.

With Sottsass's designs we are no longer discussing the tools of the Renaissance painter, that of oil and board or canvas, but rather the elements of modern twentieth- and twenty-first-century design, which range from the traditional media of clay and exotic woods to such technologically advanced materials as plastic and fiberglass. Human scale and interaction, color and its emotive power, and materials chosen for their expressive qualities rather than their technological innovations, are the instruments by which he communicates his unique and personal philosophy. His humanist values are fundamental to his creativity, and they find expression in the form of strong colors and symbolic shapes in even his most rationalized technological designs.

But the most important element of Sottsass's approach to design is the physical and psychological experience of the prospective user—his or her feelings, reactions, and relationships to the objects of our modern culture. Sottsass articulated this in a 1990 interview, with reference to his drawing from 1974 of a bed situated in an outdoor landscape:

Here, for example, we have a bed, a bed for someone to sleep on, with a small brook that murmurs along underneath it, a sound that creates a sense of coolness in a hot country. In other words, a bed, with a design that does not interest me, and [I] am equally interested neither in how it is made nor in the technology involved. What does interest me, however, is the person who sleeps in this bed; that is, I would like to know what he or she feels when sleeping in this bed, what comforting feelings arise: in a very hot country this probably means experiencing an enjoyable feeling of coolness.[3]

Naturally, the design of a functional bed always takes into consideration the scale of a human figure, but Sottsass's more immediate concern is that of the experience of the individual and the possible narrative that might arise from interaction with the object. Capitalizing on the emotive qualities of design and architecture, he stimulates our senses to elicit a response to his work. By reviewing his work in the context of two key elements—color and form—I hope to show that at the heart of Sottsass's design philosophy is his belief in the communicative nature of objects and the role that this can play in enriching the human condition.

One of the most obvious and pervasive elements in Sottsass's work is his exuberant use of color. It cuts across all media and can be seen in his earliest student paintings from 1938 to his most recent architectural projects. Sottsass came to appreciate the emotive quality of color when he began painting in 1934 while a student at Turin Polytechnic. Two years later, when he was nineteen, he traveled to Paris and experienced examples of early twentieth-century modern French painting firsthand. He especially admired the works of the Fauvists, such as Henri Matisse, noted for their bold use of color, and the Cubists, including Pablo Picasso and Georges Braque, characterized by their fragmented space and the equal treatment of objects and background. Sottsass's other influences were the German artists of the Blaue Reiter, especially the work of Vassily Kandinsky.[4] Sottsass later recalled, "For a young lad like me these artists were something like gods and as far as problems of color were concerned they became my masters."[5] In addition

to underscoring the importance of color in his work, this comment also shows Sottsass's awareness of the impact that radical, avant-garde artistic thought could have in breaking away from old associations and in communicating original and different ideas, a theme that would resonate throughout his career.

In a student painting by Sottsass from 1938, executed for a class on interior decoration, the use of bold color and flat pattern serve as the primary structural elements in the suggestion of three-dimensional space (fig. 24; see also figs. 6, 99, 100). The two chairs, arranged around a table with a vase, exist as negative space, with their shapes defined by the color-activated space around them. The vibrant blue-and-yellow-striped carpet, the bold red-tiled floor, the multicolored cubist table, and the green, rounded contours of the plant foliage are jarring in their visual intensity, shifting the focus to the central figure of the black vase and the silhouettes of the two undefined chairs. While the influence of Matisse predominated in these student paintings, the work of Paul Klee served as the source of inspiration for his earliest sketches for fabric and carpet designs from the early 1940s (fig. 25).

Fig. 24 (opposite)
Drawing for Interior Design examination,
Faculty of Architecture, University of Turin, 1938
Tempera and ink on paper

Fig. 25 (right)
Design for a carpet, 1943

Sottsass's designs from the 1950s were industrial commissions, formal exercises in applying current stylistic trends to objects meant for mass production, yet he still managed to infuse them with color. His aluminum vases from 1955, available in a variety of color combinations, featured tapering feet that were dictated by parabolic arcs cut into the aluminum shell, reflecting contemporary trends in architectural roof design (fig. **26**). A ceramic vase design from the same year incorporates simple, repeating motifs as patterned decoration: regimented groups of dots are mixed with crisscross marks, red circles, and blocks of horizontal and vertical lines in repeating graphic pattern, resembling an alphabet or hieroglyphs from an unfamiliar culture (fig. **29**). Sottsass used these motifs across a variety of media, including posters, carpet designs (fig. 27), and jewelry (fig. **28**).

Fig. 27 (opposite top left)
Designs for two carpets, 1956

Fig. 28 (opposite bottom left)
Brooch, 1968
Made by Walter de Mario (Milan, Italy)
Unique
White and yellow gold
Musée National d'Art Moderne,
Centre Georges Pompidou, Paris

Fig. 26 (above)
Group of vases, 1955
Made by Rinnovel (Milan, Italy)
Anodized and polished aluminum
The Gallery Mourmans, Maastricht,
The Netherlands

Fig. 29 (opposite right)
Vase, 1955
Made by Bitossi (Montelupo Fiorentino, Italy)
Glazed earthenware
8 x 3 x 2 in. (20.3 x 7.6 x 5.1 cm)
Collection of Joel Chen

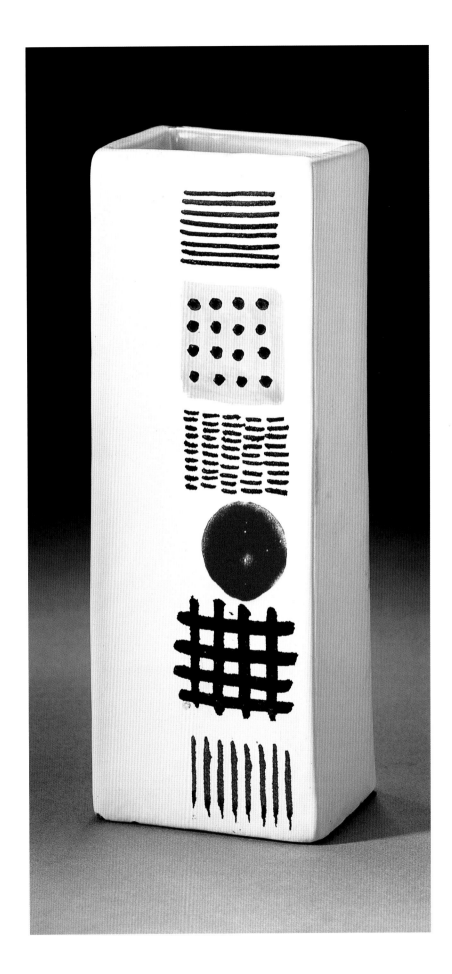

Fig. 30
Design for *Elea 9003* mainframe computer
for Olivetti (Milan, Italy), 1958
Pencil and pastel on paper
13 ¾ x 13 ⅜ in. (35 x 34 cm)
Musée National d'Art Moderne,
Centre Georges Pompidou, Paris

In 1957 Sottsass became the chief consultant designer for the Olivetti electronics company in Italy. Two years later, his design for the country's first electronic mainframe computer, the *Elea 9003*, would win the prestigious Compasso d'Oro (golden compass) award for outstanding Italian industrial design, an honor that would firmly establish his reputation internationally (fig. **30**; see also figs. 18, **66**).

The design innovations of the *Elea 9003* were motivated by Sottsass's concern with the physical, cultural, and psychological comfort of the computer operators. He lowered the height of the computer cabinets so that operators could see and communicate with each other, and he used color to unify the whole system while differentiating between the various parts. With the cabinet exteriors painted white and red, and the controls color-coded in mauve, yellow, and turquoise, he alleviated the visual monotony of the office environment and created a more pleasurable work experience.[6]

Sottsass's approach to this design reflects his ongoing interest in the dialogue between the user and the object, which he achieves by first creating a conceptual frame of reference—that of the user. Beginning with a close examination of the operators' physical actions, work styles, and work patterns, he determined the basis for his design. Sottsass deduced that "A new form had to be found which, by nature, had to be more symbolic and less descriptive."[7] To overcome what he perceived to be a growing fear of new technology in the workplace, he decided to break free from the psychological anxieties associated with the previous computer models. He accomplished this by designing entirely new forms to house the electronic components, using a color-coded system to aid in its operation. The result was a series of individual freestanding cabinets that were interconnected by a wiring system. This plan facilitated both flexibility and growth: not only could the cabinets be arranged in different configurations to accommodate different-sized rooms, but also new units could be added as needed.

Color was an important consideration in Sottsass's subsequent designs for Olivetti, along with other aesthetic concerns. He gave his *Praxis 48* electric typewriter (1964,

designed in collaboration with Hans von Klier) green-colored keys to provide a welcome visual distraction in the office environment, and sharper edges to the body to distinguish it from the prevailing typewriter designs that featured rounded edges and corners (fig. **31**). Sottsass commented, "the fact that one can have the carriage at the same level as the machine body has made it possible to make a little box out of the machine, almost a toy, a decorative object which can be left on a table."[8]

Sottsass took this idea to the next level with his now iconic *Valentine* portable typewriter (1969, designed in collaboration with Perry A. King) (fig. **32**). The bright-red, molded-plastic housing was an instant design sensation when it was introduced on Valentine's Day in 1969 amid a blitz of advertising. With its catchy name, seductive red color, shiny plastic surface, and well-orchestrated ad campaign, the *Valentine* bears all the hallmarks of Pop art—witty, sexy, gimmicky, mass-produced, and aimed at youth culture. But in actuality, his initial concept for the product was far more radical, as Sottsass suggested in 1969:

> It is called *Valentine* and was invented for use in any place except in an office, so as not to remind anyone of monotonous working hours, but rather to keep amateur poets company on quiet Sundays in the country or to provide a highly colored object on a table in a studio apartment. An anti-machine, built around the commonest mass-produced mechanism, the works inside any typewriter, it may also seem to be an unpretentious toy.[9]

In order to differentiate the *Valentine* from a standard office typewriter, Sottsass's original design broke from convention both aesthetically and functionally: at first it featured only lowercase type and no bell to indicate the end of a typewritten line—which rendered it impractical as a business machine.[10] However, Olivetti restored the missing features to the production model, so that the only reminder of Sottsass's concept of "impracticability" is the distinctive lowercase *valentine* logo in raised lettering above the keyboard. Color still remained a key element of this design. By using red, with its associations of love and passion, Sottsass employs a visual stimulus to help set a dramatic tone for the writer or poet in the introspective and

Fig. 31
Praxis 48 electric typewriter, 1964
Designed in collaboration with Hans von Klier
Made by Olivetti (Milan, Italy)
10 x 18 x 24 in. (25.4 x 45.7 x 61 cm)
Enameled metal, plastic
Collection of Daniel Ostroff

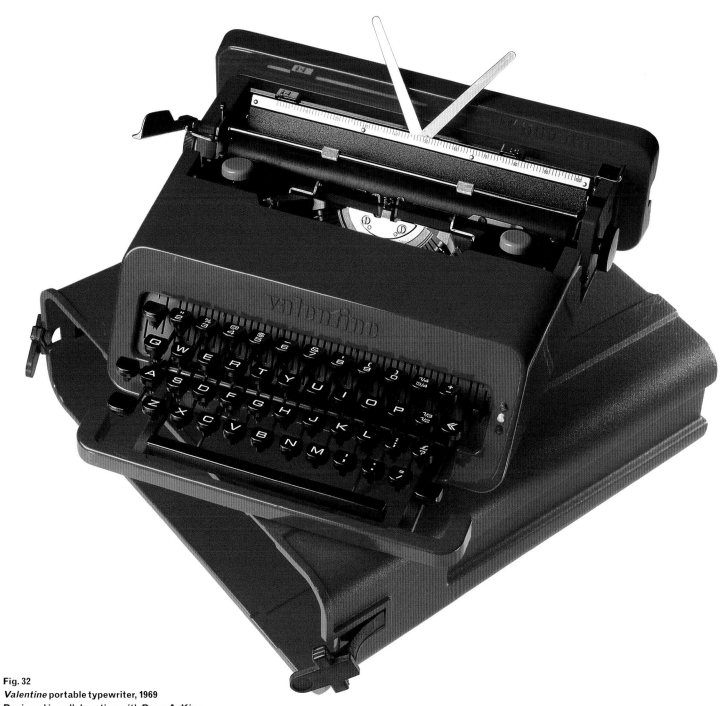

Fig. 32
Valentine portable typewriter, 1969
Designed in collaboration with Perry A. King
Made by Olivetti (Milan, Italy)
ABS plastic, metal, rubber
4 ½ x 13 ½ x 14 in. (11.4 x 34.3 x 35.6 cm)
LACMA, gift of Daniel Ostroff

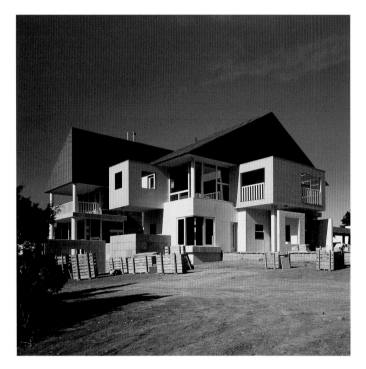

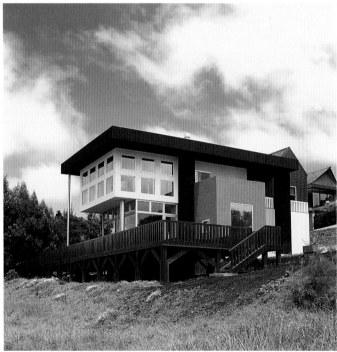

somewhat ritualistic activity of sitting down to record one's thoughts, feelings, and experiences on paper.

Sottsass's use of color also figures prominently in his architecture. Wolf House (1987–89) in Ridgeway, Colorado (fig. 33; see also figs. 47, 73) and Olabuenaga House (1989–97) in Maui, Hawaii (fig. 34; see also fig. 74) are two outstanding examples of his private residential designs, commissions received in the late 1980s when his architecture practice finally began to flourish. Developed through his architecture and design firm, Sottsass Associati, both these homes were designed in collaboration with Johanna Grawunder. In their respective locations and general appearance, the buildings correspond to Alberti's theories on the planning and architecture of villas that were expressed in his treatise on architecture of about 1452, *De re aedificatoria*. Alberti suggested that country and suburban villas be placed on hills for greater visibility and to command a view, that they be festive in architectural and decorative character, and that they appear welcoming.[11] Wolf House is situated on the slight rise of a plain and Olabuenaga House is on a hill with a view of the ocean, and the exterior color combinations of both structures are a visual delight.

On the outside of both houses, the most distinctive features are Sottsass's bold use of color and strong forms to create a visually dynamic composition. Blocks of red, yellow, and green, demarcating individual rooms within, vibrate against one another but are harmoniously balanced. Inside, the emphasis is on surface finishes, such as polished woods, marble walls, and stone-tiled floors. Simplified Classical architectural elements, such as columns, Romanesque archways, winding staircases, and balconies, contribute to the feeling of a covered piazza, connecting the inside with the outside environment (fig. 35). Well-situated windows and glass atriums use light to accentuate forms and cast shadows that change throughout the course of a day, linking daily life to diurnal and seasonal rhythms.

Because of the timing of Sottsass's architectural career, his use of color in buildings seems a logical offshoot of his furniture, lighting, glass, ceramics, and interiors from the early

Fig. 33 (top)
Wolf House, Ridgeway, Colorado, 1987–89
Architects: Sottsass Associati (Milan, Italy);
Ettore Sottsass, principal-in-charge;
Johanna Grawunder, project architect

Fig. 34 (bottom)
Olabuenaga House, Maui, Hawaii, 1989–97
Architects: Sottsass Associati (Milan, Italy);
Ettore Sottsass, principal-in-charge;
Johanna Grawunder, project architect

Fig. 35
Interior of Wolf House, Ridgeway, Colorado, 1987–89
Architects: Sottsass Associati (Milan, Italy);
Ettore Sottsass, principal-in-charge;
Johanna Grawunder, project architect

1980s for Memphis. With its characteristic mixture of color and pattern on innovative forms, Sottsass's widely popular and influential Memphis designs, and those of his associates, helped define the look of a decade. Sottsass, however, has been a champion for the use of color in architecture for over fifty years, in striking opposition to the prevailing Modernist mindset of the twentieth century, which has marginalized the role of color in deference to structure. In his essay from 1954 entitled "Struttura e colore," he criticized the chief proponents of modern architecture, particularly Walter Gropius, Marcel Breuer, and Richard Neutra, for their preference for structure over color.[12] Citing the work of the Russian-born painter and sculptor Antoine Pevsner as an example, Sottsass proposed a more artistic approach to the use of color as a determining factor in the creation of an environment or of space. He contended that color should be used with all its emotive power and no longer demonized as something frivolous or purely ornamental. He made the controversial declaration that structure should be subordinate to color and that color should dictate structure. Since he believed that color has its own rules, which follow the laws of painting, it followed that architecture and painting should be closer to each other in nature. As a solution, he called for a return to a Classical ideal, citing the architecture of ancient Greece, and the Parthenon in particular, as an example of an equilibrium in which structure could not exist without color and *vice versa*.

In order fully to appreciate Sottsass's "Classical" solution we need to imagine his example of the Parthenon not as we see it today, exalted for its gleaming white marble and for the grandeur of its volumetric forms, but as a citizen of ancient Greece would have experienced it in its full polychromatic beauty. The Parthenon was once painted with every imaginable color, reflecting the splendor and glory of the visual world that was created by the pantheon of gods within. If we situate ourselves, as Sottsass attempts to do when conceptualizing his designs, in the frame of reference of an ancient Greek pilgrim who has come to worship at the temple, we can then begin to understand Sottsass's logic. Imagine the pilgrim, exhausted from having traveled for days, walking up the hill and suddenly coming upon the Parthenon, bejeweled in every conceivable color. This must have been a striking spiritual revelation, and the combination of glorious color and monumental structure would have heightened his or her experience. In 1990, Sottsass commented, "I feel, for instance, a cosmic vibration when I enter the Parthenon or stand before it; I feel that there is something there . . . when I enter that temple, a feeling—let us say a

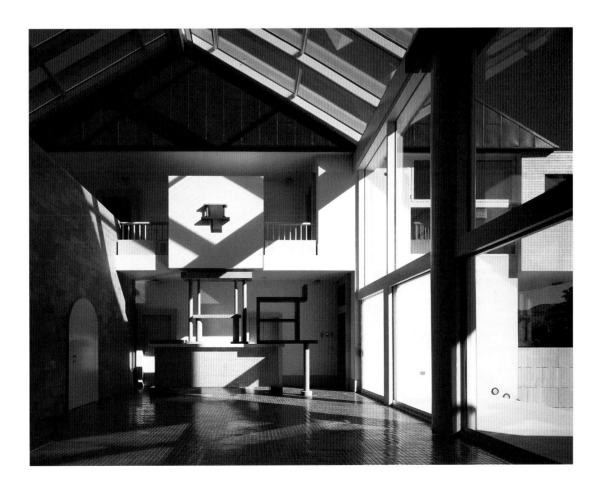

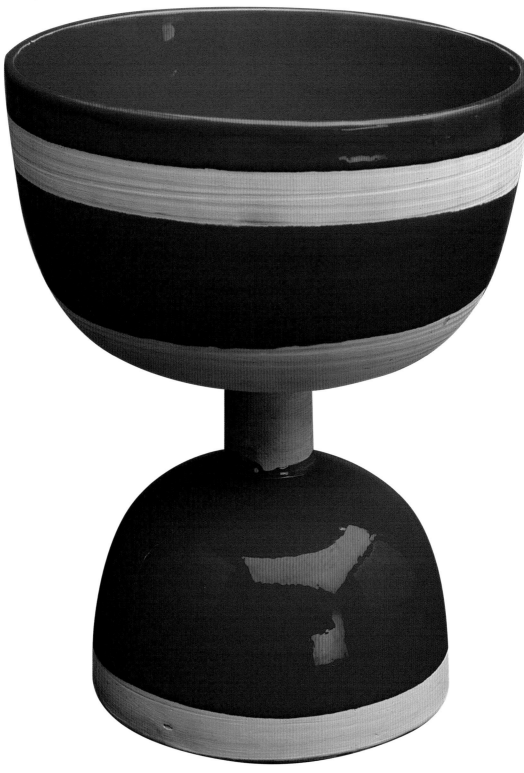

Fig. 36
Fruit bowl, 1958
Made by Bitossi (Montelupo Fiorentino, Italy)
Unique
Glazed earthenware
12 ¼ x 10 ⅝ x 10 ⅝ in. (31 x 27 x 27 cm)
Musée National d'Art Moderne,
Centre Georges Pompidou, Paris

metaphysical consciousness—seizes hold of me and I notice that I am alive."[13] It is this hyper-realization of one's existence that Sottsass hopes to achieve with his designs, realized, in part, through color—and through form.

Sottsass's humanist design philosophy extends to his use of form. Although his work may range from simple, individual objects to complex constructions with various components, his designs emphasize the emotive potential of form beyond mere shape and volume.

One of his earliest investigations into the communicative nature of objects came about while conducting research for the ceramic designs that were produced by Bitossi in the late 1950s. While his plates (1958–59) show a continued interest in blurring the boundary between art and design with their glazed painterly decoration (see figs. **8, 54**), the modest form of the goblet-like fruit bowl (1959) signals the beginning of Sottsass's search for "archetypal forms" (fig. **36**). He later explained:

> The shapes are simple, very popular, I would say large bowls, ancient bowls with very primeval colors or ancient goblets, goblets like the ones maybe used in Mycenae or in Galilee or in Ur or any other place, to drink water gushing from a spring.
>
> At the time, it seemed to me that you could find some . . . archetypal forms, not essential forms, because the essential seems to presume an ideal status or a more or less platonic metaphysical absolute, but archetypal forms, I mean forms which have been discovered by men a long time ago and which deeply belong to their history to such a point that men could not do without them, or almost to the point that the act of their history, which is the archetype, has become part of their nature, or almost so.[14]

Here, Sottsass uses the term "archetype" as an extension of theories of the Swiss psychologist Carl Jung and his ideas about the unconscious mind. In addition to the individual experiences that left traces on one's unconscious, Jung proposed the concept of a "collective unconscious," a level of the psyche shaped by the cumulative experience of the human race, in which "archetypes," or innate, preconditioned human responses to key universal experiences, could be identified.[15] By attempting to distill man-

made forms into fundamental elements that resonate within the human psyche, Sottsass combines Jung's psychological precepts with modern design. Like Jung's anthropological perspective, Sottsass's humanist approach stemmed from his contact with other cultures, which taught him that there are certain universal themes and forms. Embedded within these archetypal forms lay the collective history of mankind, a type of unconscious imprint, which, if harnessed, could infuse the objects with a deeper meaning.

Sottsass uses archetypal forms repeatedly to establish a deep psychological connection between the user and the objects of his creation. An example of this is the goblet form. A chalice-shaped object, regardless of intended function, brings with it associations of ritual, majesty, and even Christian history. Sottsass would incorporate the basic goblet/footed bowl form into his œuvre time and again, with varying degrees of modification, as can be found in his luminous glass *Schiavona* fruit bowl by Vistosi (1974; fig. 37),

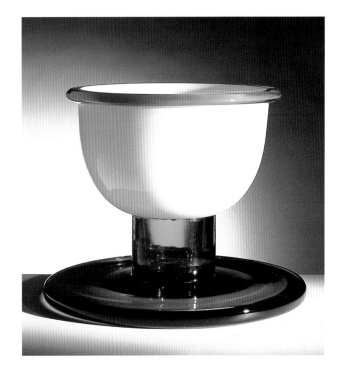

Fig. 37 (above)
Schiavona fruit bowl, 1974
Made by Vistosi (Murano, Italy)
Glass

Fig. 38 (overleaf left)
Iride fruit bowl, 1986
Made by Toso Vetri d'Arte (Murano, Italy)
for Memphis (Milan, Italy)
Edition of seven
Glass
15 ⅜ x 11 ¼ x 11 ¼ in. (39 x 28.5 x 28.5 cm)
The Gallery Mourmans, Maastricht,
The Netherlands

Fig. 39 (overleaf right)
Diane bowl, 1994
Made by Manufacture Nationale de Sèvres
(Sèvres, France)
Glazed and gilded porcelain
12 x 12 x 12 in. (30.5 x 30.5 x 30.5 cm)
Collection of Max Palevsky

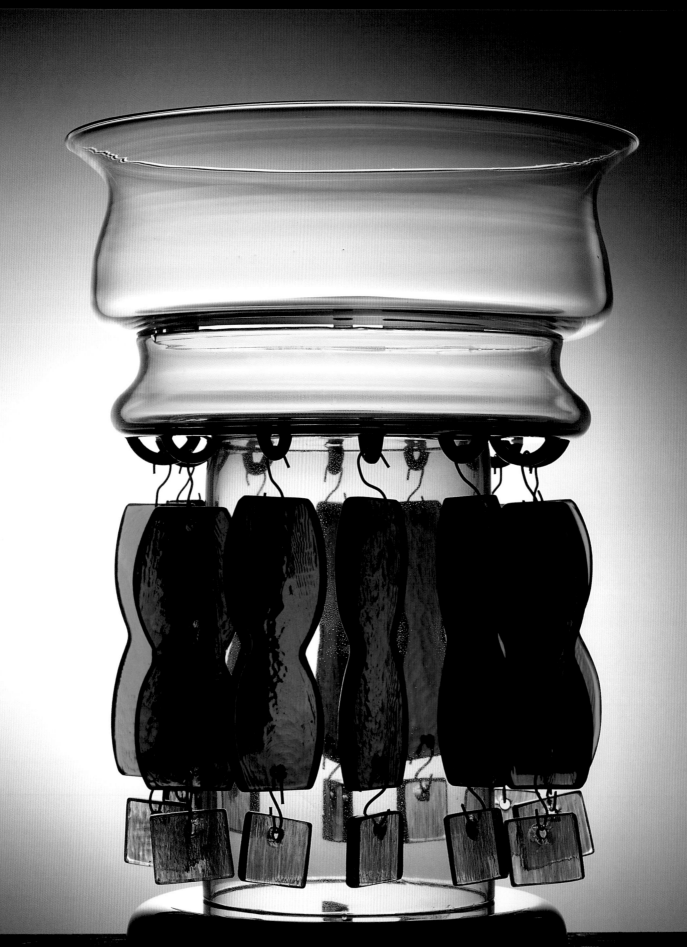

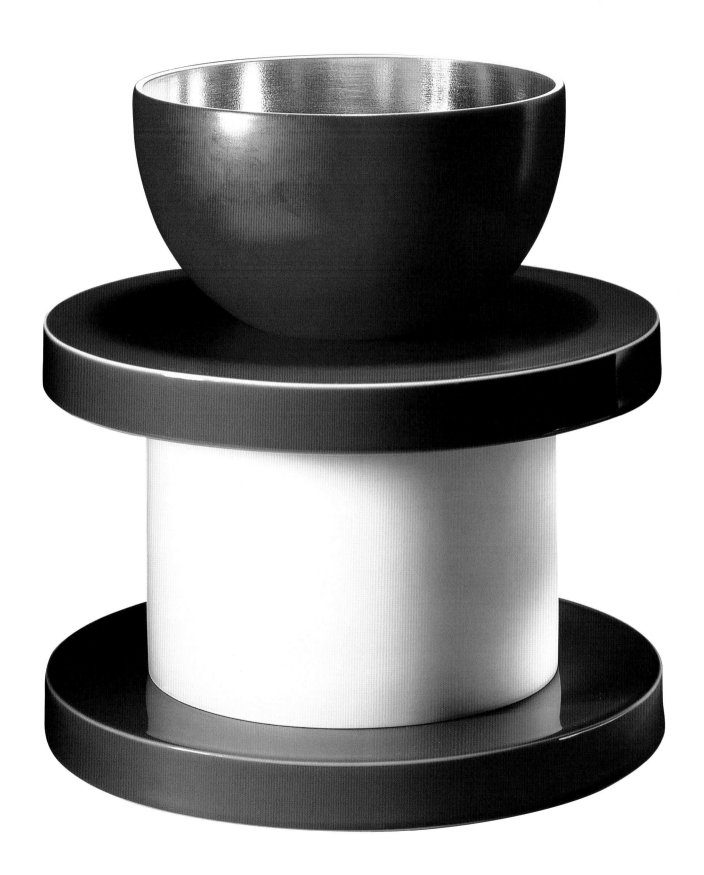

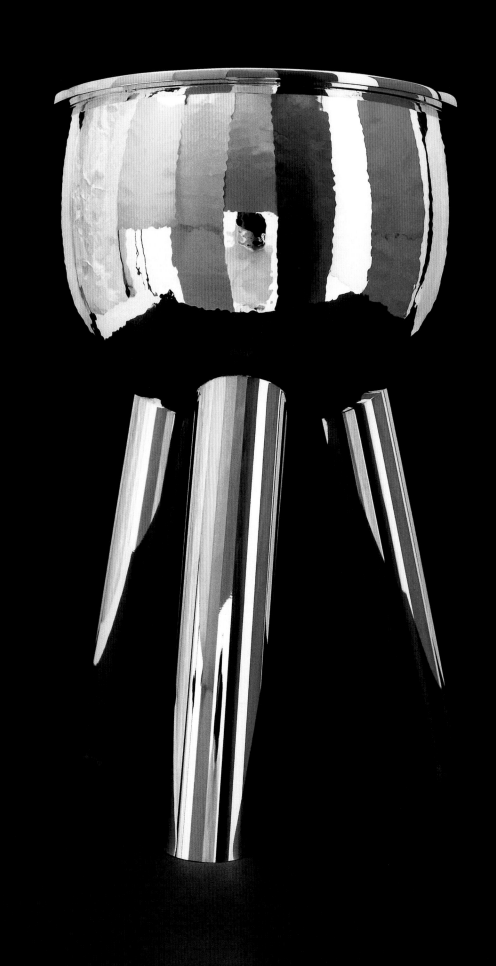

his colorful *Iride* fruit bowl for Memphis (1986; fig. **38**), his gilded porcelain *Diane* bowl by Sèvres (1994; fig. **39**), and his monumental silver *Gudea* vase by Rossi & Arcandi (2002; fig. **40**).

Another recurring motif is the ziggurat temple form, which has its roots with ancient Mesopotamian culture, as well as associations with the biblical "tower of Babel." As Sottsass wrote in 1969:

> [T]hose simple and chaste shapes of the Mediterranean and of Mesapotamic pre-history . . . keep conveying to us the image of ages . . . in which maybe the relationship of the cosmic and the human rhythms was very close; ages in which, anyhow, human destinies seemed determined by a cosmic law rather than by a human, artificial law.[16]

According to ancient Babylonian lore, the temple tower was erected at the axis of the universe where a straight line connected earth and heaven. Thus in effect the ziggurat functioned as a link between people and the cosmos. This concept of using an instrument of human invention to relate humanity to the universe is a theme that Sottsass would embrace and continue to explore. The stepped, temple-tower form may be found in his drawing for a villa on the outskirts of Rome (1966; see fig. 72), his *Lapislazzuli* teapot (1972) from the *Indian Memory* ceramic series (fig. **41**), and his *Morosina* glass vase by Vistosi (1974).

Two travel experiences were instrumental in shaping Sottsass's outlook at this time. In 1956, a short trip to New York City exposed him to the consumer culture of postwar America, leaving an indelible impression on the young designer. The seeming disposability of the products of modern life, lacking in meaning and devoid of any lasting significance in the lives of the people who were using them, disturbed him profoundly. Five years later, in 1961, a sojourn in India would provide Sottsass with insight into an approach that would lend more cultural and psychological value to the objects of his design. During his travels he was exposed to key examples of religious and secular architecture and to antiquities, and he came to admire the vernacular culture of the Near East, holding it as a model for the natural relationship that should exist between society and art. Unlike the United States, with its consumer culture driven by "new" and "improved" products, India is a developing nation with a populace that maintains an intimate relationship with its rich decorative past. Art, religion, architecture, and daily life in

Fig. 40 (opposite)
Gudea vase, 2002
Made by Rossi & Arcandi
(Monticello Conte Otto, Italy)
Edition of eight
Sterling silver
19 x 12 x 12 in. (48 x 30.5 x 30.5 cm)
Galerie Bruno Bischofberger, Zurich

Fig. 41 (right)
Lapislazzuli teapot, from the
Indian Memory series, 1972
Made by Alessio Sarri
(Sesto Fiorentino, Italy)
Glazed ceramic
7⅞ x 6¾ x 7½ in. (20 x 17 x 19 cm)
The Gallery Mourmans, Maastricht,
The Netherlands

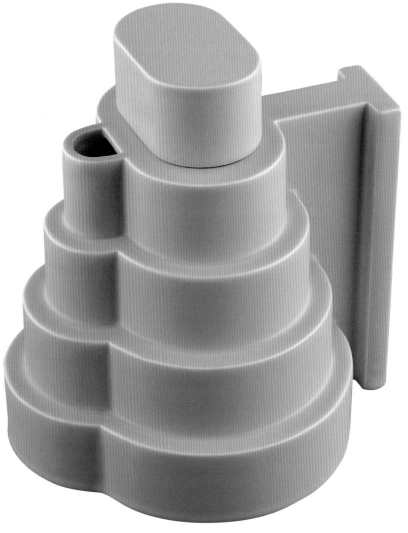

the Near East seemed so effortlessly intertwined that Sottsass saw it as a paradigm for how Western society should relate to the anonymous products of modern industry, and how he could help fulfill that role as a designer.

Sottsass's admiration for Indian culture would find expression in his subsequent work. Following his hospitalization in 1962 for a near-fatal illness, he designed the *Ceramiche delle tenebre* (*Ceramics of Darkness*, 1963), and shortly thereafter, a series of one hundred plates entitled *Offerte a Shiva* (*Offerings to Shiva*, 1964). These pieces are personal statements, unique works of art with an implied function (vases and plates, respectively) in which Sottsass attempts to give physical shape and form first to the despair that he experienced during the course of his illness, and second to the hope and joy of his physical and mental recovery. The leitmotiv of these pieces is the archetypal form of the circle. The spare cylindrical forms of the *Ceramics of Darkness* are monumental in their simplicity (fig. **42**; see also fig. **15**). The circular mouth and foot echo the luminous, circular motifs on the exterior, which vibrate against a ground of rich, dark color,

suggesting lunar cycles and the cosmos. Sottsass references universal order again in his *Offerings to Shiva* ceramics (fig. **43**; see also fig. **55**). The circle motif recurs, repeated both in the plate forms and in the surface decoration. Incised and glazed circles sometimes occur in groups of three, in homage to the third god of the Hindu triad, Shiva, who manifests the power to destroy and regenerate the cosmos. With these works Sottsass addresses the mystery of cosmological order in his search for a deeper spiritual connection to design.

Sottsass explored this spiritual connection to form further with his vases from the *Ceramiche tantriche* (*Tantric Ceramics*, 1968) and *Yantra di terracotta* (*Yantras of Terra-cotta*, 1969) series, and his large-scale, ceramic "Mandala altar" (1969). The terms "tantric," "yantra," and "mandala" come from the Hindu and Buddhist religions, which Sottsass found to be a sympathetic and inspirational source of ideas to communicate his own humanist outlook. In general, the religious philosophy of Tantra is based on an analogy between the physical body, or the microcosm, and the universe, or the macrocosm. Tantric rituals

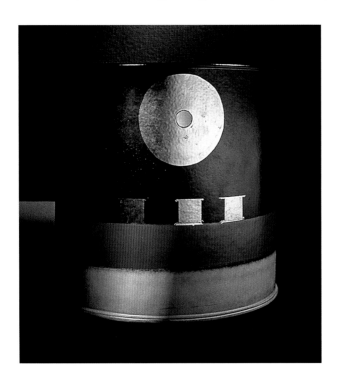

Fig. 42 (above left)
Vase from the *Ceramiche delle tenebre* (*Ceramics of Darkness*) series, 1963
Made by Bitossi (Montelupo Fiorentino, Italy)
Unique
Glazed earthenware
11 ¼ x 11 ⅞ x 11 ⅞ in. (28.5 x 30 x 30 cm)
Collection Bischofberger, Zurich

Fig. 43 (above right)
Plate from the *Offerte a Shiva* (*Offerings to Shiva*) series, 1964
Made by Bitossi (Montelupo Fiorentino, Italy)
Unique
Glazed earthenware
13 x 13 x 1 ¾ in. (33 x 33 x 4.5 cm)
Collection Bischofberger, Zurich

and techniques include meditative and sexual practices that help unify the followers with their chosen deity. One such technique is the symbolic union of the gods Shiva and Shakti, the two male–female halves of the cosmos, which may be imagined or acted out sexually by devotees. Sottsass references this union in his series of *Tantric* vases, each of which is made from two individual vessels visibly joined together foot to foot, so that one constitutes the bowl and the other the base (fig. **44**; see also fig. **17**). The vases also have the capability of being reversed, symbolizing the eternal forces of union and opposition. By addressing this Tantric technique, Sottsass pronounces his belief that individuals, in this case through ritualized body behavior, can have powerful effects on the larger world.

In Tantric tradition, yantras are geometric diagrams that represent deities and are primarily used as tools to maintain focus during meditation in order to reach a heightened state of spiritual awareness. In his *Yantra* series of ceramics, Sottsass creates three-dimensional yantras based on known diagrams and charts (fig. 45; see also fig. **52**). These simple forms, glazed with colors and sheens chosen to aid in meditation, serve the dual purpose of vase and yantra. As he suggested in 1970, "In a room (as empty as possible) not more than one of these 'Terra-cotta Yantras' should be used. Otherwise concentration will fade away and the Yantra will become just one more object in the room."[17] Here Sottsass acknowledges the importance of form in the design of an object and its potential influence on the human psyche. When a form stands alone, its shape and dimensionality increase in significance because it becomes the sole focus of one's attention. By designing vases that also function as yantras, Sottsass creates objects that are meant to raise our level of spiritual awareness.

The basis for the forms that begin as two-dimensional yantra and mandala diagrams corresponds to Sottsass's own work process, by which he develops his preliminary ideas through drawing and sketching. As Barbara Radice stated in her 1993 biography on Sottsass, "Ettore draws a great deal, mainly in the evening after work or in the late afternoon on holidays. He draws 'ideas' and I don't think he really knows, when he draws, 'what' he's drawing,

in the sense that he draws mostly figurative emotions."[18] For Sottsass, the creative process begins by tapping into his innermost thoughts and feelings at a primal level.

Sottsass noted that as a student, he learned to draw "by holding the arm outstretched in a series of gestures so improvised that they may even leap beyond your thoughts: that is, they represent those instants of existence that are without thoughts, in other words states of 'non thought.'"[19] Sottsass tries to draw his creativity from the unconscious mind so that his designs may evoke an analogous response from the user. Jung had posited ideas about the use of art as a therapeutic tool to give the unconscious its own physical reality, or a sense of "irrationality," to counterbalance the demands of modern life. Sottsass concurred, writing in 1969 that the ultimate function of a design was "a therapeutic function, like the function of a medicine which filters and rearranges the chemical and hormone balance of the complicated mechanism of human life and death according to natural orders."[20]

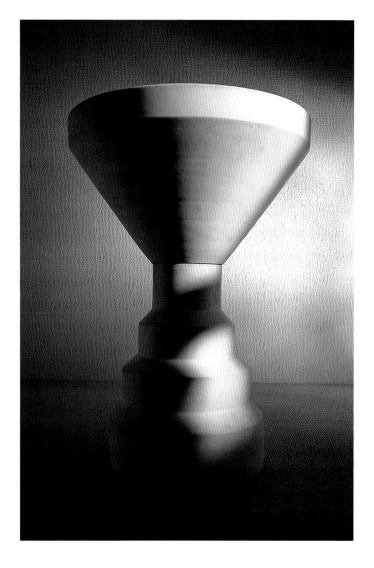

Fig. 44
Vase from the *Ceramiche tantriche*
(*Tantric Ceramics*) series, 1968
Made by Nanni Valentini or Franco Bucci,
at Laboratorio Pesaro (Pesaro, Italy)
Glazed earthenware
20 ¼ x 14 ¾ x 14 ¾ in. (51.5 x 37.5 x 37.5 cm)
Collection Bischofberger, Zurich

Jung found that the most common archetypal representation that his patients drew, as part of their therapy, was the mandala— a Hindu or Buddhist graphic representation of the universe composed of recurring circular motifs. The word "mandala" loosely translates as "circle" in Sanskrit. It was from the mandala that Jung developed his idea of archetypes. He believed the mandala to be an unconscious externalization of internalized patterns and symbolic elements from humankind's ancient origins. Jung wrote, "The severe pattern imposed by a circular image of this kind compensates the disorder and confusion of the psychic state—namely through the construction of a central point through which everything is related."[21]

With Sottsass's *Altare: per il sacrificio della mia solitudine (prima che sia profanata dai raggiri della politica)* (*Altar: for the sacrifice of my solitude [before the degradation from the arms of politics]*) from 1969, he created a three-dimensional representation of a mandala (see fig. **53**). This "Mandala altar," as Sottsass has called it, is an installation of ovoid ceramic disks of varying sizes, stacked to different heights, in concentric circles that radiate from a central axis. Rather than concentrating on a two-dimensional diagram in one's mind to elicit a feeling of freedom from the material concerns of the world, Sottsass presents a large-scale three-dimensional altar of green-glazed terra-cotta to convey a temple-like, sacred presence. Here Sottsass created an environment in which the sheer volume of terra-cotta inspires feelings of reverence and introspection by the reference to ancient temples and mystical practices. As a model for the organizational structure of life, the mandala reminds us of our relation to the infinite, the world that extends beyond our bodies and minds. By so doing, the mandala—and Sottsass—provide a solution to balance out the pressures of daily life and thus enrich the human condition.

Despite his wide-ranging and even global interests, Sottsass's design philosophy may be distilled down to the importance of each individual's personal interaction with the objects of his creation. Such Renaissance artist-theoreticians as Alberti emphasized the viewer's perspective when constructing their artwork by relying on a system of scale and proportion with the human figure in mind. Their interest in the viewer's personal engagement fundamentally changed art and architecture, and obviously had an impact on Sottsass, whose approach to design relies on the physical and psychological experience of the prospective user. Capitalizing on the emotive qualities of design and architecture, Sottsass takes Alberti's advice and applies it to modern design to arouse our senses and to elicit a personal response to his work. Sottsass borrows Renaissance humanism's focus on human scale and interaction, and on color and form with their emotive power, and turns them into a new modern design philosophy. Sottsass is in effect a "modern humanist" designer.

Many thanks are due to Carolina Alarcon for sharing her expertise and for making invaluable suggestions that greatly improved the text.

1. E. Sottsass, *Scritti: 1946–2001*, Vicenza (Neri Pozza Editore) 2002.
2. C.E. Trinkaus, *The Scope of Renaissance Humanism*, Ann Arbor MI (University of Michigan) 1983.
3. E. Sottsass, *Ettore Sottsass: Drawings over Four Decades*, exhib. cat., trans. Jeremy Gaines et al., Frankfurt am Main, Ikon, Galerie für Design-Zeichnungen, 1990, p. 69.
4. B. Radice, *Ettore Sottsass: A Critical Biography*, trans. Rodney Stringer, New York (Rizzoli) 1993, p. 33, and Sottsass 2002, p. 434.
5. Quoted in H. Höger, *Ettore Sottsass, Jun.: Designer, Artist, Architect*, Edition Axel Menges, trans. Michael Robinson, Tübingen and Berlin (Wasmuth) 1993, p. 14.
6. J. Burney, *Ettore Sottsass*, Design Heroes, London (Trefoil Publications) 1991, p. 89.
7. Quoted in S. Kicherer, *Olivetti: A Study of the Corporate Management of Design*, New York (Rizzoli) 1990, p. 42.
8. Quoted in Höger 1993, p. 38.
9. Quoted in N.H. Shapira, H. von Klier, and P.A. King, *Design Process: Olivetti, 1908–1978*, Ivrea (Olivetti) 1979, p. 120.
10. "Ettore Sottsass: Il senso delle cose" (Ettore Sottsass: The Meaning of Things), produced and directed by H. Bütler, 58 min., 2002, videocassette.
11. J. Percival and J.C. Tyack, "Villa," Grove Art Online, Oxford University Press, [February 20, 2005], http://www.groveart.com.
12. Sottsass 2002, pp. 81–84. The author would like to thank Cindy Kang for her translation of this essay.
13. Sottsass 1990, p. 47.
14. E. Sottsass and F. Di Castro, *Sottsass's Scrap-book: Disegni e Note*, Milan (Casabella) 1976, pp. 101–102.
15. "Jung, Carl Gustav," Grove Art Online, Oxford University Press, [March 15, 2005], http://www.groveart.com.
16. Sottsass and Di Castro 1976, p. 102.
17. Ibid., p. 106.
18. Radice 1993, p. 254.
19. E. Sottsass, *Sottsass: 151 Drawings*, trans. N. Akita and N. Miwa, Tokyo (Toto) 1997, p. 14.
20. Sottsass and Di Castro 1976, p. 105.
21. C.G. Jung, *Mandala Symbolism*, trans. R.F.C. Hull, Princeton NJ (Princeton University Press) 1972, p. 4.

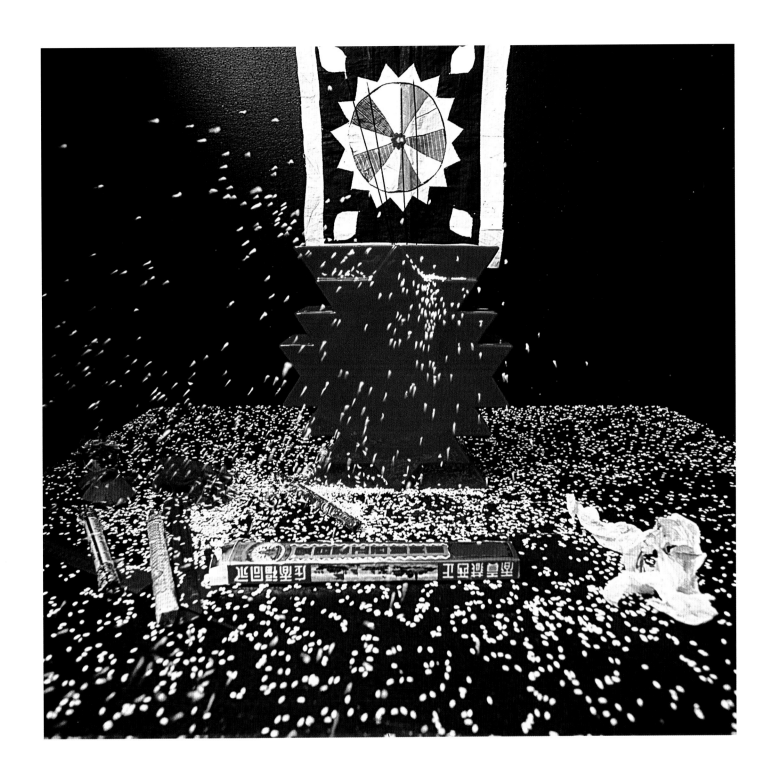

Fig. 45
Vase from the *Yantra di terracotta*
(*Yantras of Terra-cotta*) series, 1969
Various makers
Glazed earthenware

Catalysts of Perception: Material Considerations

Dennis P. Doordan

To drink water from a waxed paper cup on the highway and to drink it from a crystal goblet are different gestures. In the first case, you almost forget that you exist as you drink; in the second, for the goblet's weight, fragility, transparency and non-taste, you realize that you have in your hands an instrument that makes you reflect upon how you are living at that moment.[1] **Ettore Sottsass**

In a 1970 essay Sottsass remarked, "I have continued to approach the idea of designing objects as catalysts of perception."[2] Whether it is employed to describe something as small as a piece of exquisite jewelry (fig. **46**) or as large as a colorful assortment of simple shapes arranged to make a house (fig. 47; see also figs. 33, 35, 73), "catalysts of perception" is a particularly felicitous and insightful phrase. Sottsass's designs are seldom neutral or anonymous; instead they grab the viewer's attention and provoke vivid responses. One of the notable characteristics of Sottsass's career is the range of his work: jewelry, ceramics, furniture, lighting fixtures (fig. **48**), and office equipment. The contemplation of the varied forms, colors, patterns, and textures—the catalytic elements—with which Sottsass conjures his distinctive version of our contemporary world provides attentive viewers with an undeniable visual pleasure. The list of stylistic terms and design movements used to identify his work is equally diverse: modern, Postmodern, radical design, anti-design. This second list illustrates the challenge for critics and historians in interpreting the sheer diversity of Sottsass's work. However, the critical impulse to capture, collate, and categorize his work so that it can be labeled for the museums, indexed in the historical surveys, and promoted in the marketplace is at odds with Sottsass's own well-known efforts to assert his creative independence from movements and ideologies. His skeptical attitude to the literature surrounding his work is familiar to anyone who has followed his career. In his preface to Penny Sparke's 1982 monograph devoted to his work, for example, Sottsass wrote:

> It is, of course, very pleasing to have a book as beautiful as Penny's written all about oneself. . . . The other side of the coin is that a book such as this is also very dangerous. A book is not real life: the daily grind, the anxiety, the confusion, the excuse of a headache or the radio that would not let you work in peace, the thousands of cards covered with sketches that seemed so brilliant because you never risked finishing them. . . . A book is definite.[3]

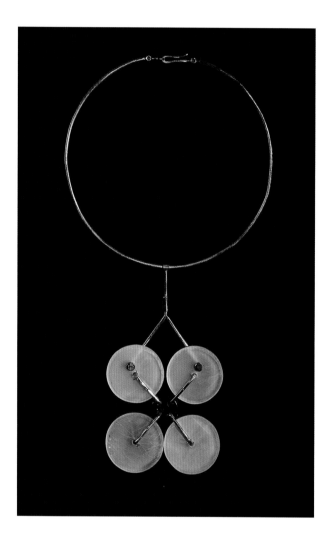

Fig. 46
Necklace, 1967
Made by Walter De Mario (Milan, Italy)
Unique
Gold, quartz
9 ⅞ x 2 ¾ x ⅜ in. (25 x 7 x 1 cm)
Musée National d'Art Moderne,
Centre Georges Pompidou, Paris

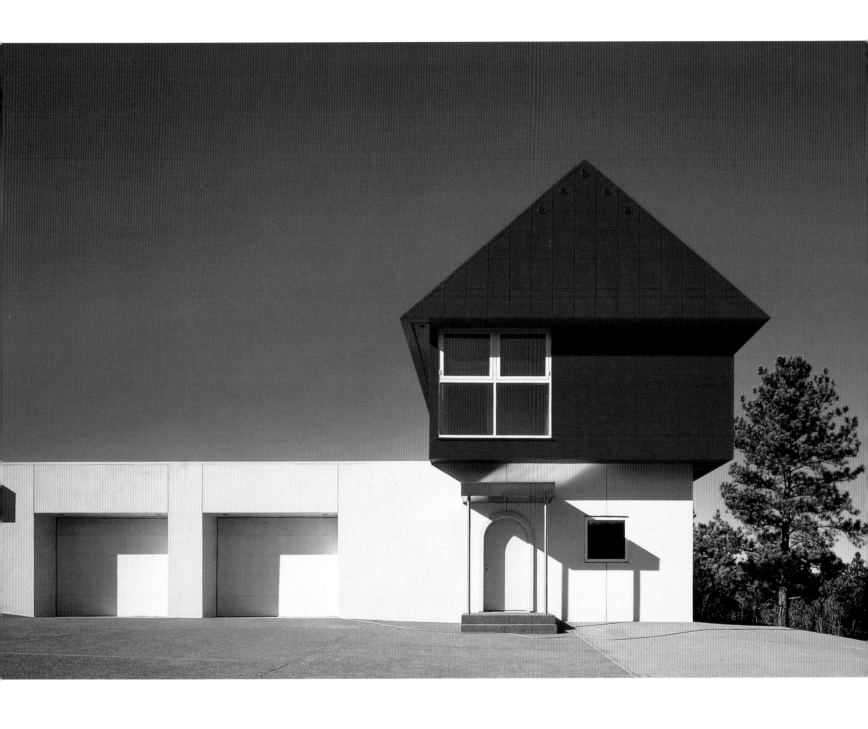

Fig. 47 (above)
Wolf House, Ridgeway, Colorado, 1987–89
Architects: Sottsass Associati (Milan, Italy);
Ettore Sottsass, principal-in-charge;
Johanna Grawunder, project architect

Fig. 48 (overleaf left)
Hanging lamp, 1957
Made by Arredoluce (Monza, Italy)
Painted metal, acrylic
37 ⅜ x 23 ⅝ x 23 ⅝ in. (95 x 60 x 60 cm)
The Gallery Mourmans, Maastricht,
The Netherlands

Fig. 49 (overleaf right)
Sargon vase, 2002
Made by Rossi & Arcandi
(Monticello Conte Otto, Italy)
Edition of eight
Sterling silver, glass
30 ¾ x 23 x 23 in. (78 x 58 x 58 cm)
Galerie Bruno Bischofberger, Zurich

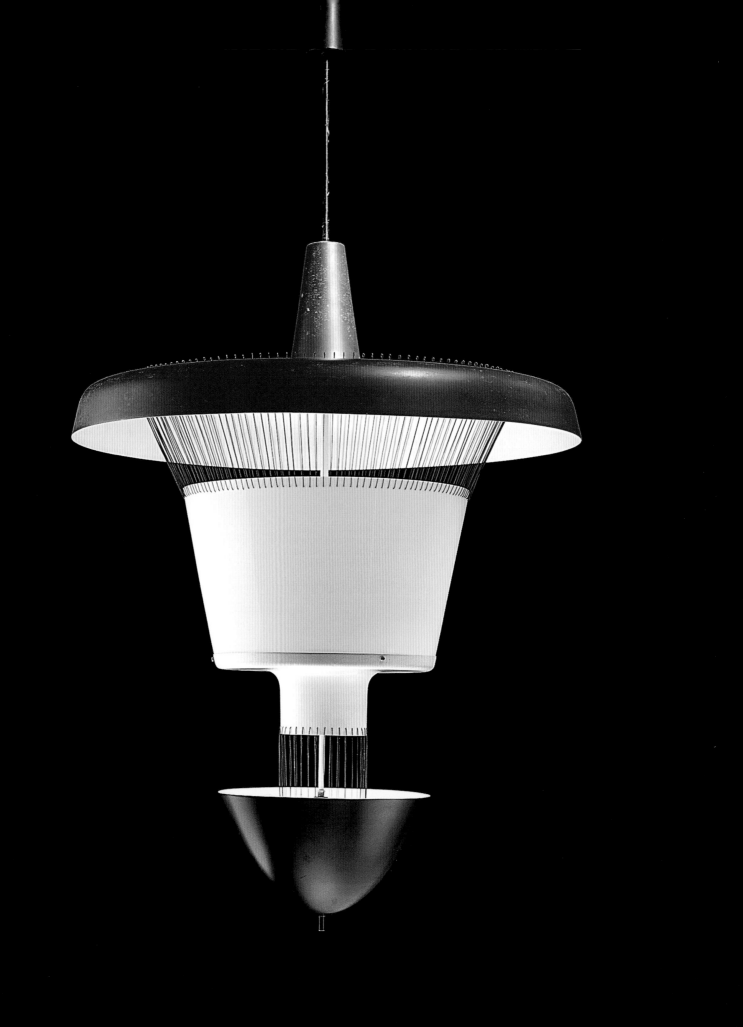

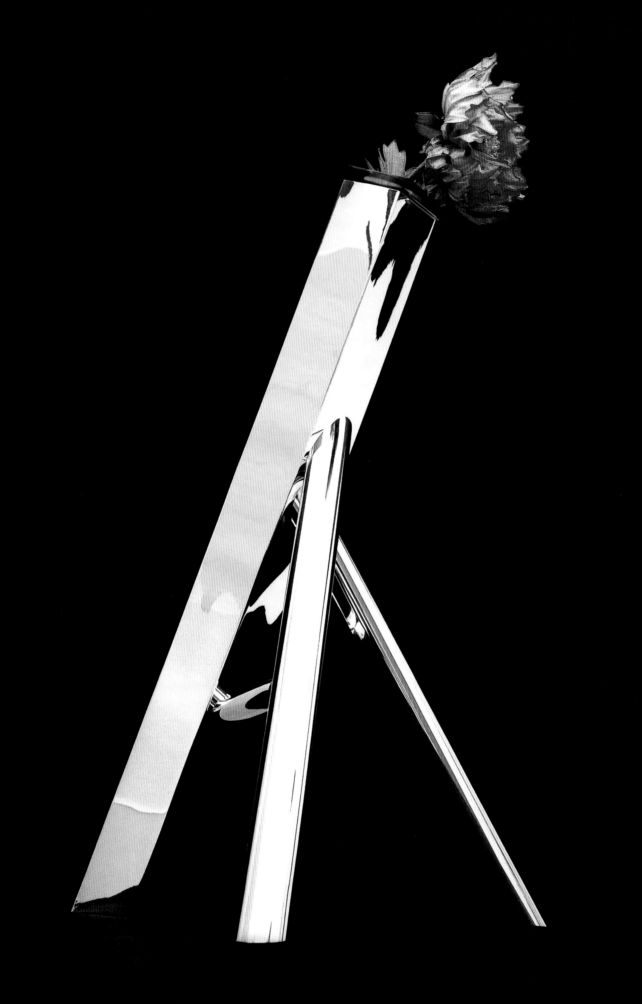

Sottsass is hardly alone among modern artists and designers in his contention that the conventions of criticism and historical scholarship cannot render "the daily grind, the anxiety, the confusion" accurately. Somewhere between the critics' "dangerous" urge to reduce Sottsass to a fixed reference point in the landscape of modern design by assigning labels to his work and the popular desire to surrender to the romantic myth of the solitary artist communing with his muse lies a more complex and honest appreciation of Sottsass as a talented designer operating in a dynamic world.

This essay opened with two lists, one of media and the other of design movements used to describe them. A third list suggests a different way to probe Sottsass's multifaceted work. Even a cursory review of the work assembled in this publication reveals an impressive array of materials ranging from some of the most ancient substances worked by human beings to products of modern science that did not exist when Sottsass was born in 1917: coral, glazed earthenware, gold, silver (fig. **49**), glass, porcelain, jacaranda wood (fig. 50), aluminum, plywood, ABS injection-molded plastic, acrylic (fig. **51**), plastic laminates. Materials and techniques—what a thing is made of and how it is made—have always occupied a place in discussions of art and design. Michelangelo, for example, spoke of liberating the form imprisoned within the marble block, while Frank Lloyd Wright made an appreciation of the nature of materials a central tenet of his philosophy of organic design. Implicit in this approach to design is a belief that materials possess an inherent set of properties bestowed by nature and acquire cultural significance through their use over time. But Sottsass's career unfolded in an era of remarkable change in the material basis of design, and one of the enduring themes in his work is a willingness to explore the technical and cultural implications of materials in a manner unfettered by convention or tradition.

Finding applications for the cornucopia of new products that are generated by the material sciences is a persistent theme in the story of modern design. In his 1940 treatise *Design This Day*, the American designer Walter Dorwin Teague noted the epoch-defining quality of modern materials. Designers, Teague observed, are no longer restricted to those materials drawn directly from nature. Science, allied with modern industry, has vastly expanded

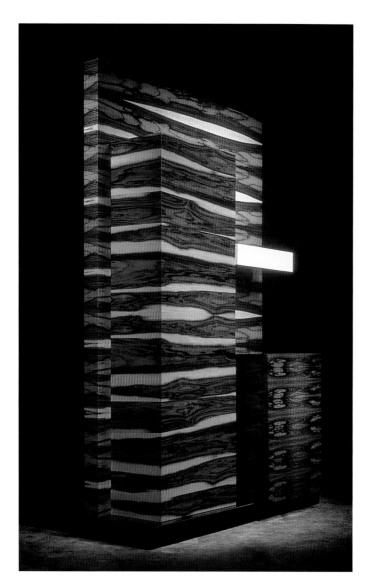

Fig. 50
Bar Furniture No. 2, 1994
Made by The Gallery Mourmans
(Maastricht, The Netherlands)
Edition of six
Wood, jacaranda and stained santos
mahogany veneers, lacquer, steel
94 ½ x 65 x 25 ⅝ in. (240 x 165 x 65 cm)
The Gallery Mourmans, Maastricht,
The Netherlands

Fig. 51
Sideboard, 2003
Made by The Gallery Mourmans
(Maastricht, The Netherlands)
Edition of six
Wood, ebonized pearwood veneer, acrylic
80 ⅜ x 82 ¾ x 23 ⅝ in. (204 x 210 x 60 cm)
The Gallery Mourmans, Maastricht,
The Netherlands

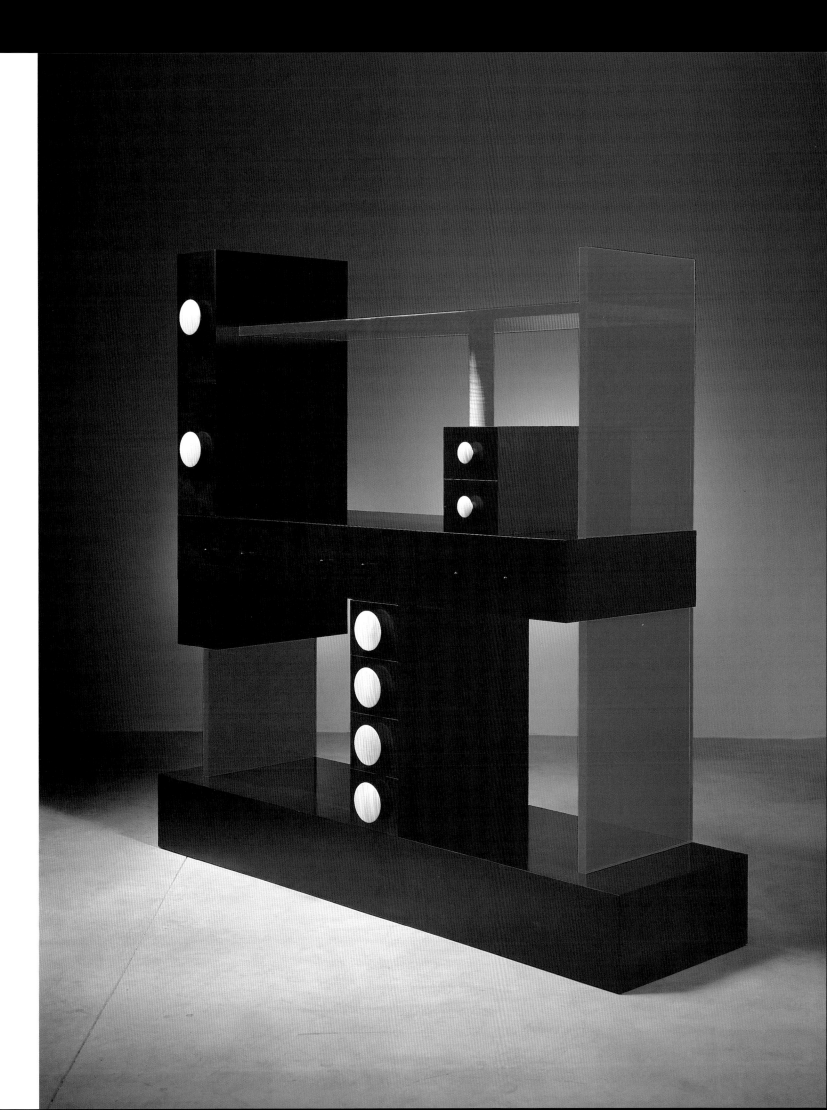

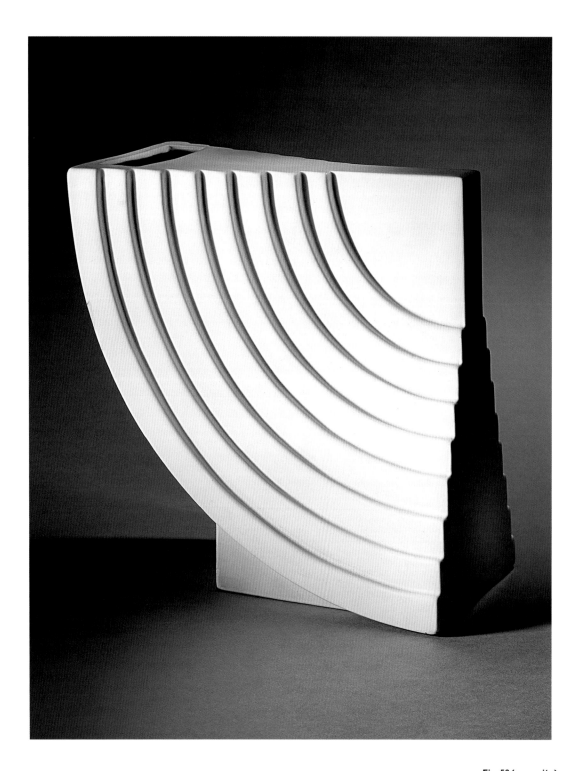

Fig. 52
Vase from the *Yantra di terracotta*
(*Yantras of Terra-cotta*) series, 1969
Various makers
Glazed earthenware
15 x 15 x 6 in. (38.1 x 38.1 x 15.2 cm)
Courtesy of Barry Friedman Ltd.

Fig. 53 (opposite)
Altare: per il sacrificio della mia solitudine
(prima che sia profanata dai raggiri della politica)
(*Altar: For the Sacrifice of My Solitude [Before*
It Is Desecrated by the Deceit of Politics]), 1968
From the exhibition *Miljö för en ny planet*
(*Landscape for a Fresh Planet*),
Nationalmuseum, Stockholm, 1969
Made by Bitossi (Montelupo Fiorentino, Italy)
Unique
Glazed earthenware
The Gallery Mourmans, Maastricht, The Netherlands

the available repertoire and in so doing has changed the way designers think about materials. The insights gained into the strengths, weaknesses, and possibilities of natural materials through generations of craftsmanship were inadequate, Teague argued, in an age of constant invention:

> The peculiar difficulty of our position is that this interaction of forces is accelerated almost beyond our ability to keep pace with it in conscious mastery of our resources. . . . But the Machine Age in its multitude of inventions has not only included our repertoire of new materials, it has enormously increased the number and kind of things we can do with materials, old as well as new.[4]

The question of how Sottsass wrestled with the "peculiar difficulty" posed by the material universe of modern design provides an intriguing perspective on the fascinating diversity of his work.

If modernity celebrated innovation and novelty, then the choice of materials could signal a different sensibility—one that subtly resists the siren call of the modern—as Sottsass's work in ceramics suggests. A visit to India in 1961 provided Sottsass with inspiration for the wide variety of ceramic pieces that he produced during the 1960s, including the *Yantra di terracotta* (*Yantras of Terra-cotta*) vase of 1969 (fig. **52**; see also fig. 45). He also created a series of large altar-like ceramic pieces exhibited in various venues in the late 1960s (fig. **53**). In a 1970 essay on his ceramic designs he reflected on this body of work:

> Now that I have made them, I ask myself why I have made them, because it would have been simpler to make mountains of inflated rubber, mountains of polyester, mountains of expanded polystyrene and so on. It must be because the first libraries were made with pieces of terra-cotta, and the tower of Babel was also made of terra-cotta.[5]

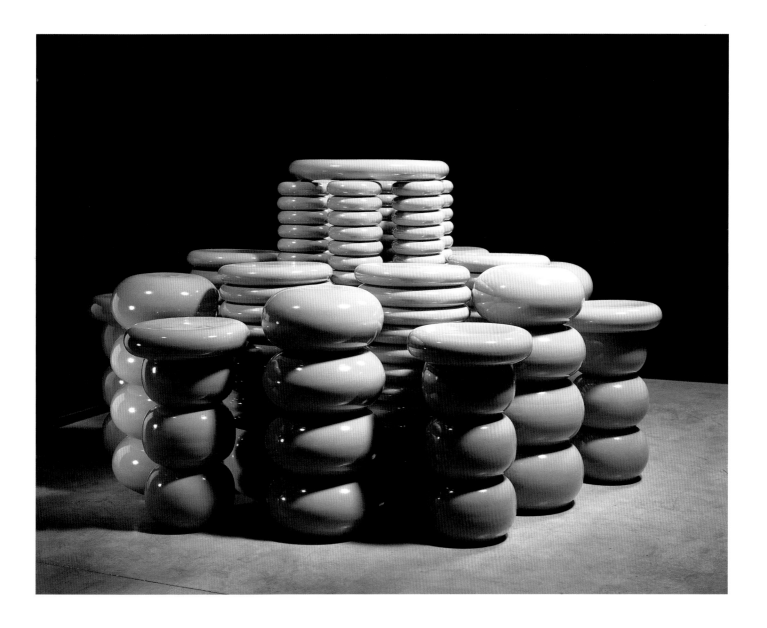

The answer to his question, why not work with polyester or polystyrene, is simple: these materials have no history. Contemporary designers follow in no one's footsteps when they employ these products of twentieth-century science. In contrast, terra-cotta is an ancient material; people everywhere recognize it and intuitively know how it feels to the touch. It bridges the gap between contemporary experience and the timeless human desire to find meaning in life and give form to human aspirations. In India, as Sottsass noted, he encountered a material culture that manipulated humble materials in profound ways:

> Eastern people have always been engaged in giving magic tensions, meditative silences, patient preciousness to the poorest materials. . . . Material with no weight, no value, no destiny but to disappear: small bamboo strips, thin palm leaves, sticks, shells, flowers, fabrics, embroideries, papers, bird feathers, berries, seeds and teeth of mysterious fish.[6]

Sottsass invested clay with primal and enduring significance. His early ceramic works, characterized by crude incised patterns on round or square pieces, capture the timeless and existential design acts of making and marking at the same time as they reflect his response to such contemporary movements in the art world as Abstract Expressionism (fig. **54**; see also fig. **8**).

The circles and lines of the *Offerte a Shiva* (*Offerings to Shiva*) series possess an enigmatic quality that is appealing because they evoke an aura of transcendental mystery rather than Machine Age abstraction (fig. **55**; see also fig. **43**). Sottsass described the *Shiva* plates as "cosmic representations" and "spiritual diagrams," terms indicative of his desire to move beyond the narrowly functionalist conception of design he felt the Bauhaus had bequeathed to his postwar generation. In the late 1950s and throughout the 1960s, the "earthiness" of clay seems to have offered Sottsass a vehicle for working out in his own mind the implications of important life events, including his first encounters with foreign cultures (American in 1956 and Indian in 1961) and a serious illness (kidney problems in 1962).

The partnership between science and industry noted by Walter Dorwin Teague in the passage cited above continued to transform the material basis of culture in the decades after 1945. Plastic in its different forms entered the catalogue of modern materials; unlike clay, it neither possesses a long history nor preserves cultural traditions. When Sottsass was commissioned to create an environment for the famous Museum of Modern Art (MOMA) exhibition entitled *Italy: The New Domestic Landscape*, in 1972, he exploited the lifeless, even alienating, quality of plastics

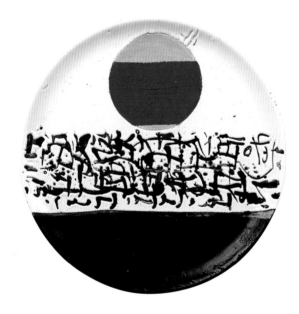 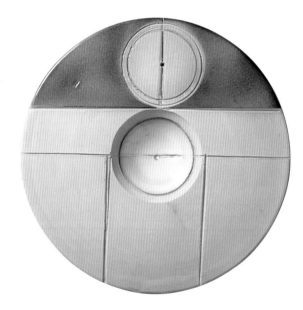

Fig. 54 (above left)
Plate, 1959
Made by Bitossi (Montelupo Fiorentino, Italy)
Unique
Glazed earthenware
11 ⅞ x 11 ⅞ in. (30 x 30 cm)
Musée National d'Art Moderne, Centre Georges
Pompidou, Paris

Fig. 55 (above right)
Plate from the *Offerte a Shiva* (*Offerings to Shiva*) series, 1964
Made by Bitossi (Montelupo Fiorentino, Italy)
Unique
Glazed earthenware
13 x 13 x 1 ⅝ in. (33 x 33 x 4 cm)
Collection Bischofberger, Zurich

to suggest a radically different relationship between human beings and their possessions. Sottsass designed a series of large plastic boxes that could be configured in a variety of ways to create habitable environments (fig. **56**; see also fig. **70**). Individual boxes could be fitted out to serve a range of functional needs, such as eating, bathing, and sleeping. In his description of the project, Sottsass emphasized that he wanted to create an environment that would dissuade people from feeling any attachment to it:

> The form is not cute at all. It is a kind of orgy of the use of plastic, regarded as a material that allows an almost complete process of deconditioning from the interminable chain of psycho-erotic self indulgences about "possession." I mean the possession of objects, I mean the pleasure of possessing something that seems to us precious, that seems to us precious because it is made out of a precious material, it has a precious form, or perhaps because it was difficult to make, or may be fragile, etc. . . .
>
> To explain this more simply, let's say that the idea is to succeed in making furniture from which we feel so detached, so disinterested, and so uninvolved that it is of absolutely no importance to us.[7]

His attempt to create an environment so neutral that it deconditioned its inhabitants from seeking pleasure or personal identity through possessing it may seem a bizarre goal for a designer. But the MOMA environment came at a time when many Italian designers were engaged in a critique of the materialistic lifestyle characteristic of postwar society.[8] In the wake of World War II, Italians faced the task of reconstruction with hope for a new civil and moral order that would replace the discredited culture of fascism. Sottsass recently recalled those halcyon days in a roundtable discussion of design that included Vico Magistretti, Enzo Mari, Andrea Branzi, and Alessandro Mendini. He spoke of the spirit that animated the emerging generation of Italian industrial leadership, explaining that "the manufacturers were different too. They were young industrialists, almost all of them anti-fascists that had entered their fathers' businesses right after the war. They hoped that Italy could come up with something new, both socially and ethically."[9]

Fig. 56
Shower and toilet prototypes, from the "container" furniture system/environment for the exhibition *Italy: The New Domestic Landscape*, Museum of Modern Art, New York, 1972
Made by Kartell (Milan, Italy), Boffi (Lentate sul Seveso, Italy), Ideal-Standard (France); with the assistance of Tecno (Milan, Italy)
Vinyl polychloride, mirror, ceramic, acrylic
89 ¾ x 43 ¼ x 39 in. each (228 x 110 x 99 cm)
Musée National d'Art Moderne,
Centre Georges Pompidou, Paris

By the late 1960s, however, the optimism of the immediate postwar years had given way to a sense of disappointment. To social critics, the student activists of 1968, and many of the designers of Sottsass's generation, the new cars and shiny household appliances resulting from Italy's famous Economic Miracle had produced not a new civil society but a market-driven culture of consumption. In the context of this essay, what is significant is that Sottsass seized on plastic as a way to deter people from emotionally identifying with objects.

But a simple binary set of terms like traditional/modern, which posits traditional materials such as terra-cotta as warm and rich with historical associations and modern as emotionally cold and impoverished, is too crude to capture the complexity of the culture of materials in which Sottsass has been immersed for decades. In the modern era, the associations triggered by materials (both new and old) are not fixed by tradition or limited by convention but, rather, are fluid and subject to manipulation. The light weight and racy red color of the *Valentine* typewriter, designed for Olivetti in 1969, were intended to evoke a sense of liberation not alienation (see fig. **32**). Plastics made true portability possible and transformed a leaden piece of office equipment into a stylish accessory of contemporary life (fig. **57**). Sottsass could transform the associations of traditional materials as well. Silver's conventional identity as a luxury metal is curiously subverted in Sottsass's design for the *Murmansk* fruit bowl, conceived as part of the Memphis line (fig. **58**). In Barbara Radice's authoritative monograph on Memphis, the illustration of *Murmansk* is paired deliberately with a quotation from *POPism*, Andy Warhol's memoir about the 1960s, in order to reposition silver as an expression of the space age. Radice cites Warhol and Hackett:

> Silver was the future, it was spacey—the astronauts wore silver suits—Shepard, Grissom, and Glenn had already been up in them, and their equipment was silver, too. And silver was also the past—the Silver Screen—Hollywood actresses photographed in silver sets. And maybe more than anything, silver was narcissism—mirrors were backed with silver.[10]

Nothing could be further from the metallic solidity of luxury and tradition than the silvery capsules of Project Mercury orbiting

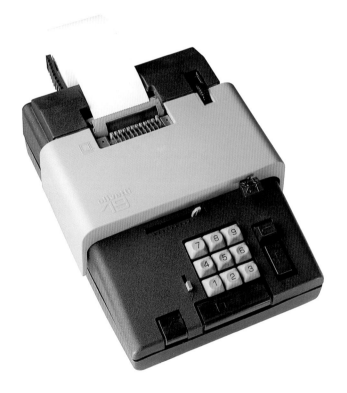

Fig. 57
Summa 19 electric calculator, 1970
Made by Olivetti (Milan, Italy)
Plastic
8 x 8 x 11 in. (20.3 x 20.3 x 27.9 cm)
Collection of Daniel Ostroff

Fig. 58
Murmansk fruit bowl, 1982
Made by Rossi & Arcandi
(Monticello Conte Otto, Italy)
for Memphis (Milan, Italy)
Sterling silver
12 x 13 ⅞ x 13 ⅞ in. (30.5 x 35.3 x 35.3 cm)
Collection of Max Palevsky

weightlessly above the earth or flickering images projected on to cinema screens. Constructing product identities through novel associations (silver is spacey and plastic is liberating) is a clever and often whimsical design strategy. But it can also be glib and manipulative. If "identity through association" were all that Sottsass contributed to the design discourse involving materials it would do little to explain his stature among contemporary designers. His treatment of plastic laminates, which figure prominently in his work from the late 1970s onward, illustrates the truly provocative quality of Sottsass's investigation of materials as catalysts of perception (figs. 59, 60).

Barbara Radice's account of Sottsass's involvement with patterned plastic laminates suggests a casual, almost accidental beginning:

> It seems that the idea of patterned plastic laminate furniture came to Sottsass as he was drinking coffee at ten o'clock one morning at the pink-and-blue veined counter of a quasi-suburban milk bar near his house, a place frequented at that time of the morning by post-office employees and old ladies looking for cats to feed.[11]

This is a classic *eureka* account of design innovation in which the moment of genesis arrives as a flash of inspiration in an unlikely setting. But the actual cast of players in this story includes more that a few idle postal workers and cat-friendly old ladies. It includes the entrepreneurial industrial leaders working closely with designers to develop new markets and capitalize on Italy's reputation for design.[12] By the end of the 1950s, tabletops and cabinets veneered with plastic laminates were familiar surfaces in many modern kitchen and restaurant interiors. In the 1960s, the Italian firm ABET Laminati pioneered the development of new, bolder colors and patterns for its product line. In the 1970s, ABET and Croff Casa, an Italian furniture manufacturer, enlisted Sottsass's aid in exploring the design potential of the latest innovation in laminates. Sottsass may indeed have envisioned the future of plastic laminate for furniture over a cup of coffee, but the challenge of plastic laminates as a new design problem was certainly posed by his contacts in Italian industry.

Early efforts in this area, such as the *Mobile a tre ante* (*Furniture with Three Doors*) wardrobe of 1980 (fig. **61**), are virtual

Fig. 59 (top)
High-pressure laminate silk-screened with *Bacterio* pattern, designed 1978
This colorway sample from the *Decori Serigrafia 83* series, 1983
Made by ABET Laminati for ABET Print HPL (Italy)

Fig. 60 (bottom)
High-pressure laminate silk-screened with *Spugnato* (*Sponged*) pattern, designed 1979
This colorway sample from the *Decori Serigrafia 83* series, 1983
Made by ABET Laminati for ABET Print HPL (Italy)

Fig. 61
Mobile a tre ante (*Furniture with Three Doors*)
wardrobe, 1980
Made by Studio Alchymia (Milan, Italy)
Wood, plastic laminate
63 x 77 ⅛ x 25 ⅝ in. (160 x 196 x 65 cm)
The Gallery Mourmans, Maastricht,
The Netherlands

billboards announcing the aggressive color and patterning characteristic of Studio Alchymia, Memphis, and the new wave of Italian design that catapulted itself on to the international scene in the late 1970s. The restless energy suggested by the *Furniture with Three Doors*'s colors and patterns is compartmentalized and contained within the boxy volume of the wardrobe. But other strategies for exploiting the visual impact of plastic laminates quickly appeared. According to Radice:

> The plastic laminate shock, besides opening up new perspectives in furniture design, paved the way for a series of reflections, revisions, and research into the theme of materials, their quality, their possible combination and matching, their semantic and cultural charge. As a result, materials have begun to be read, chosen, and utilized not only as tools or supports of design (important as these may be) but as active protagonists, privileged vehicles of sensory communication, self-sufficient cells that cohabit the design without mixing, each cell with its own personal story to tell.[13]

In the mid-1980s, Sottsass designed a series of showrooms for the clothing company Esprit that reveal his efforts to cast materials in the role of spatial "protagonists" by exploiting their surface qualities. Dramatic patterns devoid of any sense of

orientation, direction, or relationship to each other are mixed promiscuously on vertical and horizontal surfaces. The traditional logic of spatial organization encoded in the relationship of adjacent surfaces, or in the hierarchy established by distinguishing clearly between expensive and cheap materials, is abandoned. In the Zurich office, stone, wood, carpet, and plastic laminates "cohabit" in the space (fig. 62). Each surface and texture stands out against its apparent opposite. The bottom of the spatial composition, for example, consists of bold planes of color overlaid on a free-form patterned floor. The skewed arrangement of these floor coverings contrasts with the linear regularity of the ceiling panels. Elements stubbornly maintain their independence of one another rather than becoming subsumed into a single dominant idea of order and hierarchy. The visitor navigates through an environment marked by color, patterns, textures, and shapes that establish a novel system of spatial coordinates.

Everything is made out of something. As this essay has argued, this simple, indeed obvious, observation opens up intriguing perspectives on the way humans configure the spaces and fabricate the artifacts that create the environments in which our lives unfold. The alienating and mind-numbing quality of modern environments is one of the persistent laments of contemporary cultural commentary. Throughout his career, Ettore Sottsass has consistently probed the way design can be used to enhance the rhythms, patterns, and routines of contemporary life. His reflections on materiality are central to his notion of designing objects as catalysts of perception. Like ripples in a pond, Sottsass's treatment of materials disturbs the placid surface of experience. This should be reason enough to celebrate his challenging and seductive body of work.

Fig. 62
Reception area of Esprit showroom, Zurich, Switzerland, 1985–86
Designed by Sottsass Associati (Milan, Italy);
Ettore Sottsass and Aldo Cibic, principals-in-charge;
Shuji Hisada and Johanna Grawunder, collaborators

Fig. 63
Sempre più casuale (*More and More Accidental*)
vase, from the *Rovine* (*Ruins*) collection, 1992
Made by Compagnia Vetraria Muranese
(Murano, Italy)
Edition of seven
Glass
25 ⅝ x 11 ⅞ x 11 ⅞ in. (65 x 30 x 30 cm)
The Gallery Mourmans, Maastricht,
The Netherlands

1. Quoted in M.C. Tommasini, "In the World of
 Objects," *Domus*, no. 869, April 2004, p. 35.
2. E. Sottsass, "Experience with Ceramics,"
 Domus, no. 489, August 1970, p. 56.
3. E. Sottsass, "Preface," in P. Sparke, *Ettore
 Sottsass Jnr*, London (Design Council) 1982, p. 5.
4. W.D. Teague, *Design This Day: The Technique of
 Order in the Machine Age*, New York (Harcourt
 Brace and Company) 1940, pp. 69, 71.
5. Sottsass 1970, p. 56.
6. Ibid., p. 55.
7. Quoted in *Italy: The New Domestic Landscape*,
 exhib. cat., ed. E. Ambasz, Florence, Centro Di,
 and Museum of Modern Art, New York, 1972, p. 162.
8. For a discussion of this period in Italian history and
 the arts see G. Celant, *The Italian Metamorphosis,
 1943–1968*, New York (Guggenheim Museum) 1994.
9. Quoted in Tommasini 2004, p. 32.
10. A. Warhol and P. Hackett, *POPism*, quoted in
 B. Radice, *Memphis: Research, Experiences,
 Results, Failures, and Successes of New Design*,
 New York (Rizzoli) 1984, p. 117.
11. Radice 1984, p. 36.
12. Various commentators have described the special
 rapport Italian designers enjoyed with small- to
 medium-sized industries in postwar Italy. For more
 on this topic see: G. Albera and N. Monti, *Italian
 Modern: A Design Heritage*, New York (Rizzoli)
 1989, pp. 23–26; P. Dormer, *Design Since 1945*,
 New York (Thames and Hudson) 1993, pp. 24–28;
 L. Settembrini (ed.), *1951–2001: Made in Italy?*,
 Milan (Skira) 2001, p. 104–106.
13. Radice 1984, p. 67.

Imagining Utopia: The Figurative Universe of Ettore Sottsass

James Steele

To the uninitiated, the work of Ettore Sottsass presents a confounding series of dichotomies: Is he Austrian or Italian? Is he an industrial designer, artist, or architect? Is he part of the industrial establishment or intent on sabotaging it? His background suggests an affinity to Italian Rationalism, but he denies it. His architecture, in particular, appears to have many Postmodernist characteristics but at the same time is refreshingly new.

Uncovering the truth behind the mystery that is Sottsass is further complicated by the impassive mask he presents to the world, an implacable, sphinx-like visage that seems to taunt, mock, and commiserate with us in turn, challenging us to figure him out, if we are able (fig. 64). His public face is at once melancholy, detached, bemused, nonchalant, and fatalistic; a perfect mirror of the enigma he represents.

With more understanding, however, comes the realization that the fault, to paraphrase Shakespeare, lies not with Sottsass but with ourselves, and the first awareness of that fault also offers the key to unlocking the cipher of his work. The fault lies in the advance of commodification, since the beginning of the Industrial Revolution more than two centuries ago, and the concurrent growth in the expectation of specialization that this has caused. Modernism exalts the individual, and the identity of products must be singular also, to ensure better sales. Brand recognition has become the holy grail of corporate

enterprise, the economic equivalent of the protean individual in the Modernist mindset.

The increasingly pervasive influence of product advertising and marketing in all the media (which one of Sottsass's colleagues has referred to as "the terrorism of commercial values," and which Sottsass himself has been fighting against during his entire career) has had the cumulative effect of making us all take specialization for granted.[1] We distrust the plurality that Sottsass has embraced, adroitly eluding labels in his effort to subvert the subliminal reach of mass marketing. He seeks to replace it with a clear distinction between the potentially uplifting possibilities of the human need to consume and crass commercialism.

Sottsass comes by his penchant for plurality and subversion, which he refers to as "counter design," honestly. He was born in Innsbruck, Austria, in 1917, in the midst of a war that unraveled an empire. His native country was the repository of the best and the worst results of the first half of the industrial age, and the crossroads between East and West, tradition and modernity.

Sottsass's father, who was Italian, was an architect with Rationalist leanings, aligned with an architectural school of thought that will be discussed in greater detail in relation to his son's own architecture later in this essay. Sottsass Sr. was also part of the rising wave of national pride in Italy prior to World War II, which was characterized by a new reverence for the Roman Classical past. Rationalism emerged in Italy with the formation in 1926 of "Gruppo 7," an association of architects who wanted to transform their collective heritage into a modern constructive language based on the same logic and rationality as that found in ancient Roman architecture. When Sottsass was twelve, his father decided to move the family to Turin because the city had a good school of architecture, which he wanted his son to attend.

World War II intervened before Sottsass could open up a practice of his own after graduating from Turin Polytechnic in 1939. After barely surviving internment as a prisoner of war in Sarajevo, he set up his own firm, The Studio, in Milan in 1947, working primarily on INA (Instituto Nazionale delle Assicurazione, or National Insurance Institute) housing

Fig. 64
Portrait of Ettore Sottsass
Photographed January 24, 2005

Fig. 65 (opposite top)
Drawing for terraced houses in Romentino,
Novara, Italy, 1951

Fig. 66 (opposite bottom)
Design for *Elea 9003* mainframe computer
for Olivetti (Milan, Italy), 1958
Collage, felt pen, and pencil on paper
7 ½ x 28 ¾ in. (19 x 73 cm)
Musée National d'Art Moderne,
Centre Georges Pompidou, Paris

projects, sponsored by the Marshall Plan, until 1955 (fig. 65). He then began to gravitate toward industrial design and the corporate world associated with it, starting at Olivetti in 1958.

In these few years, Sottsass achieved major breakthroughs in the field, with the *Elea 9003* electronic calculator ("the first Italian computer") in 1959 (fig. **66**; see also fig. 18 and fig. **30**), the *Teckne 3* and *Praxis 48* (see fig. **31**) electric typewriters in 1964, and the *Valentine* portable typewriter (see fig. **32**) in 1969, among other designs for Olivetti (see fig. **57**), along with innovative work for Poltronova, Bitossi, and ABET Laminati.[2] The *Valentine* typewriter is especially symbolic of Sottsass's enduring equalitarian sensibilities: a well-designed, aesthetically pleasing piece of high technology, stripped to the bare minimum and intended for the masses. With it, he seemed to have finally approached the unattainable dream of William Morris and other Arts and Crafts idealists, of making beautiful, utilitarian objects available to everyone. But Olivetti eventually balked at his idea of pricing the *Valentine* in a range that would make it "the Biro of typewriters," and Sottsass's dream was compromised.[3]

Sottsass was more successful, however, in the low-profile part he played in reorganizing a segment of the production process at Olivetti. He had asked the corporation to open a separate studio for freelance collaborators in 1970, to be administered by a company official but run by Sottsass himself.

This allowed designers more freedom, protected them from manipulative corporate politics, and gave them more creative control. It was the first hint of Sottsass's ongoing determination to revolutionize the relationship between production, products, and the people for whom they were intended.[4]

Sottsass entered the decade of the 1960s at the top of the industrial design field, but felt unfulfilled. He began what in retrospect seemed to be an intuitive, reflexive attempt to ground himself, again, after his heady and highly profitable years in the corporate world. He sought to escape to what he later called "the most mysterious place I could think of," to find a "culture of origins" as an antidote to the race to keep ahead of public taste. Later he recounted why he decided to visit India, a country that has had a profound impact on his design philosophy ever since:

> I blanked out the past, ignored mathematical logic and the principles of design, trying to deny its existence. I ignored the whole philosophy of Madison Avenue, the degrading philosophy of television advertising, the logic of costings, investment, revenue, percentages, shares and money. . . . I decided to investigate the barest elements of my existence, where all that remains are nerve endings and sensory perception, a nose to smell with, fingers to touch, a tongue to taste with and eyes to see. I wanted to explore those areas where this is only my body temperature, my basic frailty, my fear, my instinctive bravery, where there's nothing more than a triumphant, violent, heroic, victorious and yet tragic sense of belonging to the planet.[5]

According to the designer and critic Andrea Branzi, whom Sottsass met during a later "radical" phase in the 1970s and who has since become, along with Barbara Radice, one of his most eloquent and prolific interlocutors, the exposure to India, as well as the journeys to Sri Lanka, Nepal, and Burma that followed, provided Sottsass with far more than the resources for a new formal vocabulary. It gave him a broader cosmological and existential view of the world beyond the narrow confines of the religious, political, and ideological boundaries of his youth. It made him more accepting and open to differences.

Sottsass also credits India with instilling an awareness of the elemental power of iconography and the metaphorical, ritualistic

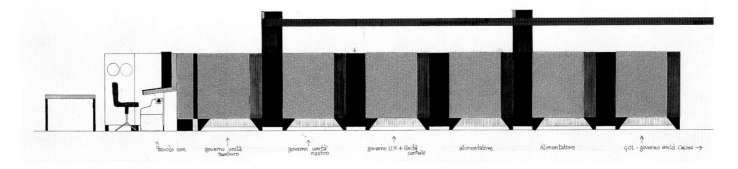

PLANS OF TEMPLES I

SCALE OF FEET
50 40 30 20 10 50 100 150

connections that all objects have with their historical origin. He searched for "starting points," what architect Louis Kahn called "beginnings," the reasons why a temple is a temple and a tomb a tomb. The images of the monuments he saw there, which seemed to "drop out of the cosmos," influenced his furniture design soon afterward, and his architecture from 1985 onward.[6]

A lithograph that Sottsass made as part of the *Il pianeta come festival* (*The Planet as Festival*) issue of *Casabella* magazine in 1972, more than a decade after his first trip to India, offers one key clue to part of the legacy of his journey. Subtitled "Temples for Erotic Experiences," the work shows the plan of an Indian temple, in which the various parts are linked together like a train, superimposed on a fanciful re-creation of a similar kind of sequential formation on a canyon floor, using far more arbitrary shapes (fig. 67). This lithograph indicates that it was not just the external appearance of monuments that left a lasting impression upon him: he also drew upon his own subsequent research into compositional conventions that dictated formal relationships. A plate made by Bitossi in 1959 has a sun-like disk above a raised horizon of runic-like inscriptions (see fig. **54**). After his trip to India, these spheres become multiplied and placed in a much more geometric field in a series of plates called *Offerte a Shiva* (*Offerings to Shiva*) (see figs. **43, 55**). The choice of deity to honor is significant: Shiva, derived from the Sanskrit word meaning "kind" or "gracious," has a darker side; also known as "the Destroyer," he is typically shown with four arms that can either build up or tear down, heal or kill.

The *Ceramiche tantriche* (*Tantric Ceramics*) vases of 1968 indicate that his research, beyond visceral impressions of monumental form, also involved religion, since the Tantra, meaning "fundamental doctrine" in Sanskrit, overlaps Buddhist belief in the Mahayana sect related to the possibility of mysticism and magic (see figs. **17, 44**).

The *Basilico* teapot from the *Indian Memory* series of 1972 (fig. 68) and the *Basilissa* vase of 1974 (fig. **69**) both recall the form of a stupa, a dome-shaped shrine originally placed over the cremated remains of the Buddha. All of these references show more than just a passing awareness of the cultural history of this country, which affected Sottsass so deeply for the rest of his life.

Fig. 67 (opposite)
Temples for Erotic Experiences,
from *Il pianeta come festival* (*The Planet
as Festival*) series, 1973
Hand-colored lithograph

Fig. 68 (top)
Basilico teapot, from the *Indian Memory* series, 1972
Made by Alessio Sarri (Sesto Fiorentino, Italy)
Glazed ceramic

Fig. 69 (bottom)
***Basilissa* vase, 1974**
Made by Vistosi (Murano, Italy)
Edition of two hundred fifty
Glass
9 x 8 ¾ x 8 ¾ in. (22.9 x 22.2 x 22.2 cm)
Collection Susan and Michael Rich

Fig. 70
Chair prototype, from the "container" furniture
system/environment for the exhibition *Italy: The
New Domestic Landscape*, Museum of Modern Art,
New York, 1972
Made by Kartell (Milan, Italy), Boffi (Lentate
sul Seveso, Italy), Ideal-Standard (France);
with the assistance of Tecno (Milan, Italy)
Vinyl polychloride, felt, foam, acrylic
89 ¾ x 43 ¼ x 39 in. (228 x 110 x 99 cm)
Musée National d'Art Moderne,
Centre Georges Pompidou, Paris

Compared to what Sottsass had found in India, Modernism appeared in retrospect to be a black-and-white ideology, reduced to judgments between good and bad, old and new; based on a false premise of certainty, logic, and limits. It seemed to deny the cultural nuances provided by history as well as cultural diversity, mystery, magic, intuition, emotion, and the possibility of a narrative. Sottsass realized that he had been instinctively, subconsciously rebelling against these restraints for his entire life, prior to this experience. India provided him with the raw material (both philosophical and physical) that he needed to construct a new theoretical stance, based on ancient continuity. He began to formulate what may be called an existential syntax, made up of elemental signs, symbols, metaphors, and primal colors, which he uses to evoke rituals, metaphysical presence, surprise, and wonder.

Sottsass had an equally significant life-changing experience in the United States, where he traveled in 1962 for medical treatment for a near-fatal bout of nephritis. While he had visited the United States once before, in 1956, the expansion of consumer culture since that time struck him, as did the differences between the Italian and American attitudes toward production. In America, he recalls, "political movements were merely intended to be criticism of society centered on human rights while European movements, on the contrary, wanted to change the system; they were much more ideological."[7]

During this time Sottsass also met the Beat Poets in San Francisco—Allen Ginsberg, Lawrence Ferlinghetti, and Jack Kerouac—each of whom was, in his own way, experimenting with the connection between linguistics and social patterns, trying to discover the extent to which changes in language can affect group behavior. He was most impressed by their willingness to bring about change through personal example and sacrifice, rather than just posturing and talking about it, by dropping out of the established corporate or academic system, where they were certainly capable of succeeding, in order to lead a nomadic existence and pursue their individual lines of inquiry.

The encounter with Ginsberg was especially fortuitous because the poet was then implementing the linguistic equivalent of the primal forms that Sottsass had seen in India, helping to

confirm Sottsass's interest in what he now refers to as "signs" in his work. Reflecting the rise of popular culture at this time, social anthropologists such as Claude Lévi-Strauss, who was greatly influenced by the linguist Ferdinand de Saussure's work in structural linguistics and semiology at the turn of the twentieth century, proposed a common framework among all people. Structuralism, a sociological proposition based on the notion that human society has a network of interrelated elements, the patterns and significance of which can be analyzed, also had a direct influence on later Italian Rationalist architecture (to which I will refer in greater detail below).

Anthropological and linguistic Structuralists, in their attempts to reduce diverse cultural systems to their essentials in order to demonstrate a formal relationship between them, have obvious importance for a group of reductivist Rationalist architects who were making parallel explorations with building components. A second generation of these architects in Italy, now referred to as the Neo-Rationalists because they are less doctrinaire than their predecessors, tried to adopt Structuralist theory in their architecture. As the critic Sola Morales has noted, "There is certainly a parallel between the Structuralist methodology of the social sciences of that period and the analytical tools developed by the Italian Neo-Rationalists in their search for the objective foundations of design. From this point of view, the recognition of the autonomous architectural object entailed a fundamental epistemological change."[8]

Discussions with the Beat Poets also validated Sottsass's recent exposure to Eastern philosophy, especially the value of acceptance and meditative reflection as an alternative to the inflexible, opinionated aesthetics of his past, further paving the way for the openness to cultural assimilation that is clear in his architecture today. Their poetry made it possible for him to begin to reconcile the seemingly contradictory values he had experienced in these two seminal journeys: the asceticism of India and the Pop art of New York, the primitivism of a developing country as opposed to the high technology available to the masses in America. He was struck by the idea that these two diametric experiences were also different sides of the same coin;

that people in each culture had to consume in order to survive, but that the disparity of financial means would result in far different manifestations of consumption. This thought validated his past involvement in production, since he began to realize that consumerism is endemic to the human condition, rather than being a luxury, and products can improve that condition and be inspiring and uplifting, if designed appropriately.

The social paroxysms of the 1960s had parallel repercussions in architecture. Groups such as Archigram (a collaboration formed in London in 1961 by Peter Cook, Ron Herron, and others) and Alles ist Architektur (All is Architecture; founded in Vienna in 1968 by architects Hans Hollein and Walter Pichler) sought to overthrow preexisting assumptions and conventions. Archigram used bold commercial colors in graphics and collage to create images of futuristic technology-driven megastructures. Hollein and Pichler employed sketches and conjectural projects to criticize the role of functionalism in modern architecture, or the idea that a building could only be designed using an analytical list of programmatic requirements needed by the intended users.

This turn toward technology is reflected in Sottsass's industrial design, such as his "container" furniture system of 1972, all-purpose compact capsules for living (fig. **70**; see also fig. **56**). The 1964 Venice Biennale was a catalyst in launching similarly radical groups in Florence and Milan, such as Archizoom, Superstudio, and UFO. These differed from their British and Austrian counterparts in their debt to the Italian Arte Povera group, which deliberately worked with everyday, found materials to create an impression of austerity that conveyed moral judgments about conspicuous consumption. They were among the first to create "environments," described as "stage sets in which the visitor enacts his or her own play."[9] Sottsass also created many such environments, including his *Altare: per il sacrificio della mia solitudine (prima che sia profanata dai raggiri della politica)* (*Altar: For the Sacrifice of My Solitude [Before It Is Desecrated by the Deceit of Politics]*) (see fig. **53**). These design groups took pride in being derivative, in borrowing ideas from many popular sources rather than toeing the Modernist line that artists and architects must not copy.

VILLA ROMANA

IL SOGGIORNO È UNA COSTRUZIONE DI MARMO SALTA E QUADRATA

LIVING ROOM.

LITTLE GARDEN DINING GARDEN

DINING ROOM

BED

They worked at a smaller scale than Archigram and Alles ist Architektur, concentrating on furniture design rather than megastructures. They were also more vocal, especially through the vehicle of the journal *Casabella* (then edited by Alessandro Mendini), which published Andrea Branzi's tracts in its "Radical Notes" section. Sottsass met the members of Archizoom in 1967, by which time they had already held exhibitions in Pistoia and Modena. Through them he met the members of Superstudio, and began to collaborate with each group.

In 1966, Sottsass returned to industrial work and that same year also designed a private house on the outskirts of Rome (figs. 71, 72). This house and a ceramic workshop near Montelupo Fiorentino, built in 1969, were his last major architectural projects until the mid-1980s. In the interim he concentrated on experimental processes and the exchange of ideas with like-minded individuals interested in developing conceptual prototypes. Andrea Branzi was an integral part of this effort. Together they helped found the Global Tools group in 1973 as a mechanism for exchanging ideas with similarly motivated designers around the world, culminating in an exhibition at the Milan Triennale later that same year. Sottsass and Branzi also collaborated in 1977–78 on furniture designs for the Milan firm Croff Casa, with an emphasis on rethinking generic furniture types such as the table and chair and reconfiguring them to adapt to contemporary needs. The 1970s were a time of intense exploration for Sottsass. In addition to the work he produced for the Milan Triennale, Global Tools, and Croff Casa, he also illustrated special issues of *Casabella*, organized several outdoor exhibitions, and was a prominent figure in another important exhibition, called *Presence/Absence*, in Bologna in 1976.

After an extended lecture tour of British universities, culminating in the award of an honorary degree by the Royal College of Art in London, Sottsass returned to Italy in 1980 and founded Sottsass Associati with the intention of continuing his work as an architect and designer. In 1981, he initiated the Memphis project, along with young collaborators Marco Zanini, Matteo Thun, Aldo Cibic, and Marco Marabelli, and by 1983 the group was well established. The philosophy behind Memphis,

Figs. 71, 72
Drawings for a villa on the outskirts of Rome, 1966
Ink and pastel on paper

which raised Sottsass's international stature and visibility considerably, was to identify the "integral relationship between objects, architecture and the environment."[10] Sottsass emphasized that Memphis was intended to underscore his belief that the distinction between objects and architecture should be done away with, to be replaced by "a continuous vision of recognizable, friendly, poetic signs, until a physical universe is imagined where the dominated logic is that of a man, not the machine that propagates it."[11]

In addition to the young collaborators with whom he founded Memphis in 1981, Sottsass welcomed Americans Johanna Grawunder and Mike Ryan, each born in California and trained in architecture, to Sottsass Associati in 1985, as well as a young Milanese graphic designer, Mario Milizia, in 1989. British collaborators James Irvine and Christopher Redfern followed in 1993 and 1996 respectively.

These widely diverse contributors have assisted Sottsass in his single-minded determination to create a new, humane, architectural language, the synthesis of all of the experimentation in which he has engaged during his long career, and to close ranks with him in his final assault against the conformity he sees as being endemic in all of the design professions. I will now

Fig. 73
Wolf House, Ridgeway, Colorado, 1987–89
Architects: Sottsass Associati (Milan, Italy);
Ettore Sottsass, principal-in-charge;
Johanna Grawunder, project architect

examine some of the most significant and visible examples of this highly productive collaboration.

The Wolf House, built between 1987 and 1989 on a high plateau in Colorado, near Mount Sneffels, emerges as one of the first clear architectural expressions of his unified intention to establish a more humane language, as well as his determination to focus on architecture (fig. 73; see also figs. 33, 35, 47). The lower levels of this house blend into the environment, while a riotous mixture of red, black, green, and yellow palettes on various façades, roofs, and projecting balconies recall Sottsass's earlier description of Indian monuments as having a cosmic reference.

A possible comparison between Sottsass's furniture and architecture begins to come into sharp focus in the Olabuenaga House on Maui (1989–97) because of its thick black tabletop-like roof, which serves as a datum, or organizing element, for each of the other elements clustered beneath it (fig. 74). Furniture assemblages, such as his *Just Back from New Guinea* desk, produced by Renzo Brugola for the Blum Helman Gallery in New York, designed during the same period as the Maui house, are revelatory (fig. **75**). Like the Olabuenaga House, the desk is based on the concept of a dominant upper shelf; this is supported by a simple telescoping column on one end and a more substantial enclosed three-dimensional structure on the other, under which smaller shelving takes its place. Sottsass may vehemently resist the comparison of his architecture with sculpture,[12] but this similarity raises the possibility that he does equate it to furniture, in which each function is allocated its own individual compartment, niche, or plane.

In the Olabuenaga House all of the various functions, allocated to different forms, seem to be huddling together under

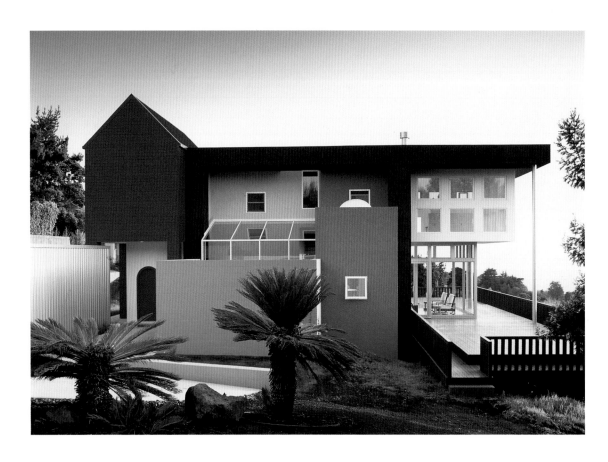

Fig. 74 (above)
Olabuenaga House, Maui, Hawaii, 1989–97
Architects: Sottsass Associati (Milan, Italy);
Ettore Sottsass, principal-in-charge;
Johanna Grawunder, project architect

Fig. 75 (opposite)
Just Back from New Guinea desk, 1987
Made by Renzo Brugola (Milan, Italy)
Limited production
Wood, stained maple, recomposed wood, and
burl veneers, metal, electrical light fixture
82 ⅝ x 86 ⅝ x 38 ⅝ in. (210 x 220 x 98 cm)
The Gallery Mourmans, Maastricht,
The Netherlands

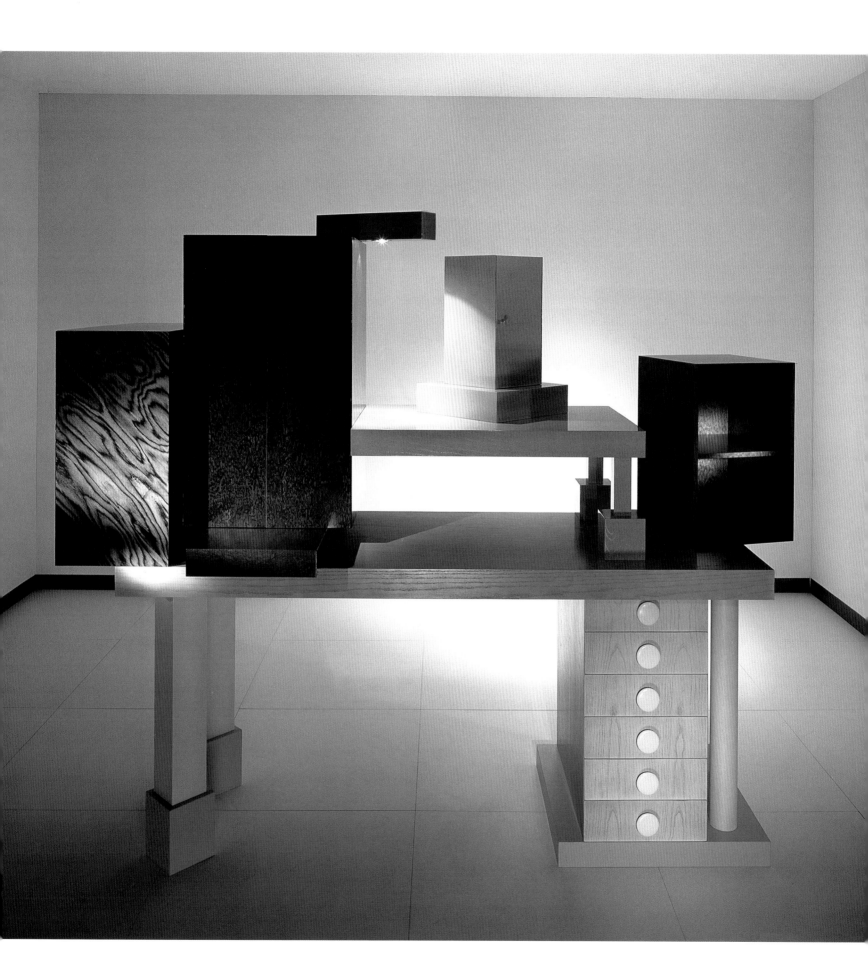

Fig. 76
Design for Twin Dome City multipurpose complex,
Fukuoka, Japan, 1991
Architects: Sottsass Associati (Milan, Italy); Ettore
Sottsass, Marco Zanini, and Johanna Grawunder,
principals-in-charge; George Scott and Paolo De
Lucchi, collaborators

the huge protective table above, as if they were taking part in a 1950s "Duck and Cover" drill rather than expansively opening up to the beauty of the beach front nearby. This introspection is slightly offset, however, by the elongated exterior deck overlooking the beach and ocean, on which the table and the volumes underneath it rest.

Twin Dome City, by Sottsass, Zanini, and Grawunder, designed for an undulating urban site in Fukuoka, Japan, in 1991, was an attempt by the architects to reconcile much more monumental functions, such as an entertainment and sports center and a thousand-room hotel, along with smaller-scale pedestrian spaces including intimate gardens and seating areas (fig. 76). They chose to use a platform 33 feet (10 meters) high to locate the complex's three main functions, and to nibble away at this base to create space for the gardens at street level. The site plan takes the form of an elongated L shape. A large gray dome, housing the sports center, visually and physically anchors the site. A smaller blue dome, covering the entertainment center, terminates one arm of the L, while a red-roofed hotel, in a more conventional, formal language, ends the other. The smaller dome rests on a novel structure of crossbeams that look like randomly scattered chopsticks supported by monumental, irregularly spaced columns. There are obvious parallels between this project and a drawing made by Sottsass for the 1972 *Planet as Festival* issue of *Casabella*. That drawing showed a circular stadium covered by a blue dome and straddling between two mountain peaks, thus illustrating the longevity and continuity of his ideas and the vast reserve of his memory.

The Central Court complex designed for the historic core of Kuala Lumpur, Malaysia, in 1992 is one of the larger projects designed by Sottsass and Grawunder (figs. 77, 78). It is a multiuse building containing offices and a seventy-room hotel as well as shops, restaurants, and bars surrounding a central atrium covered by domed skylights. Essentially fulfilling the same role as the market that previously occupied this site, but with contemporary upgrades, the complex reflects a local tradition of using a central court to organize all of the functions around it. With its perforated roof it also protects shoppers and occupants from the heat, which can be severe. The hotel/office portion of

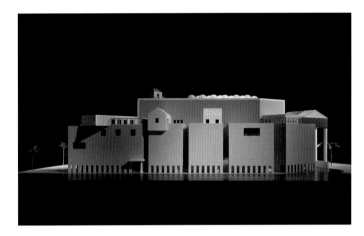

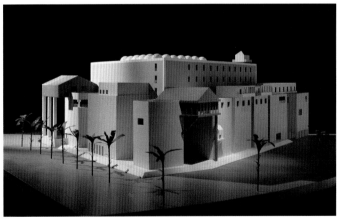

Figs. 77, 78
Design for Central Court multipurpose complex,
Kuala Lumpur, Malaysia, 1992
Architects: Sottsass Associati (Milan, Italy);
Ettore Sottsass and Johanna Grawunder,
principals-in-charge

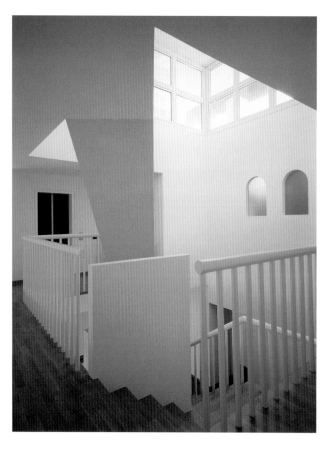

Imagining Utopia

the complex is placed at the base of a triangular plan, away from the busy intersection at the apex, where the bars are located.

The project demonstrates the architects' awareness of the importance of differentiating between public and semi-public spaces, an especially sensitive issue in this culture. The bars along the street edges facing the noisiest and most visible part of the site are designed as individual houses linked by an almost continuous colonnade, recalling the Chinese "shop" houses that used to occupy this area. Shop houses had an upper story that projected over an arcade 5 feet wide called the "Kaki Lima," a system introduced by British planners during the colonial period to provide covered, shaded passages along city streets. The Sottsass–Grawunder bars are a far cry from the Chinese shop houses in both appearance and layout, but the pedigree of colonnade below and rooms above is clear, suggesting both historical reference and cultural awareness.

Of all the architectural examples presented here, the Cei House in Empoli, Italy (1991–93), comes closest to the Rationalist tendency of using pure geometric forms, since it is square in plan and cubic in volume, with a triangular roof raised on columns above it (figs. 79, 80). This formal purity—beloved by the Rationalists because of its mathematical logic and efficiency—is echoed in the square windows flanking the entrance, which either protrude from the solemn exterior skin or are recessed into it, presenting a knife edge. The massiveness of the cubic volume is augmented by the Istria stone used over the entire surface of the two-story block. Despite the relatively small size of the 4800 square foot (450 square meter) private residence, the pale pinkish-brown palette contributes to a feeling of monumentality, making the house appear to be carved out of a single stone, with a roof levitating above it. The roof itself, which is clad in red aluminum, filters natural light on to a rooftop terrace as well as into the rooms below through a glass strip along the edge of its open, upper deck. With its triangular gable the roof imbues the ensemble with a generic feel, almost like a child's drawing of a house: it lacks only the squiggly lines of smoke coming out of the chimney and a gleeful mom and dad waving to us at the door. This generic house image is one of the symbols or signs that Sottsass often employs in conjunction with other signs, and can be found in miniaturized form in many other Sottsass projects. This is a rare instance, however, of his using it alone to create a simple and powerful commentary on domesticity.

Overlooking Lake Zurich in Switzerland, the Bischofberger House of 1991–96 (figs. 81, 82) is slightly smaller than the Cei House. It is equally elemental in appearance, but rectangular instead of square. Facing it is a garage wing the same size as the house. Both are clad in black slate, which gives the complex a singularly somber aspect. The main residential wing is three stories high, with a living room that also serves as a gallery, as well as a dining room, kitchen, guest room, and library on

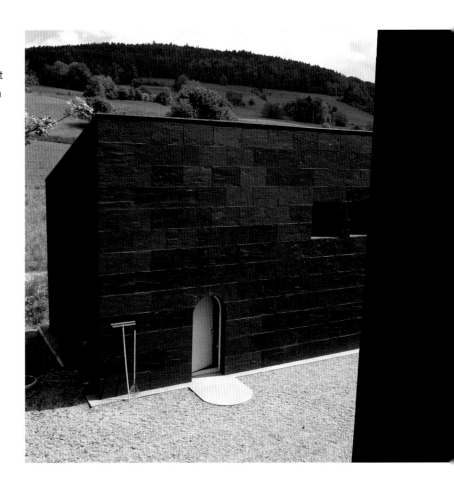

Figs. 79, 80 (opposite)
Cei House, Empoli, Italy, 1991–93
Architects: Sottsass Associati (Milan, Italy);
Ettore Sottsass, Marco Zanini, and Mike Ryan,
principals-in-charge; Milco Carboni and Tim Power,
collaborators

Figs. 81, 82 (above and overleaf)
Bischofberger House, Zurich, Switzerland, 1991–96
Architects: Sottsass Associati (Milan, Italy);
Ettore Sottsass and Johanna Grawunder,
principals-in-charge; Gianluigi Mutti, project architect

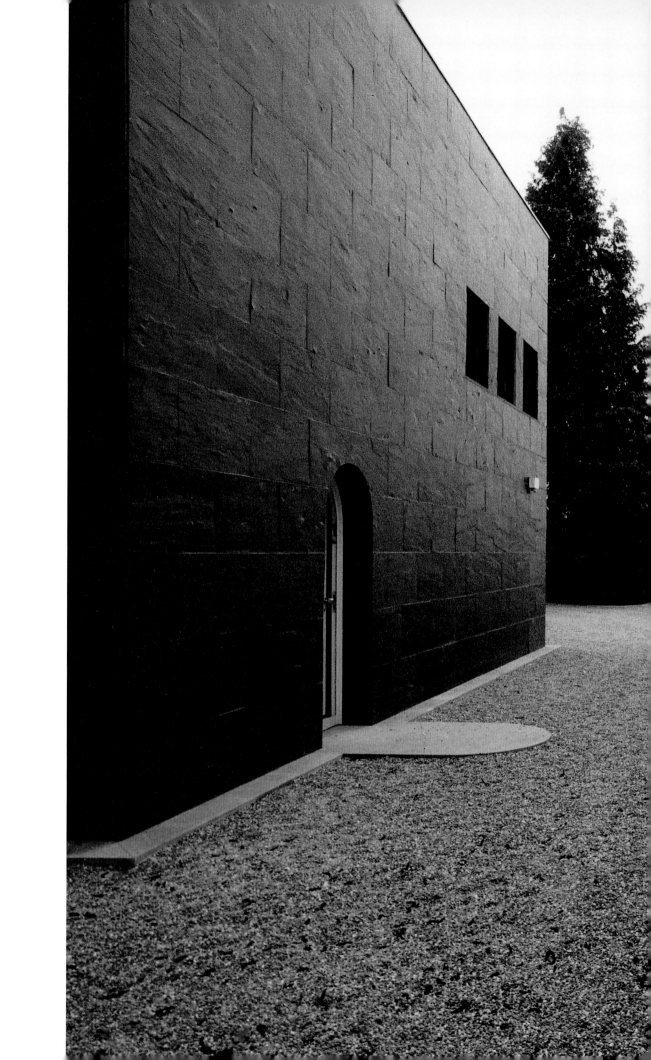

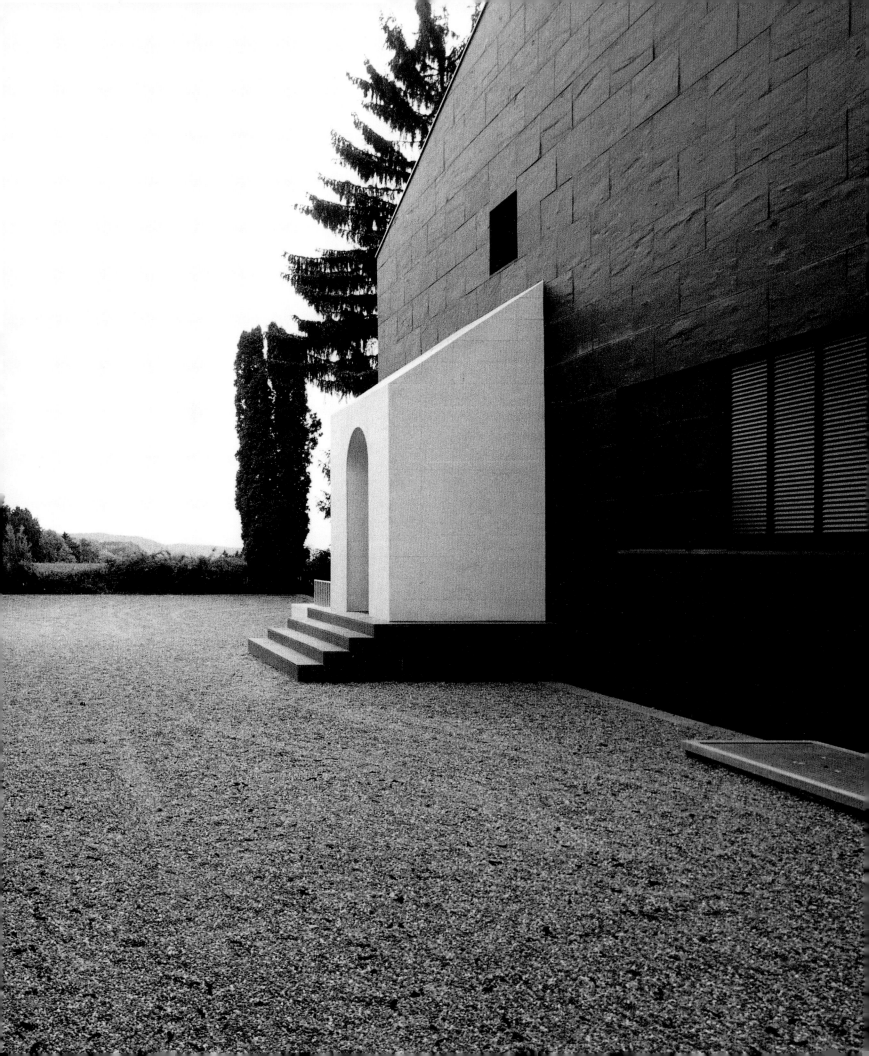

the lower floor and two large bedrooms above. A projecting entranceway, designed to look as if it has been carved out of the same pale Istria stone as that used on the Cei House, differentiates the house from the garage. Sottsass and Grawunder engage in an amusing visual game here by placing a partially rounded step in front of an arched doorway into the garage. It appears as though the white step has fallen down, to bridge the chasm between the two black blocks. The protruding white entrance to the house has the same arched doorway recessed into it, creating the illusion of a conversation across the abyss, between the house and garage.

Like the Bischofberger House, the Van Impe House in St. Lievens Houtem, Belgium (1996–98) was designed for a gallery owner and contains an internal exhibition space; it also features an outdoor "sculpture park" (figs. 83, 84). At 7500 square feet (700 square meters) it is substantially larger than Sottsass's other European residences. It is also more upbeat: the main art gallery spine is covered in blue marble, and the wings that run parallel to it to the east and west are sheathed in various shades of white stone. A vaulted, glistening, ribbed stainless steel roof covers a physiotherapy studio used by Mrs. Van Impe, making this residence visually stand apart from the other commissions.

The integration of architecture and furniture, described earlier in reference to the table-like Olabuenaga House, is attempted by Sottsass and Grawunder at an even more literal level in the Yuko House in Tokyo (1991–93), which has an office/showroom on the ground floor (fig. 85). Instead of the datum being an all-encompassing roof, as in the Olabuenaga House, this design follows the precedent set by Twin Dome City, in 1991, of using a raised plinth base to unify diverse elements. This may be because the standard streetscape in both Tokyo and Fukuoka is not very attractive: narrow lanes, fast traffic, and large amounts of carbon monoxide are typical of each city. Sottsass and Grawunder use a solid wall along the street in Tokyo, perforated only by their characteristic arched doorway, to confront the automotive overload outside, and cap it with an equally long window line. This is divided by thick vertical concrete columns set at regular intervals, which serve as both

Figs. 83, 84 (above and opposite)
Van Impe House, St. Lievens Houtem, Belgium,
1996–98
Architects: Sottsass Associati (Milan, Italy);
Ettore Sottsass and Johanna Grawunder,
principals-in-charge; Gianluigi Mutti, project architect

a visual and a structural podium for the two wings of the house above and the small courtyard between them. (The furniture displayed in one of these window segments appears to be part of the architecture.) These two blocks have their tops sliced off, like long lumps of sushi, in an irregular diagonal cut that gives each of them something vaguely resembling a traditional gable roof, but the varying angle makes them seem much more monolithic, as if they were standing up to this hostile urban condition.

The Zhaoqing Golf Club and Resort, in Zhaoqing, China (1994–96), is one of the largest projects completed by Sottsass and his young collaborators (figs. 86–89). Once again designed in association with Johanna Grawunder, the 43,000 square foot (4000 square meter) project includes a golf club, an indoor gymnasium, three restaurants, and a twelve-room hotel, as well as administrative offices, a sauna, and locker and shower facilities. As in the case of Twin Dome City and the Yuko House, a podium base is also the design expedient used to unify the disparate elements of the Zhaoqing Golf Club and Resort, which is located in a hilly, bucolic landscape complete with its very own lake. Sottsass and Grawunder placed two blocks on top of this raised platform and used different materials and colors to differentiate their diverse roles. The administrative wing, where the main entrance is located, has a large welcoming roof covered in traditional Chinese green-glazed tiles, supported by five huge drum columns wrapped in darker green tiles. The second wing, set off at an angle from the first and separated from it by a small garden court, contains the gymnasium, the restaurants, and the hotel. This wing is clad in native yellow ceramic tiles. As in Kuala Lumpur and Tokyo, the use of local design prototypes and materials indicates a heightened sensitivity to the traditions of a particular country.

There is a quiet architectural revolution now taking place in Singapore, with local practitioners trying to redefine the regional aesthetic by introducing large expanses of glass on thin steel structures into the conventional equation. This Neo-Modernist movement has met resistance from several diehard traditionalists, but the battlefields have typically been single family homes for the wealthy. Sottsass's commission for

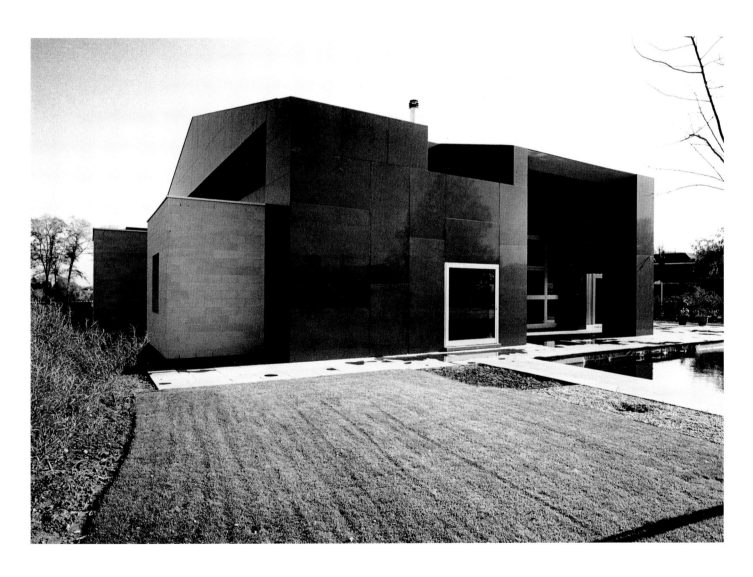

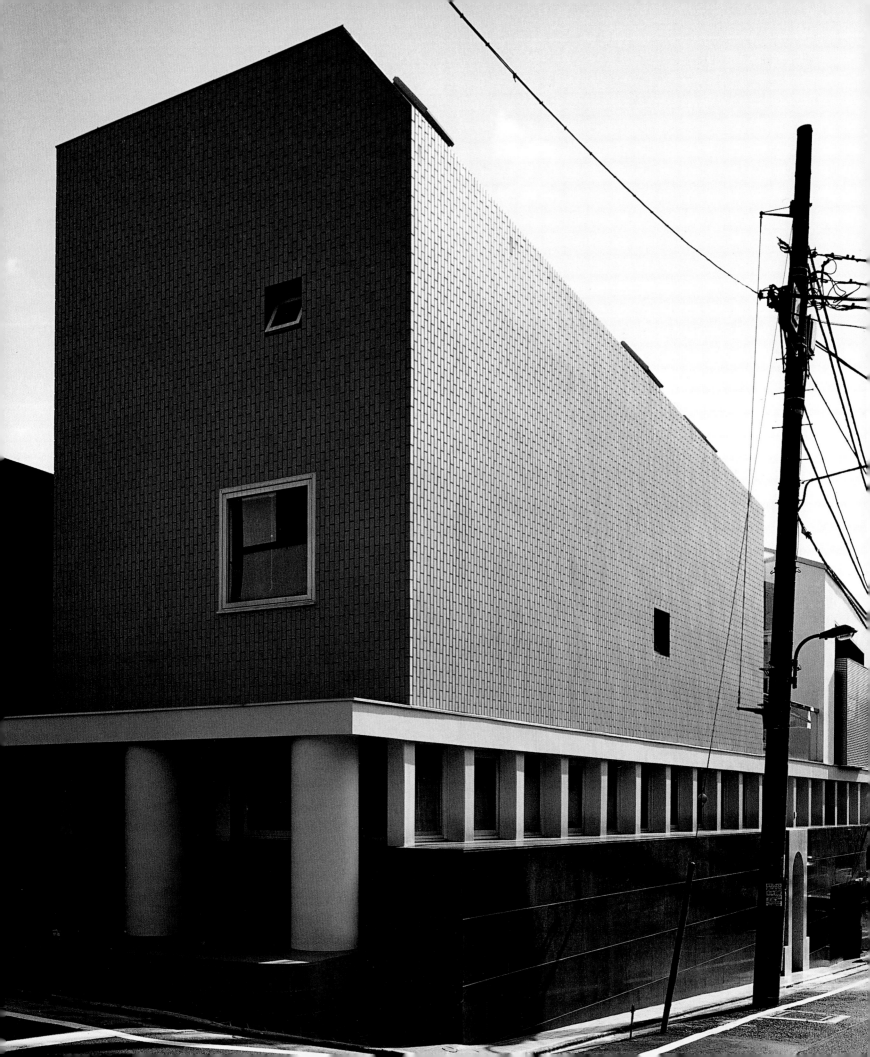

Jasmine Hill, a small housing development built in 1996–2000 (figs. 90, 91), is a clear example of his attempt to provide a compromise solution and displays the same degree of contextual sensitivity as Central Court in Kuala Lumpur, the Yuko House in Tokyo, and the Zhaoqing resort in China. His mediation between tradition and modernity and his ability to reflect local forms and materials have special meaning in this instance because the arguments on both sides are so clearly drawn.

The ten projects discussed here raise important and difficult questions about Sottsass's influences. Where do they fit in the contemporary scene? What is the aesthetic agenda behind them and does that agenda have an ideological edge? Is that aesthetic influenced by others? How are we to understand this work and place it? It initially seems to share much in common with both Rationalism (and Neo-Rationalism) and Postmodernism, and so this seems to be the obvious place to start the search. To do so, however, requires a brief overview of the background of each of these architectural directions and their theoretical thrust.

The Rationalist tradition in architecture can be traced back to the eighteenth-century Enlightenment, the proponents of which championed reason and observation as the most reliable source of truth. Such philosophers as Descartes and Voltaire wished to replace the abstract analysis characteristic of a Church-trained intelligentsia with a scientifically based philosophical system that would determine the appropriate framework for human action in the world. By breaking away from the hermetic scholastic tradition that had been in place since the Middle Ages, these "*Philosophes*" also intended to weaken the power of the monarchy, whose authority was closely intertwined with that of the Church. The Rationalist tradition, then, began with a political as well as a scientific agenda.

Works soon appeared that used the scientific method to categorize and clarify available knowledge, with Diderot's *Encyclopédie* (published from 1751) at the forefront. The application of Rationalist principles to architecture was a natural extension of this intellectual thrust, and began with the Abbé Laugier's *Essai sur l'architecture* of 1753. Laugier declares that "It is the same in architecture as with all the other arts. Its principles are founded on nature itself, and in the processes

of nature are to be found clearly indicated, all of the rules of architecture." These rules, he maintained, are based on absolute beauty "independent of the habitude of the senses." Architectural composition is susceptible to "all of the operations of the mind that are capable of disorder," which must be controlled, with design being "subjected and confined by strict laws."[13] This effort to establish an immutable, systematic theory of building led Laugier to make his inspired, if naïve, allusion to the first "primitive hut," an idyllic metaphor through which he attempted to reduce the elements of construction in early shelter down to the most essential parts. His desire was to substitute scientific principles for what he referred to as the "caprice" he saw around him in such fashionable styles as the Rococo.

Laugier's attempt to quantify the essential elements of architecture was expanded upon by Jean-Nicolas-Louis Durand, whose *Recueil et parallèle des édifices en tout genre, anciens et modernes . . .* (*Studies of All Kinds of Buildings, Ancient and Modern . . .*) of 1800 classified architecture according to its period, function, or form. He adapted the concept of species (then being applied to biology) to the idea of typology in building, to imply generic principles behind individual structures. His tactic of determining general attributes from specific examples has remained one of the basic tenets of Rationalist architecture. Like Laugier, Durand viewed the excessive eclectic historicism in France at that time as a corruption of the "true principles" that existed in the first architecture, but Durand raised the bar with the idea of type and mathematical certainty of form. While they both placed similar emphasis on these ideas, Durand made other critical distinctions which have also become accepted wisdom among Rationalists. His abstraction of various building types into pure Platonic geometries of circles, squares, and equilateral triangles, as well as his separation of form from the exigencies of use, may still be clearly traced in the Rationalist camp in architecture today.

The link between the Enlightenment and the Rationalist tradition that was well established in Italy by the time of Sottsass's apprenticeship with his father is Classicism, which became the style of choice at the Ecole des Beaux-Arts in Paris, and was greatly influenced by Durand's "true principles." The

Fig. 85
Yuko House, Tokyo, Japan, 1991–93
Architects: Sottsass Associati (Milan, Italy);
Ettore Sottsass and Johanna Grawunder,
principals-in-charge

Classical architecture of Greece and Rome lent itself to the Rationalist's mindset because its various components, such as columns, are based on strict harmonic proportions and geometric conventions. It surfaced in the Classical Novecento Movement in Italy, started by architect Giovanni Muzio soon after World War I. It was refined by the Rationalist Gruppo 7 (founded in 1926), which sought to synthesize the emerging national pride embodied in Italian Classicism with the precision made possible by industrialization. This group, made up of Sebastiano Larco, Guido Frette, Carlo Enrico Rava, Adalberto Libera, Luigi Figini, Gino Pollini, and Giuseppe Terragni, was also careful to distinguish itself from the newly minted Italian Futurists, who wanted a complete break with the past. The Gruppo 7 Rationalists significantly made it clear that they had no intention of breaking with tradition.[14] Nonetheless, as Rationalist historian Panos Koulermos points out, "the issue of tradition was interpreted differently by the various members of the Gruppo 7 and other architects who gravitated around the early Italian Rationalists and later formed the Movimento per l'Italiano Architettura Razionale in 1930. One cannot help but think that a wider meaning was attributed to the word 'Rationalist.' It implied modern at large."[15]

Despite Sottsass's protestations to the contrary, the ten projects briefly described above display many characteristics found in the work of the Rationalists, as well as the Neo-Rationalists, such as Aldo Rossi (for which Sottsass has acknowledged a fondness).[16] One of these is the use of primal forms, such as cubes, squares, colonnades, circles, domes, and massive tubelike columns, also manifested as the minimal abstraction of the house as a gable roof and boxlike base. Another is the use of color to evoke poetic associations, something that Rossi has done in many of his projects. At a deeper level, there seems to be a basic similarity of intent also best described by Panos Koulermos, who believes that Neo-Rationalist architecture is close "to Neo-Classicism and even Post-Modernism, in which projects demonstrate rigidity and formal fixations with imagery—icons and restricted morphological scenarios . . . the choice of the type or figuration and its development definitely requires subjective and intuitive involvement."[17]

Figs. 86, 87, 88 (top, bottom, and opposite)
Zhaoqing Golf Club and Resort, Zhaoqing, China, 1994–96
Architects: Sottsass Associati (Milan, Italy); Ettore Sottsass and Johanna Grawunder, principals-in-charge; Federica Barbiero, project architect

The two critical points relative to Sottsass's architecture that Koulermos raises here, then, are the possibility that it is not an issue of either Rationalism or Postmodernism being a generic influence but both, as well as the insight that the Neo-Rationalists compromised the strict objectivity of earlier Rationalists. They did this by resorting to metaphoric forms that elicit an emotional, rather than reasoned, response. By employing forms and colors that were intended to evoke memories or send subliminal messages, the Neo-Rationalists revoked the fundamental ban on emotional content in architecture dictated by their Rationalist predecessors. Ettore Sottsass uses this same technique in his frequent symbolic references to cultural paradigms.

Sottsass's protestations and those of his dedicated band of supporters notwithstanding, all of the projects discussed here contain many distinctly Rationalistic elements. Whether it be the pedantic, transformational explanation of the various configurations that a roof can take on the Wolf House; the play on the cube and the square as parts of the family of Platonic solids most beloved by the Rationalist order at the Cei House; the thorough explanation of the arcade or colonnade typology in

Kuala Lumpur, Tokyo, and Zhaoqing; or the recurring use of the elemental house forms at various scales in all these projects, in clear recollection of Laugier's "primitive hut," the Rationalist "tendenza" or tendency is unmistakably present.

Rationalist architects are also fond of referring to the house as a miniature city, pointing out that it has the same components but at a smaller scale: the meeting place or plaza (the living room), the restaurants or areas to eat (the dining room and kitchen), and so forth. To Sottsass, however, the house is more like large-scale furniture, with each function allocated its own particular shelf or cubicle, coinciding with his view that architecture is a stage-set upon which the tragicomedy of our lives is acted out. For this reason each of his designs, with whichever collaborator he selects, is highly legible in form, with a plan that is very conventional and compartmentalized. There is nothing radical about the layout of the spaces; rather, it is the way in which he juxtaposes three-dimensional forms, supports them (or not), shapes them, and colors them that is unique. Rather than using recognizable typologies—such as the roof, the window, the door, the courtyard, or the arcade—as a commentary on historical continuity, durability, and similarity, as do the Rationalists, Sottsass composes forms as a commentary on consumption. In his architecture, this narrative involves the way the users of his buildings consume life itself; it is about the common human rituals of daily existence: cooking, eating, relaxing, sleeping, bathing. His built forms are settings for the sometimes humdrum, sometimes exhilarating, but usually metronomical, drama of daily living.

What, then, of the possibility of a specific Postmodernist influence on Sottsass? Postmodernism has a much shorter history than Rationalism but is as heavily freighted with ideology. It began in the mid-1960s as a reaction against what its early proponents claimed were the sterile, restrictive aesthetics of the Modern Movement in architecture, which they asserted did not address people's deep psychological needs or aspirations—a position that closely echoes Sottsass's own reaction to the Modern Movement at this time. Much of this sterility, early Postmodernists said, had to do with the same Rationalist strain within Modernism that has just been discussed, in which logic

was preferred over emotion and scientific certainty over intuition, thereby eliminating human interaction at anything other than a pragmatic, functional level. Robert Venturi, who was one of the first of the renegade architects to propose a more humane alternative to what he referred to as the aloofness of Modernism, wrote in *Complexity and Contradiction in Architecture* in 1966 that buildings should be more interesting, in order to engage their users.

He was followed by several others, in quick succession, such as Charles Moore and Michael Graves, who added the notion that to become more engaging, buildings should "speak" to people—echoing the work in semiotics, or "the science of signs," that linguistics experts such as Saussure were involved in at the same time. Suddenly, in the mid-1960s, semiotics courses became very popular among architectural students, who attempted to convert linguistic techniques into built form in order to communicate their intentions more effectively to those for whom they designed.[18] Venturi, Moore, and Graves, followed by an international groundswell of others, began experimenting with an architectonic alphabet of signs with which to send their messages: "∧" for shelter, "∩" for entrance, a perfect square for window, or domesticity, an enlarged column for stability. They also championed the use of bright colors and historical reference, which they argued had been excluded from modern architecture because its founders saw these as emotive distractions.

The Postmodernists' emphasis on signs, colors, and historical reference as effective ways of communicating with a building's users finds an analogue in Sottsass's work, but it is the concept of commodification that makes this association an even stronger possibility. Soon after it emerged, Postmodernism proved to be very successful in the commercial sector, where it struck a chord with the entrepreneurial spirit that, arguably, built American society. Big, bold, and brash, the new Postmodernist buildings shouted "look at me," in dramatic contrast to the essentially European understatement and reserve of the International Style. Fredric Jameson, in his book *Postmodernism, or, The Cultural Logic of Late Capitalism* (1991), offers a cogent analysis of Postmodernism as a commodification of culture in an era of post-industrial capitalism. He argues that, whereas Modernism was based on the understanding that

Fig. 89
Zhaoqing Golf Club and Resort, Zhaoqing, China, 1994–96
Architects: Sottsass Associati (Milan, Italy); Ettore Sottsass and Johanna Grawunder, principals-in-charge; Federica Barbiero, project architect

materialism should be the subject of critique, culture in the Postmodern period has been "dilated" into the "sphere of commodities" alone, so that it has itself become a product. Jameson identifies this repackaging of society's notions of culture as the birth of a "media society," driven by electronic representation rather than production on the assembly line model, which allows it multinational scope. He argues that "aesthetic populism" has transformed the economic basis of capitalism, as defined by Marxism, so that "aesthetic production today has become integrated into commodity production generally: the frantic economic urgency of producing fresh waves of ever more novel goods at even greater rates of turnover, now assigns an increasingly essential structural function and position to aesthetic innovation and experimentation."[19]

Jameson's theory effectively describes the Postmodernist phenomenon, but it is most directly related to experience in the United States. In Europe the story of Postmodernism has been rather more ambiguous: it owes much, on the one hand, to the influence of such architect-theorists as Aldo Rossi and their investigations into the form and reconstruction of the European city, and, on the other, to the work of French philosophers such as Jean-François Lyotard in the field of language and semiotics. In Lyotard's hypothesis, Postmodernism can be represented as a game of language—the Sottsass issue of signs, once again.

Figs. 90, 91 (above and opposite)
Jasmine Hill, Singapore, 1996–2000
Architects: Sottsass Associati (Milan, Italy);
Ettore Sottsass and Johanna Grawunder, principals-
in-charge; Federica Barbiero and Marco Polloni,
project architects

He argues that the status of knowledge is altered as societies enter the post-industrial age.

Diversity, fed by the same cultural influences from around the world as those that feed Sottsass's forms, now takes precedence over the unified vision of Modernism. Whereas Modernism advocated abstraction, on the basis that the sublime or the reality of daily life could never be represented, Postmodernism is based on the belief that reality is representable, and so discards abstraction in order to be more in tune with real life.

There are many overlaps between Postmodernism's main tenets and those found in Sottsass's architecture, as there are in Rationalism and its later transformation in Neo-Rationalism. These include Sottsass's use of metaphor, color, and signs, primarily through a shared concern with semiology and formal syntax. Sottsass's use of color, however, differs from that of the Postmodernists in that his main interest lies in using it to make primary, existential, and cosmological associations (as opposed to the vaguely contextual purpose that guided its appearance in Postmodernism). Color, for Sottsass, equates with life.[20]

An even more profound touchstone, however, is Sottsass's similar view that Postmodernism sprang from the integration of aesthetic production with commodity production. Following this argument, Postmodern rebels took the position they did for the sake of change alone, because of the ever-increasing nexus between aesthetics and commodification, the need to search for the new. Referring to his own industrial design work, Sottsass has described this phenomenon as the "black marketeering business, the gigantic hectic rush . . . the giddy wheel that keeps turning faster and faster," the rat race that he felt compelled to escape from in the early 1960s and which he has since fought to redefine and redirect.[21]

Because of the pressure to change, the singularity that was characteristic of Modernism has been replaced by shameless imitation, simulacra, pastiche, and recycling of the past. This is the "cannibalization of history" that Jameson contends is part of the culture of consumption that characterizes today's world: a culture against which Sottsass claims to be fighting. While also attempting to tap into cultural history and memory, custom tailored to location, Sottsass tries to transcend mere imitation, searching out the psychological tap root in each instance. He resists the trend of making architecture yet one more commercial object, to take its place as a product among many others along streets that are increasingly "like aisles in a department store."[22]

Like Jameson, Sottsass has pinpointed the beginning signal of this incestuous cycle as being the Pop art movement of the 1960s, in which the barrier between high and mass culture was finally erased for good, and consumer products replaced human and natural subjects as the focal point of art. As an antidote to this incessant cycle, Sottsass proposes a return to commercial products and architecture that recover their original position as an essential part of human existence, completely free of those economic considerations that are superfluous or not necessary for human welfare. The irony, of course, is that his designs in both arenas can only be experienced by the rich, because only they can afford them. For this reason, as well as because of the opaque contradictions that I have described as being part of his methodology, Sottsass seems to face an uphill battle in attracting converts. But this was also true in his previous life as an industrial designer, when he declared that he was trying to renew the culture of his craft and return it to its original social mandate, one that lay beyond merely commercial value. Like William Morris before him he is, it seems, haunted by the problem of being separated from the very people he wishes to serve.

Sottsass still insists on being viewed as a protagonist in the struggle that he perceives as being waged between, on the one hand, beneficial commodification, leading to well-being, happiness, and delight, and, on the other, crass commercialism, driven by mindless buying and the need for novelty and brand status. This involves the declaration of a clear position within the process of commodification and consumption just described as being central to the Postmodern condition, over and above its architectural manifestations, which are now history. In each of the locations in which he has designed, he has found his relative and appropriate place—from development abundance to developing poverty. He sees his position as being free of the moralistic constraints of Catholicism, Communism, Rationalism, or any of the other "isms" imposed by nationality or society, and believes he is trying to promote common good.

Now well into his eighties, Sottsass—against all odds—still seems to believe that utopia and magic are possible. He keeps trying to remake the world as he wants it to be, one object, building, or part of a city at a time.

Current events have shown that economists' predictions of a brave new world, resulting from the inexorable mechanics of globalization, were flawed. Grave economic disparities still exist. The threat of homogeneity has led to heightened defensiveness, and a redefinition of cultural identity, throughout the world. The nation-state, recently declared to be anachronistic and redundant, does not show signs of being replaced by multinational superpowers anytime soon. Sottsass anticipated this twenty years ago, by seeking out, rather than ignoring, contradictions, and then subjecting them to his own methodology of doubt so as more accurately to reflect difference. In this, by any measure we can devise, he has certainly succeeded.

1. A. Mendini, quoted in B. Radice, *Ettore Sottsass: A Critical Biography*, trans. R. Stringer, New York (Rizzoli) 1993, p. 23.
2. *Global Village: The 1960s*, exhib. cat., ed. S. Aquin, Montreal, Montreal Museum of Fine Art, and Ghent (Snoeck Publishers) 2003, p. 34.
3. Ibid., p.35.
4. Radice 1993, p. 112.
5. E. Sottsass, *The Curious Mr. Sottsass: Photographing Design and Desire*, London (Thames and Hudson) 1993, p. 217.
6. Radice 1993, p. 148.
7. Quoted in *Global Village*, p. 34.
8. Sola Morales in P. Koulermos, *20th Century European Rationalism*, ed. James Steele, London (Academy Editions) 1995, p. 15.
9. K. Frampton, *Modern Architecture: A Critical History*, London (Thames and Hudson) 1973, p. 152.
10. G. Pettena, "From Radical to Memphis," in M. Carboni (ed.), *The Work of Ettore Sottsass and Associates*, New York (Universe Publishing) 1999, p. 34.
11. Quoted in Radice 1993, p. 142.
12. See E. Zaiden, "Instruments for Life: Conversations with Ettore Sottsass," in this volume, p. 121.
13. Quoted in J. Steele, "The Epistemology of Reason," in Koulermos 1995, p. 9.
14. Koulermos 1995, p. 14.
15. Ibid., p.15.
16. E. Zaiden, p. 107 of this volume.
17. Koulermos 1995, p. 16.
18. J. Steele, *Architecture Today*, London (Phaidon Press) 1997, p. 73.
19. F. Jameson, *Postmodernism, or The Cultural Logic of Late Capitalism*, Durham, NC (Duke University Press) 1991, pp.102–105.
20. Sottsass 1993, p. 88.
21. Radice 1993, p. 76.
22. Ibid., p. 77.
23. A. Branzi, "Formal Quality in the World," in Milco Carboni (ed.), *The Work of Ettore Sottsass and Associates*, New York (Universe) 1999, p. 4.

Instruments for Life: Conversations with Ettore Sottsass

Emily Zaiden

Fig. 92 (above)
Ettore Sottsass
2004

Fig. 93 (opposite)
Lingam, **1998**
Made by CIRVA (Marseilles, France)
Edition of three
Glass
28 x 9 ⅞ x 9 ⅞ in. (71 x 25 x 25 cm)
The Gallery Mourmans, Maastricht,
The Netherlands

EZ: In more recent years, architecture has become much more of a focus in your work. Do you have a different process or approach for designing architecture than for designing objects?

ES: Lots of people ask me this, also in reference to how I do photography and other art forms. When we go to a "chic" dinner, we dress a certain way, for the evening. Then we go home to sleep and we put on something else. Then we wake up in the morning and put on something else to go to work. That is to say, we design ourselves in certain ways that allow us to immerse ourselves in different environments and to anticipate appropriate circumstances. The materials may change but we are always the same fundamentally, that is, *we* are always the same selves, designing who we are, thinking about how to approach a specific situation through design, how we want to appear in a certain situation, and how we want to converse with design. What I mean is that the techniques may differ, but the person, or the designer, is always the same. Since the Renaissance, artists have worked on architecture, sculptures, paintings, and anything else they choose. It has always been this way. Raphael painted canvases and rooms, frescoes, religious scenes, secular scenes, mythological stories. It's clear that there is a difference in the technique of *making* things, but it ends there. If I design a piece of glass, then I can go to someone who knows how to make glass, and ask him how to make it. But, among other things, I can only design the piece. I can't make the actual piece of glass. I can design a typewriter, but it's not as if I can build it myself. I can design a computer, but I'm not the engineer who constructs the piece. The makers are occupied with realities. I always have to accept that no matter what, I work with other people who know how to solve the problems of actually crafting the objects. There is always a relationship between the person who thinks and the person who makes.

EZ: So, there is a moment in which the design leaves your hands?
ES: I follow it, but I abandon it, really, at the same time.

EZ: Although you pursued architecture at the beginning of your career, you've said that you were truly ready to design architecture only at a later point in your life. When was that moment?
ES: It seems to me that that moment was during the 1980s, or 1970s. I was fifty, or fifty-five years old. I started early, I have always designed architecture, but exactly when I felt *truly* ready to design architecture was in that period. . . . Maybe it's the same for painters, or a little earlier, like at thirty-five, but for architecture, it takes a little longer to be ready.

EZ: So this period when you began practicing architecture marked on some level your maturity as an artist. Do you believe, then, that you have progressed as a designer over the course of your career?

ES: Well . . . I have not had an evolution. What is evolution? That I've gotten better at what I do? No. For me, as an Italian, I think that life is a *commedia*; it's not a mathematical drawing. As for design in general, there is continuous movement, perhaps. Today we say the conventions are these, and we follow them. But history is always moving. Tomorrow, [maybe] the convention is that architecture is under the earth.

EZ: Is it possible to say that your buildings are more powerful expressions than your objects?

ES: [*Pauses*] But they are both different things, very different, because buildings affect the entire body. [*He draws a building with an object inside it*] If it is cold inside instead of hot, if it is loud instead of silent, we are here inside, different, affected by these factors. Whereas, the object here inside, I might not have even seen it, because I walked around it. Many objects engage fewer [levels] of our existence in a certain sense, at least normally that's how objects are designed. This may sound a little presumptuous, but I try to design objects that make you aware that you are living; some objects are not designed that way. You don't have any relationship to them almost. You have a very primitive, functional relationship. It has to function, it has to turn. But there are objects like the ring, an ornament on a woman, it makes her life . . . more enhanced. It's not just ornamental. It's her design. She's having an appointment with a boy, so [by wearing it] it's not just an ornament. . . . They are different ways to design. . . . I divide the word architecture and the word building. It makes a big difference to me. Buildings, it's 99.9% of what we call architecture. Buildings are buildings, houses, skyscrapers. There are mountains of rooms. And architecture is the design of an artificial place that when you enter you start crying. It's like the difference between a newspaper article and a poem. There is a big difference.

Fig. 94 (top)
Elevation drawing for building project, 1945

Fig. 95 (bottom)
Architectural study drawings, 1950
Ink on paper

Fig. 96 (opposite top)
Gallery of the Contemporary Furniture Museum,
Ravenna, Italy, 1992–93
Architects: Sottsass Associati (Milan, Italy); Ettore
Sottsass and Johanna Grawunder, principals-in-
charge; Federica Barbiero, project architect

Fig. 97 (opposite middle)
Ring, 1964
Made by Walter De Mario (Milan, Italy)
Unique
Gold, quartz
Musée National d'Art Moderne,
Centre Georges Pompidou, Paris

Fig. 98 (opposite bottom)
Necklace, 1961
Made by Walter De Mario (Milan, Italy)
Unique
Gold, quartz
11 ⅜ x 5 ½ x 1 in. (29 x 14 x 2.5 cm)
Musée National d'Art Moderne,
Centre Georges Pompidou, Paris

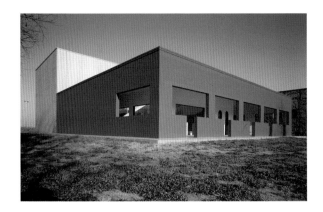

EZ: Which architects influenced you the most initially?

ES: Le Corbusier, the Germans, like Gropius, Mies, and so on, because at that time I was young and they were the so-called avant-garde architecture. . . . I loved very much Aldo Rossi. . . . Many years ago I went to Los Angeles to take pictures of Frank Gehry's architecture, and at that time he was influenced by the Dutch American artist Claus Oldenburg, and then he started developing the idea that architecture is art, which I don't think [is true]. Art you look at, architecture you inhabit it, you live in it. If you go into an old cathedral, even if you are not religious, if you don't believe in God or whatever, that place is designed in such a way that you change your psychological state. You change, totally, because of the dimensions, because of the axis, because of the windows, because of the perfume, because outside it's warm and inside it's cool. It's not only that you look: you look but you *feel*. And the idea that architecture is art, or that architecture is something so strange that you look at it as though it's a sculpture in a museum, it's an idea that is very useful to the companies that are doing the financing, to the so-called power élite. The power needs architecture that isn't so much about being comfortable or consoling as much as it's about shocking people.

EZ: So you don't feel that architecture is art?

ES: When I was at the university, almost every afternoon, I would go to see this painter named [Luigi] Spazzapan, because I was really interested in painting. I still am. But I feel that there is a realm of building, and then there is one for architecture, and then art is another realm. Art is another system of expression, as are literature and poetry. All of these systems are about contemplating life. Buildings, however, pertain to money, which is another problem—the money it takes to build them.

EZ: How does this apply, then, to the way in which your objects are viewed? Are they "art"?

ES: The word art is a big word. . . . When I was in Paris when I was eighteen years old, or so, I didn't know a word of French, I saw Picasso's *Guernica*, and I [thought], I can design an object that's nice, as intense as I can, but I will *never* reach that kind of intensity, I don't think. I call objects "instruments for life." Naturally, *Guernica* is an instrument for life, but it's maybe more than an instrument. It touches your life more. The Japanese design a beautiful vase with a flower. Okay it's an instrument for life, but it's a delicate moment, it's lyric. This [*Guernica*] is a poem, a *poema epica*.

Figs. 99, 100
Drawings for Interior Design examination,
Faculty of Architecture, University of Turin, 1938
Tempera and ink on paper

EZ: How did you become so interested in the use of color?

ES: Well, I don't know if can explain very well why I've always been interested in color. It's part of my earliest memories. I used to go to that painter [Spazzapan] because I was interested in color. He explained to me all the problems that you encounter with colors, how you use them, what they signify, etc. Then, when I was eighteen, and I went from Turin to Paris to see this big exhibition, and there I saw all the Fauve painters—Van Gogh, Picasso, Matisse, all of them—and they were all devoted to color. European figurative culture had discovered color. The colors of the Renaissance were very simple. They mainly used the colors of the earth, rather calm. A little later, Venice interested me in terms of colors. Tuscan painting was much more serious. The colors of the frescoes were always washed out, never the colors that you see in a gas station or something, the colors that I like now. Now we're in an age in which colors are even stronger, more violent, more phosphorescent.

EZ: Please describe the role of color in your work.

ES: Colors are like words. With colors you can tell stories. Words have histories and stories and significances within themselves, for example "*love*" means one thing, but "*amore*" in Italian, means something else, slightly different. Sanskrit has many words that we don't have the means to explain. We understand, but we don't have a sense of the nuances. Colors are the same. Each color has its own significance. Once I had to do a color catalogue for this company, and I decided to divide them by country. Colors that were French, colors that were American, Mediterranean colors, Japanese colors, Mexican, because if you think about it, each nation has its own type of colors. The French are more elegant, more feminine, while the Mexicans have very sensorial colors, sensual. Italians, Mediterraneans use colors that are more luminous, fresh like the ocean, more "spring-like." Volumes have been written about these problems of color. Kandinsky wrote about all the meanings of color. It's true that each color has its own story, but these stories are interpretations. If you take a dictionary and write something, you inevitably interpret the significance of the words. For instance, with philosophers, they use a word and assign it its significance. If you can't figure out what meaning the philosopher gives the words, you don't understand what he is trying to say. With colors, it's kind of the same thing. The colors are design elements that have associations. If you use bricks, immediately you say, oh this is a bit Tuscan, kind of country-farm. If you use a white wall, then it seems a little intellectual-snobbish, something that's trying hard to be hip. If you use deep, violent colors, you might say they make it feel like a brothel. Architecture is made of color. Even those who don't want to use color must use it in the end. It's fundamental.

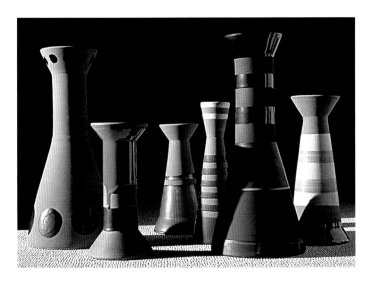

Fig. 101 (top)
Rocchetti (*Spools*) vases, 1959
Made by Bitossi (Montelupo Fiorentino, Italy)
Limited edition
Glazed earthenware

Fig. 102 (bottom)
Imera and *Pasifila* vases, 1986
Made by Toso Vetri d'Arte (Murano, Italy)
for Memphis (Milan, Italy)
Glass

EZ: Do vernacular references play a role in your designs, either in architecture or object design?

ES: Well, when I designed ceramics, for example, a man who sold ceramics in New York bought ceramics in Tuscany—in Montelupo, where there is an ancient tradition of ceramics. By chance, he asked me to design ceramics to be sold in New York City. But I didn't know anything about ceramics. So I went to Montelupo and found there a vast tradition of ceramics—a humble yet very deep tradition. There, ceramics have always been thick and coarse, a modest material. The people historically used three colors: yellow, blue, and green. Now there are chemical dyes so there are hundreds of colors, and pottery wheels which they use to make different shapes. But on the other hand, I also met Peter Shire, in California, who makes ceramics with slabs connected together. It's a completely different system. So, going to Tuscany, and making the ceramics with a Tuscan worker, I had to design a different kind of ceramics entirely. During the Renaissance, it seems that the Medicis threw these grand banquets and they wouldn't wash the tables or plates afterward, they just threw them out. So, there was this idea that ceramics were disposable, and temporary, provisional—apart from the Della Robbia wares, which were made as ceramics for the church. When I designed my ceramics I couldn't ignore the existence of the local tradition, the colors and the materials, and even the fundamental idea of ceramics.

EZ: Where do the titles for your pieces come from, by the way?
ES: The names come after the pieces are made. They are just for fun. When we did Memphis, I chose names of Greek girls, Greek prostitutes, or names of hotels like the Excelsior, names of trees, fruits, salads, names are just fun—not to be taken too seriously.

EZ: Are your projects linked to particular moments in time? Can they be viewed as records of history?
ES: My projects are never stopped in time, never. Everything that happens is an improvised interpretation. When I look at my projects, I see one thing. If you look at my work, you see something else. If a Chinese person sees my work, he thinks something else. Where is the eternity in all of this? There isn't.

EZ: So the projects from the 1960s are still as relevant today as they were then?
ES: Well, they can't be, exactly. But they are, to some extent. These ideas, you simply hope that the wind carries them a certain distance, and then you see. Sometimes the moment passes, you put on a jacket, and you can't feel the wind. I don't believe in eternity. Eternity doesn't really interest me. I'm interested in the moment. Existence is made of moments. Life is about moments.

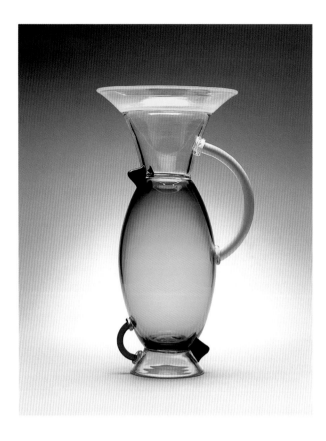

Fig. 103
Altair vase, 1982
Made by Toso Vetri d'Arte (Murano, Italy)
for Memphis (Milan, Italy)
Glass
16 ⅜ x 9 ½ x 5 in. (41.6 x 24.1 x 12.7 cm)
Collection Susan and Michael Rich

EZ: Your work has been described as a collection of signs. What kind of signs do you think will be used in the future?

ES: This is a very difficult question because the future for me is about my old age. I have experienced a lot in my life. Life is always changing. I have changed a lot. Even now, I'm changing. I'm getting older every year. Getting older means having more experience, knowing a little more, but maybe it doesn't serve the future, sadly. It signifies living in nostalgia. You always think about when you were young. I remember being happy, I remember when I worked more at night, when I was drunk, when I was enchanted by things. And you live in the present, but with a strange connection to the present. The present is something incomprehensible and unfamiliar for older people. The elderly always protest the new times, they always think, "Oh, in my time . . ."; they think about when they were young and happy. Even in designing, and planning, this becomes an issue. For example, think about the role of the computer nowadays—but I don't even know how to turn one on.

EZ: Really?

ES: Not only that, but there is this new computer language that I don't know. I call it the language of the priests. There are twenty, thirty, fifty words that I don't understand . . .

EZ: That's interesting since you designed one of Italy's first computers.

ES: When I worked on the *Elea* it would take a week to put one of those together. It was so complicated. But in my life, I've seen a time when no one had even heard of electronic things: there were only huge, central computers that filled entire rooms, for the universities, and then only some universities. The banks didn't even have them yet. No one used them, there were no personal computers. And from that point in time to now must be less than fifty years.

EZ: How has all this technology affected your design process, or has it?

ES: For one, I have an old-fashioned idea of color, that is, color that you apply and work with a brush or with your hands. With the computer, the colors are whack! [*he claps*]— and that's it. For me, that's not color. That's not what I think confronts the true possibilities of color. Sure, there are new possibilities using the computer, I understand. But if I see a design made by computerized color, I'm almost unable to understand what it means, what color it is. If I see a real painting in the flesh, it makes itself understood, naturally.

EZ: Do you think that with technology are we more limited?
ES: It's not that we are more limited, we are just different. But with old age, you can't catch up with what's new. By the time you understand it, it's already too late. You are not part of it. You aren't the cutting edge. You might get to a point where you understand it—if you're lucky, you might figure it out. When I was young I was part of the new. So because of this, I don't know what will happen with the future. Currently, we are designing some stores for clothing, for the middle market, not high end, not Armani or Prada. I woke up in the middle of the night thinking, what is modernity? I can't understand. Saturday night, if here is a street and here is a bar [*sketches*], with two hundred kids out until midnight with glasses in their hands, I don't know what they are talking about, I don't know what they are hoping for, what they do. I don't think that they are hoping for the same things that I hoped for. I've never experienced what they do. I was never like them. In my times, no one went to bars.

EZ: You have always worked with young architects and designers, especially at Sottsass Associati. So do you learn from young people?
ES: I'm trying to *understand*, above all. I try to continue learning, but only within my capacity. I cannot go and stay in the discotheques until four in the morning. I can't go and learn the names of the songs or what they mean. I think about how that's the future, that's the new way of being, but I am not that way, I am not part of that world. I can't think like a young person or an old American. I think in a different manner.

EZ: When you went to India, did you relate to the culture?
ES: When I went there forty years ago, I was not ready to understand what Indian culture was, that wasn't it. I was looking to take something away. I was looking for that kind of possibility. I found confirmation for what I had at that time as an idea of life. . . . It's very difficult for me to understand lots of things outside of my experience. Becoming older also means that one needs to work harder to understand. When I was younger, I didn't have to understand anything, I could just *be*. I didn't need to understand. I was creating.

EZ: But you still are.
ES: Maybe, I don't know.

EZ: Why do you put bases on everything you design?
ES: If you put it like that, you separate this piece from everything around it. You are looking at this piece in a different way than if it would be in a mix [of things], but even then, when I put it in the mix it still stands out.

Fig. 104
Enciclopedia per chi ama la vita—Auguri per sempre
(*Encyclopedia for He Who Loves Life—Best Wishes Forever*), 1963

EZ: Even for everyday, functional objects?

ES: Why can't you put these up on pedestals? Every day, you have to know [and be reminded] that you are living. You have to know that you are taking these objects [*he picks up a plain glass*] **and using them. It becomes a deliberate motion, makes you aware of your actions and the rituals of life. You are constantly in contact with them.**

EZ: Do the bases create a connection between the object and the earth?

ES: No, the opposite, it's to separate them from the earth. I'm always creating boundaries between things. For example, I made some ceramics; I put a white line on the edge of them so that the color didn't carry over. In a room a white line [the molding] creates a break between the wall and the ceiling. The color of the wall is one thing and the ceiling is the ceiling. There is a detachment, but at the same time, everything is always linked and connected. Each piece has its own life. For example, you can make a big red glass like this, [*sketches the stem of the glass*] **it's very thick and heavy, but you can say that the part that you attach it to [the bottom of the bowl of the glass] is very thin—see, it's a play of weight.**

EZ: Does this come through in your architecture?

ES: Yes, also in my architecture, but that's not something I invented. Le Corbusier made the Villa Savoye [*he sketches it*]. **Again, it's a play of weights. . . . But a piece of architecture by Gropius, also the new architecture, it was always the factory idea. It was nothing of that kind. It was a block of glass, it was a volume, this [by Le Corbusier] is a novel.**

EZ: When you design architecture, where do you start?

ES: I start with a plan. First of all, the space is where you live. You need to have the bathroom next to your room, the kitchen close to the dining room, and then the living room. Architecture always starts with inhabitation. That is how the rooms are laid out.

EZ: That sounds like more of a straightforward approach, as though it is first and foremost a "building"?

ES: [*Laughs*] **No, because there are all of these channels that you must respect, and I must always think about these things. Even when I worked for Olivetti, I started with the social relationships that occurred in the space.** [*Sketching a floor plan*] **Normally, in a building, the director has the office in the corner because he has two windows. All the others have one window or maybe they have no windows. Then, here is the secretary. He sees the secretary thirty, no, fifteen times a day. Then, there is a man who sits on the other side of the**

Fig. 105 (top)
Ginevra glass service, 2003
Made by Alessi (Crusinallo, Italy)
Lead crystal
Decanter with stopper: 11 ⅝ x 3 ½ x 3 ½ in.
(29.6 x 9 x 9 cm); sherry glass: 4 ½ x 1 ¾ x 1 ¾ in.
(11.5 x 4.5 x 4.5 cm); tasting glass: 6 ¼ x 3 ¾ x 3 ¾ in.
(16 x 9.5 x 9.5 cm); champagne flute: 7 x 2 ½ x 2 ½ in.
(17.8 x 6.4 x 6.4 cm); wine/water glass:
6 ½ x 2 ¾ x 2 ¾ in. (16.5 x 7 x 7 cm)
LACMA, gift of Alessi

Fig. 106 (bottom)
Vase for Sheikh Saud, 2001
Glass, stone base, metal wire
Unique

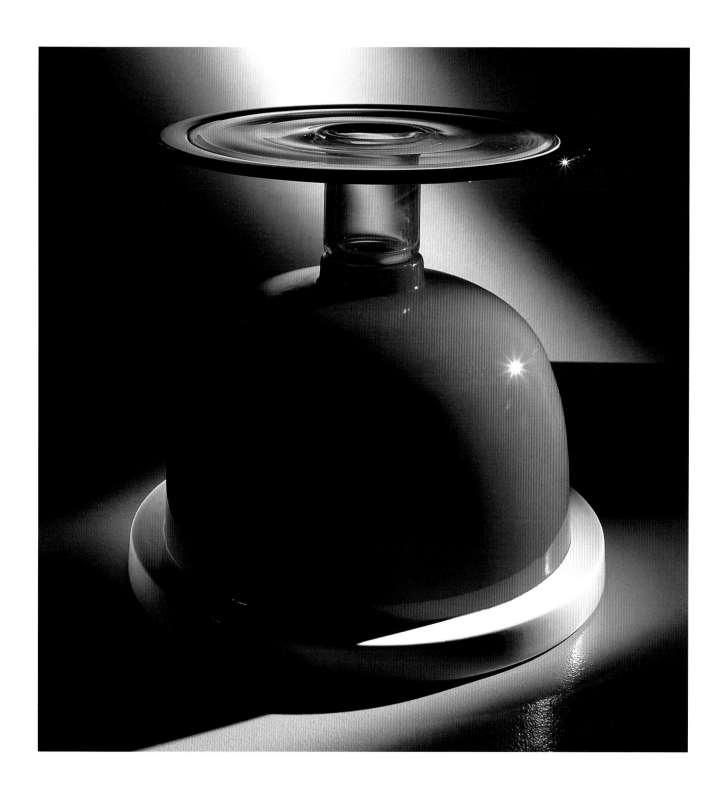

Fig. 107 (above)
Cuculo vase from the *Short Stories* project, 2003
Glass, glazed ceramic
Edition of thirty-three

Fig. 108 (page 115)
Interior views of a home in Milan, 1959

office normally, whom he also needs to see. So essentially, there is a problem of communication here. It's all a plan of offices and the offices themselves are laid out based on this internal structure, but the life of the people who use the space has to enter into the puzzle. Then take the color of the walls. They are white, let's say, but not just basic white. The light is important, in this office, and it doesn't make shadows. The so-called ergonomics and functionalism of the space are the problems you must solve. There is also a psychological issue that you confront, and then there is also a political level—you must consider the relationships contained in the space and expressed by the space.

EZ: So do you sit and watch how people use their spaces in order to design for them?

ES: Sometimes, yes. The fact is I have really just worked on private architecture. For these clients, I have gone to dinner with them to get to know who they are, and for them to get to know me, and what we can do. . . . The thing that makes me happiest, or most satisfied, is when, after I've designed a house for somebody, they tell me, "Ettore, this house is perfect for us. We feel good in this house."

EZ: What happened when you met the designer George Nelson?

ES: George Nelson was over here in Florence for a few months, to study or something. His mentality was less typically American, you could say. One night, he came to Milan and I met him at someone's house. He said I should go to America, he said I would like it. But with what money I asked? So he told me that he could put me to work in his studio, and that he could give me 125 dollars each week, which for me, in Italy at that time, seemed a huge amount. So I was happy, and I went to New York City in 1956, I think it was in the spring, and it was a great experience for me.

I arrived in New York with all these skyscrapers, the steam coming out of the street, these vapors, this huge metropolis, and then the studio of George Nelson. It wasn't much bigger than this studio [the Sottsass Associati office], actually maybe it was a little bit smaller. But it was clear that George, and Charles Eames, and three or four American architect-designers were the ones who were doing modernity. Most of Italy hadn't heard of him; only a few knew about Modernism like this. They maybe knew Gio Ponti, but he [George Nelson] wasn't famous in Italy. And he was already doing furniture that was very modern, simple. Bauhaus had started long before, with Breuer and Le Corbusier and all the rest. They were doing stuff that was very new, even twenty years before this. However, he was American and had a different way of doing things. It also wasn't very easy for him to live in America and work for the Americans. It's not like more Americans understood him. Most furniture at that time was in the Art Deco style. Anyhow, what left the strongest impression on me was that for the first time, I saw an industrial culture. It was industry that decided the life of the people, not artisan craft. Sure, there were people like Nakashima, but he was considered more of an artist than a designer. And even the architects that were starting to build in California—Neutra, Schindler, and others—the majority were from other places, and wound up in America. They were a very exclusive part of American culture. But this idea that civilization existed in industrial culture was a huge shock for me, because in Italy, even today, even with industrial design, often there is this special quality that comes from the influence of hand craft.

EZ: Did you learn anything specific about aesthetics directly from the Americans?

ES: It's not that I learned about the problems of aesthetics, so much as about the different approach to design. If you design for something, knowing that it will be made by a machine, it's different than if you're designing for something to be made by hand. Even something not made by hand can have its beauty. Even plastic, used in a certain way, can be beautiful. I used plastic all the time. But plastic is a material that no one loved. It's for the kitchen or the bathroom, not for the living room, or for decorative objects. This little vase [on his desk] is made of plastic, but in the 1960s it was never accepted—you made vases by hand, with glass, or other things. When I went to America in 1956 I completely changed my views . . . even my paintings. I knew I needed to do something that looked more machine-made, like the way Warhol painted. The same thing happened in design, and in architecture. We needed to start thinking about architecture not as handmade but as skyscrapers made by machines, structures made of glass, for factories. This is what I saw in New York. More than anything, it was a shock for me. If you look at all of the Memphis decoration, you never see the human hand. . . . When I first got to Nelson's studio, and he gave me the first 125 dollars, he gave me a check. He had these huge books for the checks and I remember getting it from him, then three days after, the taxman came and he took 30% on this 125 dollars, and that was another shock for me. When I came back I became an important man just because I had been to America. Maybe because of this, a few years later, in about 1959, Olivetti called me. Maybe I'm wrong, but I think it was because I had been to America.

EZ: What were Florence and Milan like in the 1960s?

ES: That's very easy. Milan had an industrial rhythm. Milan had many small craft workshops. These craftsmen took some machines and began working in a different manner. Little by little, very slowly, they became industrial, but at first they didn't know what industry was. We didn't have industry until fifty years ago. The only industry was military industry or heavy industry for the state, trains; the only factory was Fiat. But there was no industry for everyday objects. I was in charge of the Triennale in '57 I think, for the design section, and I couldn't find anything modern, not a glass. Everything was carved. It was handmade. Industry is about sales more than production. Industry requires financing. It costs a lot, the machines *etc*. Finance commands. Production is something very secondary. Financing says we'll give you the money if you do this, if you put this in it, if not, we won't give you the money, so there is this strange relationship. This is what decides the destiny of design.

EZ: Is this what happened in Milan?

ES: In Milan there were craftsmen, but they were open to industry, they figured out how to become industrialists. In Tuscany, though, there has always been grand, elegant aesthetics, but no industry. It was more about crafts. In fact, I designed ceramics in Tuscany, made by craftsmen. I designed furniture that was artisan handcrafted. In Tuscany, the head of Poltronova had gone to art school. He wasn't someone who had gone to technical school for making furniture or whatever. Design was still very much linked to the artistic production of objects, and as in the case of building and architecture, I make a big distinction between industrial design and design. I am from the side of design. Italy at that time was more on the side of design than industrial design, because there was no industry yet, it was just beginning.

EZ: Can you explain the distinction between them?

ES: There is a hierarchy still today. For example, today, I design only for art galleries. Because of my ideas about art I can't work for industry, because industry must sell. So now when I design I do so thinking about the galleries, about the design itself, not about the market. I don't have to think about the mass market, because the market learns from me. I am what in the industrial world they call the "research zone." I do the physical theory. Not every project is business-oriented; there are physical projects that are experimental. Every time you make love, it's not like you want to make a child. You make love because you like making love.

EZ: Do you know about Target? It's essentially a mass-produced "good design" emporium.

ES: I don't think that you can do good design that is intended for the market. . . . Maybe it's possible, but true, good design comes from cultures that are outside of the market. These cultures get cultivated, used. If not, the market doesn't know what to do with itself. For example, people are starting to use color in their design. Just five years ago it wasn't done this way. This happened because Memphis, the poor thing, shattered the idea that everything needed to be made in wood, or steel.

EZ: But perhaps there is some value to those trends that become popularized?

ES: Well, yes. But you set out either wanting to make money or wanting to design.

EZ: But these popular design elements speak to greater segments of society.

ES: Yes, but these poems *are* for society. They just aren't initially made for consumption. Look at some poor black kid on the outskirts of San Francisco, who's down on the street and starts dancing like crazy—now in all of the discotheques, everyone dances crazy like this guy who, thirty years earlier, started dancing that way out of desperation. In my opinion, you must respect the people who invent these ideas. Pasolini wrote something that has always interested me. He said that the inventions of language, not only the spoken language but also the language of aesthetics, always come from the periphery. There is a core zone at the center of society, and it's more conservative and fascist. Then there is a zone for the bourgeoisie, let's say, and they are listening to these crazies who invent things and who seem, at least to the people at the center, to be evil, dangerous beasts. But the bourgeoisie takes in part of this stuff in some way, and they redesign it and resell it, and very, very slowly these ideas become more and more accepted.

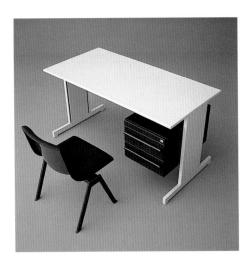

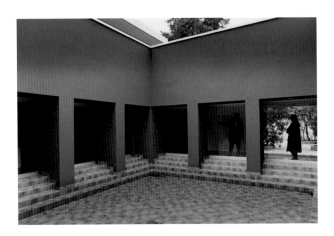

EZ: Where are the new centers of design, in your opinion?

ES: Certainly, London is very interesting. That's a living city. Also, I think in the US, but Americans do more industrial design than design. They design nice cars, vacuums, nice computers maybe, things like that. With the Apple computer the company wanted to do something more than just functional with that. . . . It's quite rare to find interesting industrial furniture. It doesn't exist. In every design magazine, whether it's Italian or whatever, if there are a hundred photographs, eighty of them are chairs or sofas, never beds. The interest of designers is mostly about chairs or sofas.

EZ: Why were you never interested in designing chairs? Why could you design a table or a light but not a chair?

ES: Maybe because there are enough chairs designed already. . . . I had to design a chair once. I designed a yellow chair for a secretary. It was a very new design. George Nelson wrote a letter to me saying, Ah, that's the new thing for chairs! He was very kind. I designed a really stupid chair, with irony. Then I designed another chair. Horrible. They were statements, not chairs. I have the belief that no chair is really comfortable. If you sit eight hours in a chair, in front of the computer, you will hate the chair anyway. And then, I always say if you're sitting somewhere, waiting for your lover, you can stay eight hours, but you don't even consider the presence of the chair. You're just waiting.

EZ: How would you define the relationship between architecture and power?

ES: Architecture has always been a representation of power. In Egypt, and also in the Renaissance, power had something to do with God. Now it has to do with money. At one time, power was concentrated, and this cultural concentration had authority over the connections with God. Now, it's not concentrated, it's more dispersed. The pyramids were representations of the power of the pharaoh. But they were also tombs, so they were representations of the unknown. Temples and churches are the same thing, they've always been about connection with the unknown. But none of this exists today. [Now] the terms are to produce, to sell, to make money; this money goes to producing even more, in part it goes to the army for the protection of the state, *etc*. So, if architecture is just a representation of power, I'm not interested. I have nothing to do with it. If you look, I only design architecture for private commissions.

Fig. 109 (top)
Desk and chair from the *Sistema 45* collection, 1973
Designed in collaboration with Perry A. King,
Albert Leclerc, Bruno Scagliola, Masonari Umeda,
and Jane Young
Made by Olivetti (Milan, Italy)

Fig. 110 (bottom)
Nanon House, Lanaken, Belgium, 1995–98
Architects: Sottsass Associati (Milan, Italy);
Ettore Sottsass and Johanna Grawunder, principals-
in-charge; Oliver Layseca, project architect

EZ: Yes, but the buildings are for rich people.

ES: Yes, they're rich, okay. But the people I work for are special. Some of them are rich, but not always. The problem is that the poor can't build. I would love a poor guy to ask me to build for him. I'd really enjoy that. One time, I designed a house for *Domus* for a worker from a big steel factory here in Milan. This project had a swimming pool, a place for horses, a small room, library; it had everything that rich people want to have.

EZ: How do you see your objects being blended together to create interior spaces?

ES: The problem is this. For 99% of the public, interior design spaces are what I call "*anthologies.*" You take "literary" pieces and you put them together and it makes an anthology. But it's a different thing to write a poem. You might design an individual "literary" piece that winds up in some anthology. I know that if I take a piece of Memphis and put it in a room, it's going to be difficult to put a second one in the room, because it sends off such strong vibrations. However, if I put out something like a chair from 1700, it sends out small vibrations. Then close by I can put something that's Stile Liberty, because its vibrations are also small, less powerful, less disturbing. Memphis is too shocking. You can't ignore it, but you can almost forget these other pieces. This is true not only for Memphis stuff, of course, but also for something simple and very clean, like Shaker furniture—it can still have very intense vibrations. You can't put just any chair with it, because it doesn't work. You have to leave a lot of space around it. It's very poetic. It's like a living poem. It's not just a piece of furniture. It's another way to compose things inside a space. But people like anthologies, they just put everything together that they think is beautiful. They are collectors, they are not designing anything. I don't think many designers think about how their designs make complete interiors. . . .

EZ: How do you feel when you see your work in someone's house?

ES: I feel very desperate . . . not all of the time, but for instance, if I design a vase, thinking that someone will put flowers in it, what I've found is that nobody's able to put the flowers in it. Putting the flowers in the vase is a science [*he sketches how the flowers fall over*]. You have to know what you are doing with how you place the flowers inside. It's the same with putting fruit in my fruit bowls. You can only have two oranges or whatever, and the color is blue because it works with orange, and that's all you can put there! [*He laughs*]

Fig. 112 (bottom)
Fruit bowl from the *Geology* series, 2000
Made by Alessio Sarri
(Sesto Fiorentino, Italy)
Edition of twelve
Glazed earthenware
12 ¾ x 16 x 16 in. (32.5 x 40.5 x 40.5 cm)
The Gallery Mourmans, Maastricht,
The Netherlands

Fig. 111 (top)
Casablanca cabinet, 1981
Made by Memphis (Milan, Italy)
Wood, plastic laminate

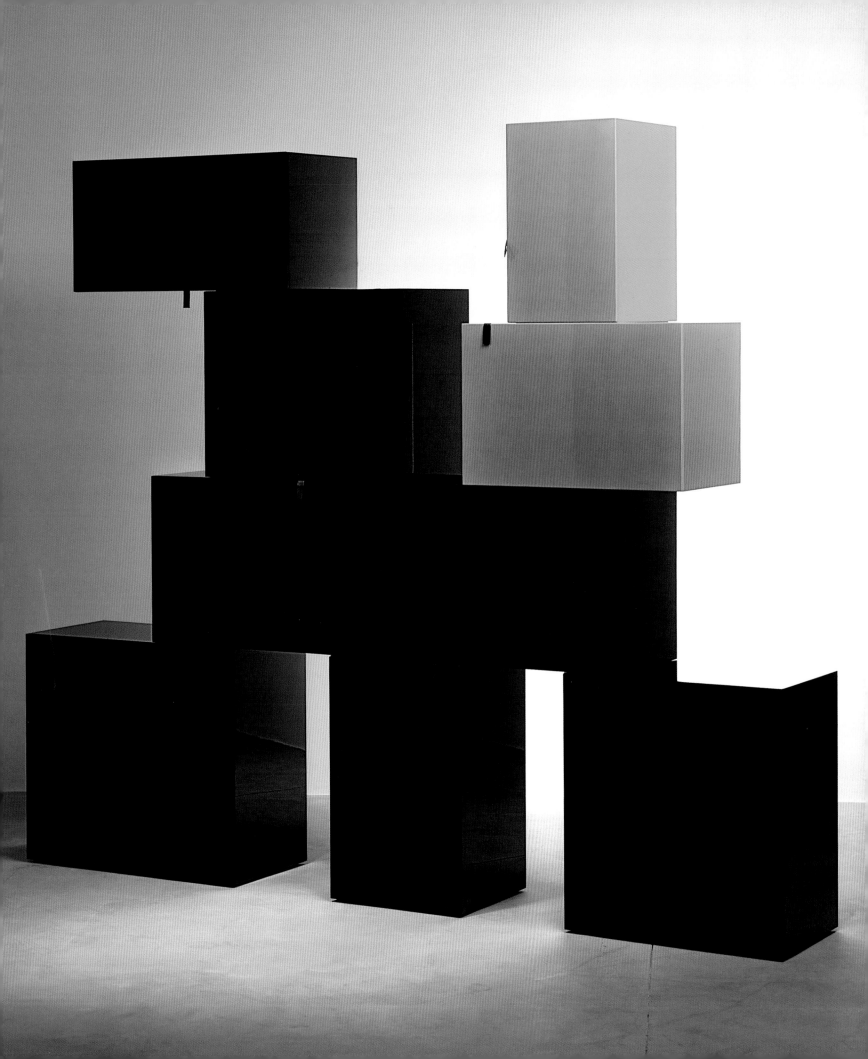

EZ: So do you design with a picture of how your pieces will work inside people's homes?

ES: [*He sketches*] **I'm not thinking about it working with other pieces. These pieces of furniture are first and foremost ideas. If there is a rhythm, then you balance it with something else. Maybe you put something [Memphis] next to a table by Breuer, which is very pure, and they can be together, and then you add a vase of flowers. I've seen people who bought my furniture, or other pieces by friends of mine from that period, and if they don't know how to build the entire space it's horrible. What's a comparison? If you have a song and you decide to put in a trumpet and then another loud instrument, it's difficult for them to play together and to make a nice song.**

EZ: But what about the many designers who approach design as though they were conducting the entire orchestra?

ES: These are the famous great designers, Josef Hoffmann or Frank Lloyd Wright or even Le Corbusier. You couldn't put extra pieces in their work. [Their interiors were like] paintings inside.

EZ: Which objects do you live with?

ES: In my house? [*Sketching*] **In the living room, there are two windows and a very simple Corian table, very white and thin. We had one, this blue table, plastic, very long, big legs, all blue but with some fake wood, but when you have people over, a long table is uncomfortable. You can't talk to everyone; there are people in between you. Instead, the one we have now is more cubed. Four, six, even eight people can fit, more or less. The chairs are American, aluminum. They were office chairs, very neutral. I have an immense Francesco Clemente painting that he gave to me, so it's like a fresco. Here there is a very simple thing and here is that thing that plays music, what is it called?** [*a CD player, I say*]**, and here there is sort of a library; very minimal, but also very sensorial, very interesting colors. Then I was given a Chinese scroll with a General and everybody thinks it's my portrait. That's already too much [stuff], but it's far away enough. The whole house is like that more or less.**

EZ: And no stand-out pieces?

ES: No, because if I get stand-alone pieces I need to change my house.

EZ: Your house is more neutral.

ES: Rather. . . . The design is more about proportion than decoration.

EZ: Why did you stop doing architecture early on?

Fig. 113 (page 118)
Adesso però (*But Now*) bookcase from the *Rovine* (*Ruins*) collection, 1992
Made by Design Gallery (Milan, Italy)
Stained wood, glass
82 ⅝ x 67 x 19 ¾ in. (210 x 170 x 50 cm)
The Gallery Mourmans, Maastricht,
The Netherlands

Fig. 114 (page 119)
Cabinet, 2001
Made by The Gallery Mourmans
(Maastricht, The Netherlands)
Edition of six
Carbon fiber, lacquer
74 ¾ x 77 ⅛ x 15 ¾ in. (190 x 196 x 40 cm)
The Gallery Mourmans, Maastricht,
The Netherlands

Fig. 115 (above)
Vase for Sheikh Saud, 2001
Glass, stone base, metal wire
Unique

ES: I didn't have cultural surrounding or support. I needed to be near resources for what I wanted to do. I was looking to move the Rationalism into another realm. I wanted to get out of the old scheme of architecture. But at that moment I had doubts, so I stopped and did houses that [were] very simple. It's one thing on paper but in reality it's a bit more difficult. This was a period when I was trying very hard to get rid of the Cartesian vision of space—doing connections that have curves. But I was so alone, I am always alone, I don't know, by DNA, I always do things without the fortune of surrounding. So it was very tiring. . . .

EZ: So now in your architectural projects, do you use these concepts?
ES: I haven't. I just gave up . . . it's personal masturbation.

EZ: You use that phrase a lot. What does it mean?
ES: I think the architect has a social responsibility. Any time he is making something he changes the landscape, so I ask myself, why is it like that, every time. Why should a house be like that? What's the reason? There is no reason, so why shouldn't I build a house like that? Maybe I change the color or I do different movement, but it stays. It's a house. Why should I live in a room where all of the walls are flat and straight? These are questions that one in this profession can ask himself every day. How can I respect certain laws that belong to our body, because in our body we have an axis, one axis, then another and another. Why should we escape this kind of structure? Maybe we need it for stability. When I see the houses of Frank Gehry, especially some of them, the new ones, everything twisted, off-balance, except for Bilbao, let's say, it's a sculpture. One day, I read that Frank Gehry said a phrase, "They say I am designing sculpture, but every three-dimensional structure is a sculpture." But this is not true because in architecture, you go *into* that sculpture. So it's another problem. And to say that a Gothic church is a sculpture, it's a *church*, you go into the church, you pray, you hear the organ play, it's another problem. I don't want to inhabit a sculpture.

EZ: What about your objects, which some people view as sculpture?
ES: An object is something that I look at.

EZ: Is it sculpture then?
ES: It can become a sculpture. But for instance, if you look at all of the objects I have produced, they always have [been functional], even the series of ceramics that I did called *Calligraphies*, and they were [considered] sculpture.

EZ: But they had a function.

Fig. 116
Architectural study drawings, 1953
Ink on paper

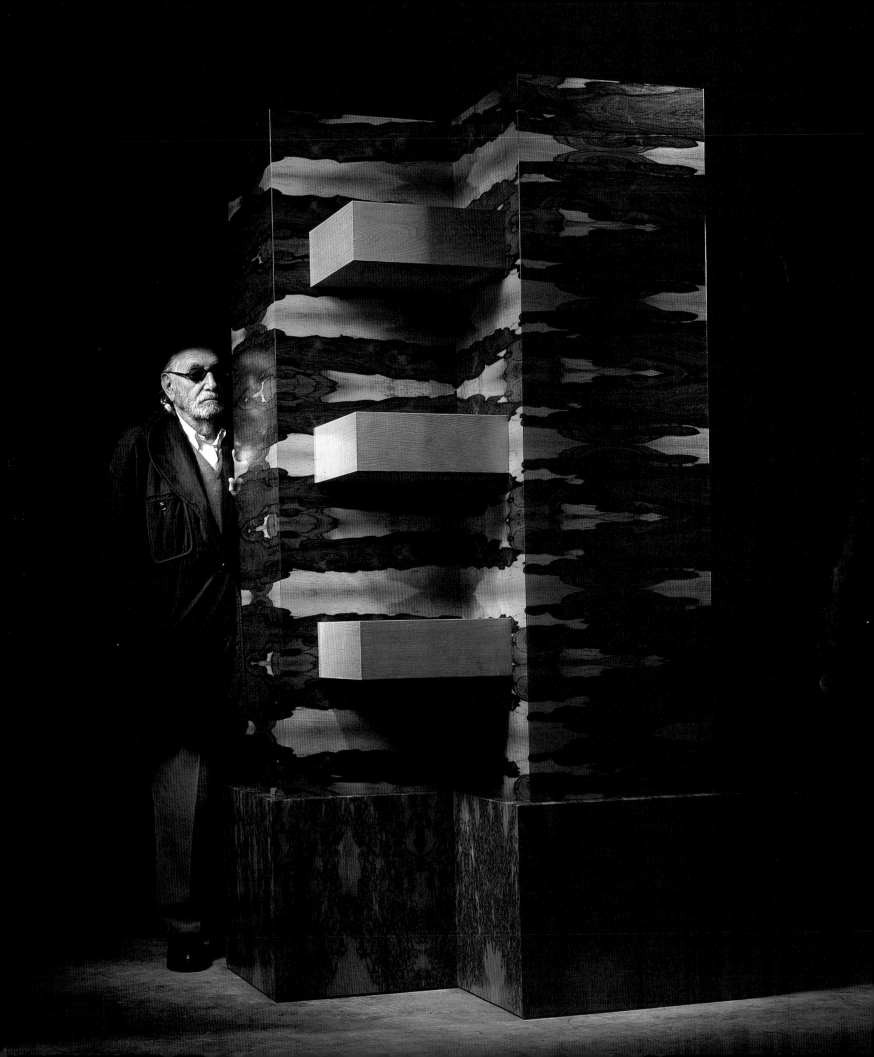

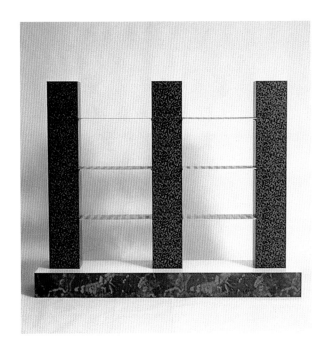

ES: They had a hole here to put a flower, to avoid somebody thinking that they were just non-functional sculptures. It's a vase, it's not a sculpture. It's clear there's a border between sculpture and the vase. But it's a very trembling border. It's not so sharp. That's happened rarely, but for instance, I made vases for Sèvres, they were tipped, and why, because the flowers are [supposed to be] like this [straight up]? It's like the bookshelves I did. Normally, they are like this [*sketches, straight lines*], but the bookshelves for Memphis are like this [*diagonal lines*]. But the fact is, even in a normal bookshelf, the books slant over to the side often, not always, but most of the time, and if you have books like that, they use the space best. Now I'm joking, and I don't mean that this is more rational than that, but there are different possibilities.

EZ: Do you want your work to be looked at as sculpture or as functional objects?
ES: Surely not as sculpture, but as a different approach to the destiny of an object.

EZ: And therefore, a different way of life?
ES: Yes.

The interviews were translated by Emily Zaiden and conducted in both English and Italian.

Fig. 117 (opposite)
Ettore Sottsass with *Stereo Cabinet No. 1*, 1994
Made by The Gallery Mourmans (Maastricht, The Netherlands)
Wood, jacaranda, cerejeira, and stained ash veneers, steel
87 ¾ x 59 ⅞ x 30 in. (223 x 152 x 76 cm)
The Gallery Mourmans, Maastricht, The Netherlands

Fig. 118 (above)
Alessandria d'Egitto bookcase, 1979
Made by Studio Alchymia (Milan, Italy)
Wood, plastic laminate, metal

Fig. 119 (right)
Bookcase, 1994
Made by The Gallery Mourmans (Maastricht, The Netherlands)
Edition of six
Wood, plastic laminate
65 x 78 ¾ x 15 ¾ in. (165 x 200 x 40 cm)
The Gallery Mourmans, Maastricht, The Netherlands

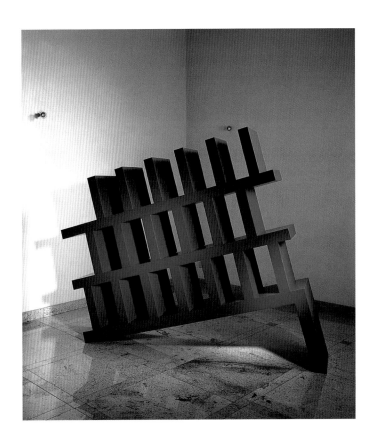

Emily Zaiden

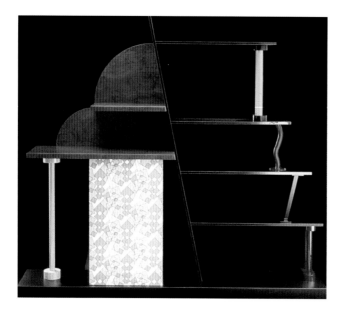

Fig. 120 (above)
Malabar room divider, 1982
Made by Memphis (Milan, Italy)
Wood, plastic laminate, burl wood veneer,
lacquer, painted metal
92 ½ x 100 x 19 ¾ in. (235 x 254 x 50.2 cm)
LACMA, gift of Max Palevsky in honor
of the museum's 40th anniversary

Fig. 121 (opposite top)
Condiment set, 1978
Made by Alessi (Crusinallo, Italy)
Stainless steel, lead crystal
Stand: 7 ½ x 7 x 3 ¼ in. (19 x 17.8 x 8.3 cm); oil and
vinegar bottles: 6 ½ x 2 in. each (16.5 x 5 cm); salt
and pepper shakers: 4 ⅛ x 1 ½ in. each (10.4 x 3.8 cm)
LACMA, gift of Alessi

Fig. 122 (opposite middle)
Nuovo Milano (*New Milan*) cutlery, 1987
Made by Alessi (Crusinallo, Italy)
Stainless steel
Soup ladle: 10 ¼ in. (26 cm); serving fork: 9 ½ in.
(24 cm); serving spoon: 9 ½ in. (24 cm);
knife: 9 ⅛ in. (23 cm); fork: 7 ⅝ in. (19.5 cm);
spoon: 7 ⅝ in. (19.5 cm);
dessert knife: 7 ½ in. (19 cm);
dessert fork: 6 ¾ in. (17.1 cm);
coffee spoon: 5 ½ in. (14 cm)
LACMA, gift of Alessi

Fig. 123 (opposite bottom)
Round basket, 1981
Made by Alessi (Crusinallo, Italy)
Stainless steel
2 ¼ x 7 ⅞ x 7 ⅞ in. (5.7 x 20 x 20 cm)
LACMA, gift of Alessi

*Sottsass has worked in collaboration with numerous
manufacturers and galleries over the years. Profiled here
are the designer's main collaborators, and those involved
in objects featured in this exhibition.*

ABET Laminati

Laminate manufacturer ABET Laminati remains today one of
the leading international producers of high-pressure decorative
laminates, with almost six hundred original patterns and
thousands of color and texture variations. ABET Laminati was
founded in Bra, Cuneo (northwestern Italy) by the Garbarino
family, who had formerly run a leather-tanning company called
Anonimo Braidese Ente Tannico (ABET). Recognizing the
success of Formica in postwar America, and the similarities
between processing leather and producing high-pressure
laminates (impregnation, curing, and cutting), ABET entered the
laminates market and became ABET Laminati in 1957. Shortly
after it opened, the company decided to move beyond the
production of imitation wood and plain white kitchen laminates.
ABET started manufacturing laminates in bold, unexpected
colors that could be used not only in the utilitarian realm of the
kitchen but also in the living room and other parts of the home.
Sottsass began working with ABET in the early 1960s along with
other designers from all over the world who created patterns for
their silkscreen printing laboratory. In 1978, Sottsass designed
the *Bacterio* pattern, which was followed by others that proved
to be very popular.

 During the 1980s, ABET Laminati played an integral part
in the early days of Studio Alchymia and Memphis (fig. **120**).
Sottsass relied heavily upon its laminates in his designs
during that period, and with his partners continued to create
imaginative patterns for the company even until recent years.
Sottsass's work truly helped redefine the nature and role of
laminates in design. The laminates provided him with dense
colors and vibrant patterns, which helped enhance the sensorial
nature of his designs. Sottsass helped shape ABET's product
lines by using light, translucence, and reflection, not just color
pigments. Sottsass believed that laminates were capable of
being re-envisioned and updated to be compatible with the
taste of the times.

Alchymia *see* Studio Alchymia

Alessi

The Alessi family hails from Luzzogno in northern Italy's Strona
valley, a region that has been a European center for metalwork
and housewares manufacturing since the 1700s. The company
started when Giovanni Alessi Anghini opened a metal workshop
in 1921 at Omegna near Crusinallo, producing well-made nickel,

chrome, and silver-plated coffee pots, trays, and other goods. In 1929, Alessi started focusing on specialized housewares; in 1932, Giovanni's son Carlo, who had trained as a designer, began developing a new concept for household objects with more sophisticated forms. When stainless steel became popular after World War II, Carlo, who became head of the company in 1955, made great use of the new material. Steel was much easier to mass produce than the metals previously used by the firm, thus allowing Alessi to reach a wider market. Carlo's brother Ettore supervised the technical aspects of the company as of 1945, and they started working with outside designers and architects.

In the 1970s, Carlo's son, Alberto, took over and branched out beyond steel into glassware, ceramics, plastics, and wood, offering artistic objects at affordable prices, and creating relationships with leading designers such as Sottsass, who designed his famed condiment set for the company in 1978 (fig. **121**). Ettore Sottsass started consulting for Alessi in 1972. In Alberto's words:

> Uncle Ettore and I met him. He was preceded by the fame of his work for Olivetti, his reputation as the guru of radical design . . . and he was the first person of truly international standing with whom I had dealings. He is something of a philosopher, bursting with charisma, and he has something interesting to say about everything. It was with him that I began talking over the "high" topics of design, the role of industry in society. Although we meet up only once in a while . . . he was the first person I met through work who for me has become a real mentor, one of my maestros. (Alberto Alessi, *The Dream Factory: Alessi Since 1921*, Milan [Electa] 1998, p. 23.)

In the 1980s, Alessi became well known for its expressive, elegant, and playful products—including Sottsass's round basket of 1981 (fig. **123**) and iconic pieces by such architects and designers as Philippe Starck and Michael Graves—which reached cult status. At the end of the 1980s, the firm offered appealing, practical designs that made witty statements, inspired by the ideas of Studio Alchymia and Memphis, and other design concepts of the time. Today, Alessi continues to support design innovation and young designers with its applied arts research center, lab, and museum.

Arredoluce

One of the first companies for which Sottsass did consultancy, Arredoluce helped him build his reputation when he designed abstract sculptural lighting for them in the late 1950s. Located in Monza, Angelo Lelii's Arredoluce was one of a group of small-scale companies producing sculptural lights in Italy in the 1950s, alongside Arteluce and Stilnovo. In these early

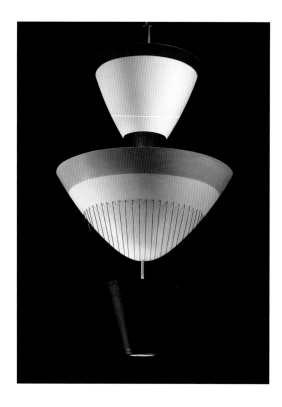

projects for the company, Sottsass's interest in color and texture was already emerging (fig. **124**). He continued designing for them into the 1970s.

Artemide

The lighting and furniture manufacturer that helped fund Memphis, Artemide changed the nature of Italian furniture production by bringing molded plastics into the domestic environment in the 1960s. Artemide was founded in Milan in 1959 by the engineer Ernesto Gismondi and the designer Sergio Mazza, who soon enlisted leading architects and designers as their advisers. The company set out to redefine the nature of plastic as something more than a functional, cheap material. In the 1960s, Artemide made lamps, plastic furniture, and accessories, but it eventually switched gears to focus solely on lighting. After Artemide purchased a share of the Murano glass company Vistosi in 1980, lamps incorporating this glass became an important part of production. Because the company sponsored Memphis, many designers from that group worked with Artemide to create furnishings and lighting. Sottsass designed several noteworthy pieces for the company in the early 1980s, such as the *Callimaco* lamp in 1982. Today, the international company focuses on experimental lighting.

Bitossi

Guido Bitossi's ceramics workshop in Montelupo Fiorentino, Tuscany, which was established in 1921 and later became known as Manifattura Cavalier G. Bitossi & Figli, was critical to Sottsass's achievements as an artist-designer. The Bitossi family's history with making terra-cotta dates to the mid-1700s, continuing the ancient traditions that had developed with the Etruscan population that settled in the territory of Montelupo Fiorentino. In 1956, the importer-businessman Irving Richards, of the New York firm Raymor, introduced Sottsass to Aldo Londi, who had been Bitossi's artistic director since 1946. Londi was a ceramics expert who wanted to make ceramic wares that had a "higher" purpose, and were more than just ornamental. By his own account, Sottsass knew little about ceramics, but Guido Bitossi's sons Marcello and Vittoriano, then owners of the business, gave Sottsass and Londi room to experiment. As Sottsass relates in an interview with the writer Fulvio Ferrari, Londi was "kind, and we became such great friends, also with the workers, because I brought new ideas to them and I made them do things they never imagined they could do, and I did them because I didn't know what I was doing. I kept asking if we could make something, and they would say, well, we'll try, and then it would work." (Fulvio Ferrari, *Ettore Sottsass: tutta la ceramica*, Turin [Umberto Allemandi] 1996, p. 12.)

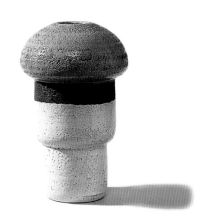

Fig. 124 (top)
Hanging lamp, 1957
Made by Arredoluce (Monza, Italy)
Painted metal
37 ⅜ x 20 ½ x 20 ½ in. (95 x 52 x 52 cm)
The Gallery Mourmans, Maastricht,
The Netherlands

Fig. 125 (bottom)
Vase from the *Ceramiche di lava*
(*Ceramics of Lava*) series, 1957
Made by Bitossi (Montelupo Fiorentino, Italy)
Unique
Glazed earthenware
11 ¾ x 7 ⅞ x 7 ⅞ in. (30 x 20 x 20 cm)
Collection Bischofberger, Zurich

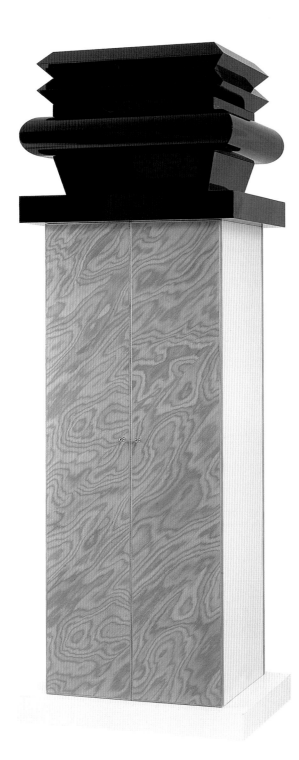

Fig. 126
La torre di Madras (*The Tower of Madras*)
wardrobe, 1990
Made by Renzo Brugola (Milan, Italy)
Edition of twenty-five
Wood, recomposed wood veneer, lacquer,
plastic laminate
98 ⅜ x 35 ½ x 27 ⅝ in. (250 x 90 x 70 cm)
Galerie Bruno Bischofberger, Zurich

Over the years Bitossi executed most of Sottsass's designs for ceramics, including his earliest pieces, the *Ceramiche di lava* (*Ceramics of Lava*) (fig. **125**) and *Ceramiche delle tenebre* (*Ceramics of Darkness*) series, and the *Menhir, Ziggurat, Stupas, Hydrants, and Gas Pumps* works. Bitossi was purchased by Flavia in 1976 and its various divisions are now known as Gruppo Bittosi.

Bottega d'Arte Ceramica Gatti di Dante Servadei

The painter and sculptor Riccardo Gatti opened this Faenza workshop in 1928, where he produced ceramics inspired by the Futurist movement. Upon his death, in 1972, his nephew and student Dante took over with his son Davide. They have since formed creative partnerships with a number of artists and designers, including Sottsass, whose designs they have executed.

Renzo Brugola

Brugola was an old friend of Sottsass's who had worked with him at Poltranova in the 1960s. The owner of a carpentry workshop, he asked Sottsass in 1980 to work with him to produce a new line of furniture. This proposal was an important impetus for the formation of Memphis. Brugola's shop was primarily responsible for producing the furniture for the Memphis collection. Brugola continued to make furniture for Sottsass's later projects, such as pieces for Sottsass's limited edition 1987 commissions for the Blum Helman Gallery in New York City and other subsequent designs (fig. **126**).

Franco Bucci

Born in Colbordolo in the north-coast province of Pesaro in 1933, Bucci has worked as an artist and designer since the 1950s. In 1958, Bucci executed enameled copper pieces for Sottsass, which were shown at the Il Sestante gallery. Sottsass included Bucci's creations in the Milan Triennale in 1960. Bucci went on to help establish in 1961 a center for ceramics and copper-enameled objects, called Laboratorio Pesaro, with a group of artists that included Nanni Valentini, who also produced ceramics for Sottsass. In 1968, Sottsass designed his *Ceramiche tantriche* (*Tantric Ceramics*) series, constructed by Laboratorio Pesaro, which was under Bucci's direction as of 1960. Bucci is still based in Pesaro, where his prizewinning work straddles design and craft and is always experimental in terms of techniques, aesthetics, and function. He is interested in reviving essential forms from popular traditions, and creating everyday objects that are not one of a kind, but rather produced in series.

Ceramiche d'Arte San Marco *see* Porcellane San Marco

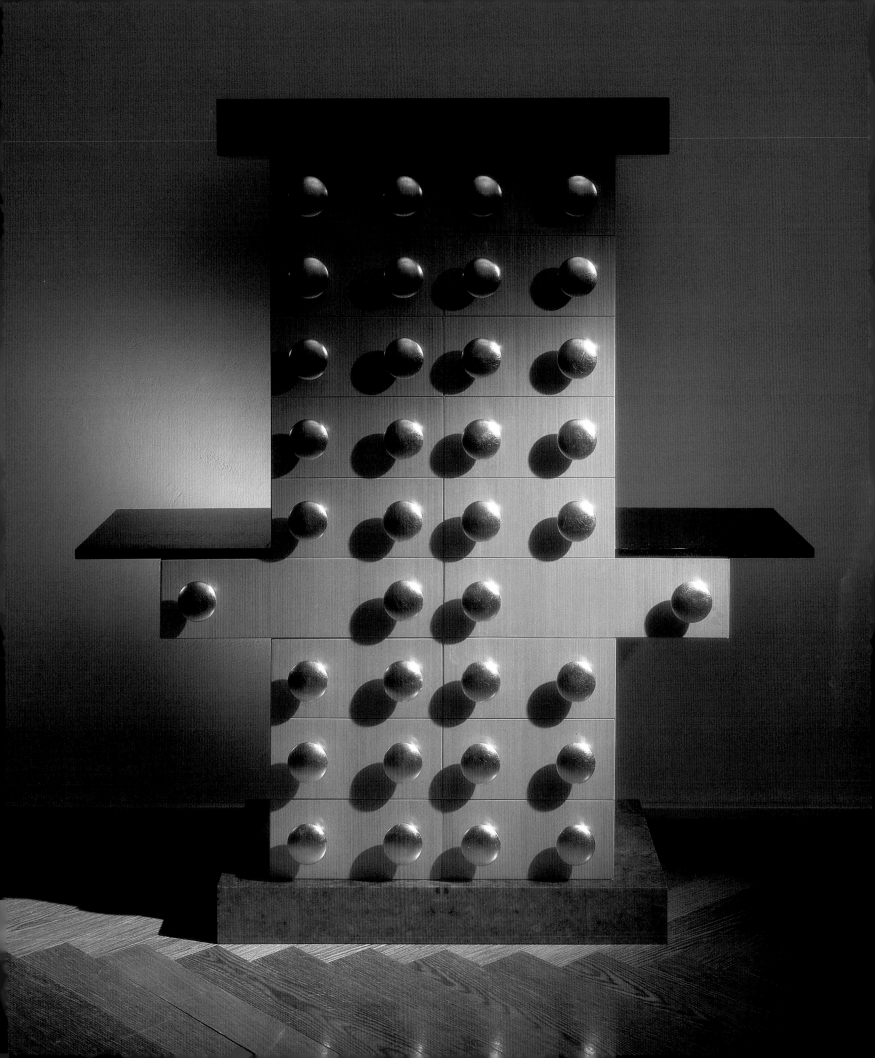

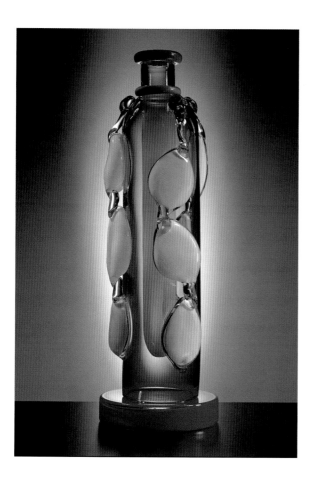

CIRVA

CIRVA (Centre International de Recherche sur le Verre et les Arts) was founded in Aix-en-Provence as an international research center for glass and art in 1982. It moved to Marseilles in 1987, and over the years its workshop has produced glass for distinguished artists in many countries, including Sottsass (fig. **128**).

Compagnia Vetraria Muranese *see* **Toso Vetri d'Arte**

Walter De Mario

Milan artisan Walter De Mario made Sottsass's jewelry designs in the 1960s. It is likely that Sottsass came into contact with De Mario through the Il Sestante gallery, as De Mario owned a shop near the gallery and had produced jewelry for other artists whose work was featured there, such as Arnaldo Pomodoro. De Mario was sought out for his specialized skills in working with coral and organic materials.

Design Centre

The Design Centre was a trademark of the furniture manufacturer Poltronova. It was started by Poltronova's founder, Sergio Cammilli, and directed by him, starting in 1967. With a gallery located in the heart of Milan, the Design Centre initially featured lighting, and, from 1969 to 1979, displayed and sold Sottsass's *Yantra di terracotta* (*Yantras of Terra-cotta*) earthenware series. In 1984, during a period of increasing international success for Italian design, it put several *Yantra* models back into production. In 1986, the Design Centre featured a collection of work by artists and architects who came together to design "useful sculpture," with Sottsass being one of the contributors.

Design Gallery Milano

The Design Gallery Milano was founded by Brunella and Mario Godani in 1980. The Godanis, who had a showroom in which they represented Poltronova, approached Sottsass to re-edition some of this early furniture around the time that Sottsass was leaving Studio Alchymia and developing Memphis (1980–81). Instead, he suggested they produce his new work and so they came to present the first Memphis collection, in 1981. The couple again worked with Sottsass in the late 1980s, when they produced and distributed more of his "new design" pieces at their gallery, including the *Mobile giallo* (*Yellow Furniture*) chest of drawers from the *Bharata* collection (fig. **127**). In 1992, Sottsass designed the *Rovine* (*Ruins*) collection for the Design Gallery, which included glass, furniture, and ceramics executed by the ceramics company Flavia.

Fig. 127 (opposite)
Mobile giallo (Yellow Furniture) chest
of drawers, from the *Bharata* collection, 1988
Made by Indian craftsmen
Wood, stained birch, ebonized ash, and burl
veneers, gold leaf
57 ½ x 52 x 18 ⅛ in. (146 x 132 x 46 cm)
The Gallery Mourmans, Maastricht,
The Netherlands

Fig. 128 (above)
Lingam, 1998
Made by CIRVA (Marseilles, France)
Edition of three
Glass
36 ¼ x 9 ⅞ x 9 ⅞ in. (92 x 25 x 25 cm)
The Gallery Mourmans, Maastricht,
The Netherlands

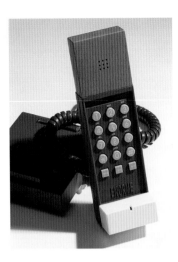

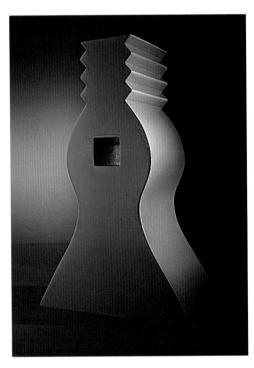

Fig. 129 (top)
Telephone, 1986
Designed in collaboration with Marco Zanini,
Marco Susani, Richard Eisermann, and Larry Larsky;
engineered by David Kelley Design (Palo Alto,
California)
Made by Enorme Corporation, USA
Plastic, rubber
Handset: 7⅝ x 2⅛ x 1⅞ in. (19.4 x 5.4 x 4.8 cm);
cradle: 1¼ x 4⅜ x 4 in. (3.2 x 11.1 x 10.2 cm)
Private collection

Fig. 130 (bottom)
Voglio dire (*That Is to Say*) vase, from the *Rovine*
(*Ruins*) collection, 1992
Made by Flavia (Montelupo Fiorentino, Italy)
Edition of nine
Glazed earthenware
17⅜ x 17 x 6¼ in. (44.1 x 43.2 x 15.9 cm)
The Gallery Mourmans, Maastricht, The Netherlands

Enorme Corporation

Enorme was a very small firm founded by Sottsass Associati in the early 1980s with outside partners and collaborating designers. The goal of the company was to design, produce, and distribute high-tech electronic household and office products. The team of designers, including Marco Zanini, Marco Susani, and outside partners Richard Eisermann and Larry Larsky, worked with engineers at David Kelley Design in California's Silicon Valley to create a telephone (fig. **129**), a radio, a television, and a calculator.

Flavia

Like Bitossi, the Montelupo Fiorentino ceramics factory Flavia was established with the goal of radically transforming the nature of factory production by melding traditional artisan work with industrial design. Flavia purchased Bitossi in 1976 and several years later redistributed and reissued the early Bitossi pieces for Il Sestante gallery in Milan. Flavia also produced some of the Memphis ceramics, and made the ten vases in the *Ruins* collection for the Design Gallery Milano in 1992 (fig. **130**).

The Gallery Mourmans

Since the early 1990s, Sottsass's work has regularly been displayed at The Gallery Mourmans in Maastricht, The Netherlands, and Knokke-Zoute, Belgium. The gallery itself generally oversees production of the Sottsass objects it sells (figs. **132**, **137**). In addition, gallery director Ernest Mourmans's own home in Lanaken, Belgium, which includes an elaborate aviary for an extensive bird sanctuary, was designed by Sottsass Associati under the supervision of Sottsass and Johanna Grawunder from 1996 to 2001.

Kartell

Kartell was founded near Milan in 1949 by the chemical engineer Giulio Castelli, with the intention of using plastic materials and new construction technologies to make progressive furniture that would be functional and attractive, durable and affordable. By employing plastics to this end, Castelli and the designer Gino Columbini wanted both to challenge conventions and to inspire society. Initially focusing on small housewares made in bright colors, Kartell developed its first plastic chairs in the early 1960s (after plastics were developed that were sturdy enough to be used as material for furniture). Plastics had been stigmatized as cheap and inferior, but Kartell changed those perceptions by working with such top designers as Sottsass. One of the most significant projects that Kartell produced for Sottsass was the container furniture system that he showed at the exhibition *Italy: The New Domestic Landscape*, held at the Museum of Modern Art, New York, in 1972. Kartell also manufactured avant-garde prototypes for Gae Aulenti and Marco Zanuso for the exhibition.

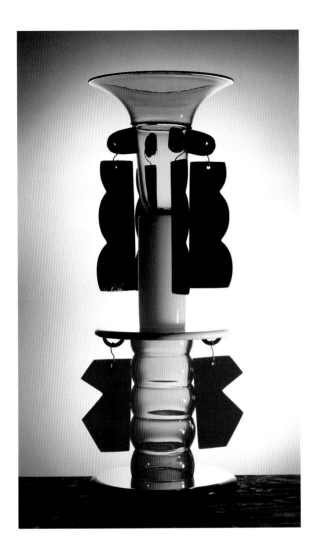

Sottsass's environmental containers were made with the support of the manufacturers Boffi and Ideal-Standard, and the assistance of Tecno.

Laboratorio Pesaro

The Laboratorio Pesaro was founded in Pesaro in 1961 by a group of artists including Nanni Valentini and Franco Bucci, who took over the artistic and technical direction in 1966. Still producing fine stoneware outside of Pesaro in Montelabbate, they work with international designers to produce commonly used objects that are rooted in tradition yet ahead of their time in form and function.

Memphis

The Memphis group was initiated over the course of several nights in December 1980 when Sottsass invited several young Milanese designers, including Michele De Lucchi, Marco Zanini, Aldo Cibic, and Matteo Thun and writer Barbara Radice to his home to discuss several proposals he had been offered by the carpentry shop owner Renzo Brugola and Design Gallery Milano owners Mario and Brunella Godani. As they listened to Bob Dylan's *Memphis Blues Again*, they fleshed out their ideas for a company that would soon be backed and distributed by Brugola, Mario Godani, investor Fausto Celati, and Ernesto Gismondi, president of Artemide. Gismondi soon became the main sponsor of Memphis, and its president. With Studio Alchymia as a precedent, the loose association of Memphis designers wished to create and promote new ways of living and designing environments by communicating through objects, blurring the lines between popular culture and high art, and treating furniture as the sculpture of everyday life. Unlike Studio Alchymia, however, Memphis was set out as a commercial venture, and it succeeded as such. In September 1981, Memphis held its first exhibition, featuring fifty-five pieces (furniture, clocks, lamps, and ceramics). The exhibition attracted much publicity, and was attended by more than two thousand people.

The group's use of an unconventional mixture of materials, vivid colors, and irregular forms broke from convention and had a profound, liberating effect on definitions of "good taste" (fig. **131**). Design shifted to emphasize bold color, surface decoration, multifunctionality, and symbolism. Memphis went on to become a loose association of designers from all over the world, including Michael Graves, George Sowden, Daniel Weil, Shiro Kuramata, and Peter Shire, who showed a new collection of work each year. The extremely popular and fashionable Memphis style came to define the essence of the decade, and by the mid-1980s Memphis was being imitated all over the world. Sottsass announced he was leaving Memphis in 1985, but the other designers who remained involved continued to create influential products. Nonetheless, it dissolved as a group in 1988.

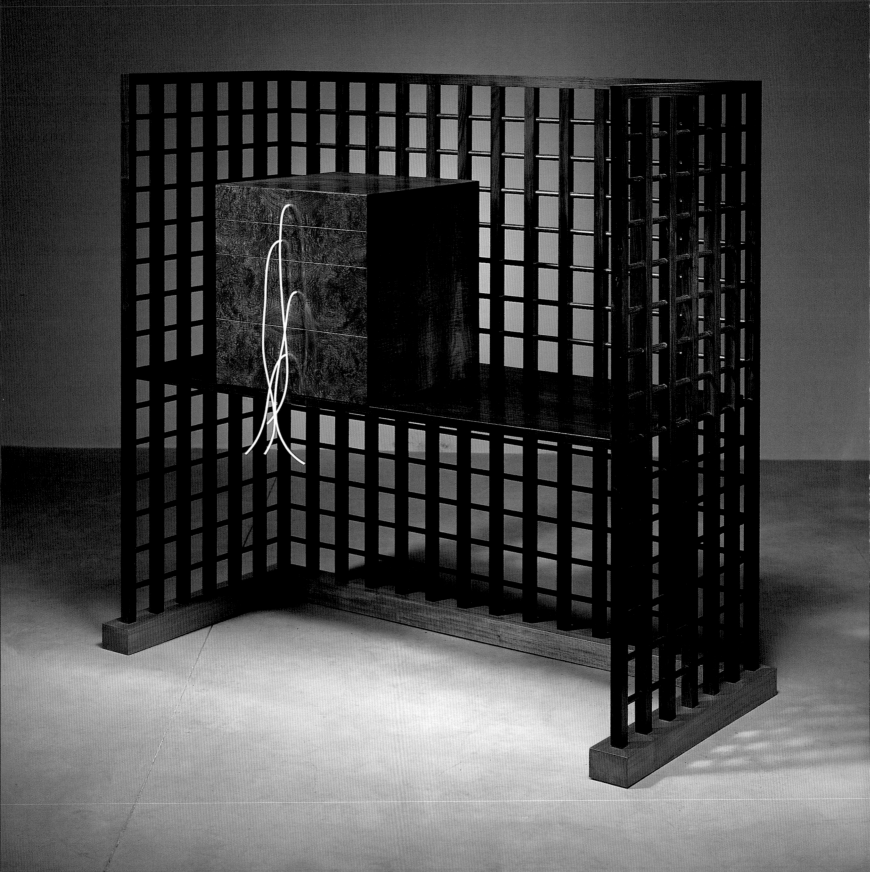

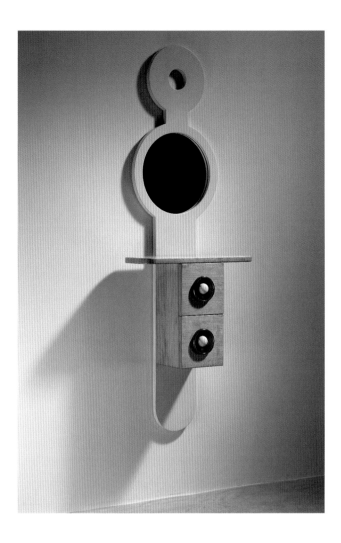

Olivetti

Sottsass has designed more projects for Olivetti than for any other company over the course of his career. Olivetti was a constant force in twentieth-century design, making office machines and furniture that balanced functionalism and elegance, and helping to create the notion of a unified corporate cultural identity. The Olivetti Typewriter Company was established by manufacturing pioneer Camillo Olivetti in 1908 in Ivrea (near Turin), modeled after companies that Olivetti had seen in the United States. The company's first typewriter, presented at the Turin International Exhibition in 1911, was based on the simple, clean lines of American models. The company's corporate identity was developed by Camillo's son Adriano, who reorganized the factory in the 1930s and led the modernization of the company and its graphic identity, and eventually brought in such leading designers as Sottsass.

With the industrial boom of the post–World War II years, Olivetti became a household name. Sottsass started working for Olivetti's electronics division as a design consultant in 1957 after he returned from his stint in designer George Nelson's studio in New York City. Sottsass's debut project for Olivetti was the first Italian data processing device, the renowned *Elea 9003* mainframe computer, which was manufactured in 1959 and conceived as a user-friendly control room. Although Olivetti offered him a full-time job, Sottsass preferred to continue on a freelance basis, giving him more freedom to focus on design rather than the operations of the company. Sottsass's work for Olivetti became a model for Italian industrial design, proving that design was not simply a function of commerce but rather a way to create a new role for industry in society.

Many projects followed the *Elea* after Adriano's son Roberto took over in 1960, such as the *Praxis 48* office typewriter designed in collaboration with Hans von Klier and produced in 1964, and the iconic *Valentine* typewriter, which Sottsass designed in 1969 with Perry A. King. The company has weathered several economic crises from the 1970s to the present, but it is now operating with international subsidiaries.

Poltronova

In 1957, Sergio Cammilli founded Poltronova in the Tuscan countryside between Agliana and Montale, a location where there was very little industry. Cammilli, who had an art background, wanted to utilize the traditional industrial production process to design household objects, but with a new approach. After seeing Sottsass's work for nearby

Fig. 132 (opposite)
Desk, 2003
Made by The Gallery Mourmans
(Maastricht, The Netherlands)
Edition of six
Indian palissander
59 x 64 ⅝ x 29 ⅞ in. (150 x 164 x 76 cm)
The Gallery Mourmans, Maastricht,
The Netherlands

Fig. 133 (above)
Mirror, 1963
Made by Poltronova (Agliana, Italy)
Painted wood, wood veneer, silver-coated glass,
anodized aluminum
74 ⅜ x 25 ⅜ x 10 ⅞ in. (189 x 64.5 x 27.5 cm)
The Gallery Mourmans, Maastricht,
The Netherlands

Fig. 134 (top)
Euphrates vase prototype, 1983
Made by Ceramiche d'Arte San Marco (Nove, Italy)
for Memphis (Milan, Italy)
Porcelain
17⅜ x 8⅝ x 8⅝ in. (44 x 22 x 22 cm)
The Gallery Mourmans, Maastricht, The Netherlands

Fig. 135 (bottom)
Tigris vase, 1983–85
Made by Ceramiche d'Arte San Marco (Nove, Italy)
for Memphis (Milan, Italy)
Porcelain
15⅜ x 7½ x 7½ in. (39 x 19 x 19 cm)
The Gallery Mourmans, Maastricht, The Netherlands

Tuscan ceramics workshop Bitossi, Cammilli approached the designer and began collaborating with him. It was at this time that Poltronova truly began to flourish. Cammilli and Sottsass became great friends, traveling through Tuscany and discussing the ideas that would result in the Poltronova concept. Both wanted to escape the straitjacket of Rationalism and explore innovative uses of color, material, and decoration.

Sottsass initially traveled back and forth between Milan and Tuscany, acting as art director. Then, in 1958, he made his first simple furniture designs for the company. By 1965 he was designing avant-garde desks and other Pop art-inspired furniture for them (fig.**133**). Poltronova produced Sottsass's *Superbox* laminate-covered wardrobes, starting in 1968, and the *I mobili grigi* (*The Gray Furniture*) prototypes were made in 1970. Almost all of Sottsass's domestic furniture was made exclusively by Poltronova until the early 1970s, and his ceramics were marketed by the company in the 1960s. Other leaders of the "radical design" movement followed Sottsass and worked for the company in the late 1960s and 1970s, and Poltronova became a center for creative innovation. Poltronova manufactured eleven objects by Sottsass and other designers included in the groundbreaking show *Italy: The New Domestic Landscape* held at the Museum of Modern Art, New York in 1972. Over the years, Sottsass has completed more than sixty projects for Poltronova, and he still works for them today.

Porcellane San Marco
(now Ceramiche d'Arte San Marco)

San Marco produced Sottsass's first designs for porcelain, which he made for Memphis from 1983 onward (figs. **134**, **135**). San Marco was founded by Giuseppe Dal Prà in the late 1800s as Ceramiche Dal Prà. After World War II, the company split into two separate divisions, for porcelain and ceramics. Giuseppe's two granddaughters each took over one operation and changed both names to "San Marco." The porcelain shop closed in 1997 but Ceramiche d'Arte San Marco is presently run by the same family, who have maintained the highest level of workmanship. Their shop is located in Nove, Bassano, an area in the Veneto that is historically known as a center for ceramics production. San Marco also put some of Sottsass's earlier *Indian Memory* pieces back into production with different colorations in the 1980s.

Rinnovel

In 1954, the New York housewares manufacturer Raymor asked Sottsass to design a series of aluminum vases, which were manufactured by Rinnovel in Italy. Based in Milan, the company produced Sottsass's highly sculptural yet functional pieces, and helped establish his reputation.

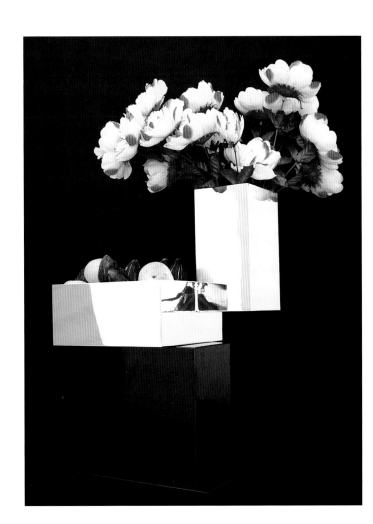

Rossi & Arcandi

In 1959, partners Romano Rossi and Severino Arcandi founded a silver company in Monticello Conte Otto, Vicenza. They wanted to make exclusive handmade objects using the traditional techniques of Venetian and other Italian silversmiths. They employed a team of highly skilled craftsmen, who helped them build their reputation. In the mid-1970s, designer, entrepreneur, and Sottsass collaborator Cleto Munari approached them to make his silverware, and from then on Rossi & Arcandi became renowned for its superbly crafted, custom-designed silver. The firm was a logical choice for Sottsass when, in 1982, he started producing designs in silver for Memphis, and he continued to work with the company for many years (fig. **136**).

Alessio Sarri

Based in Sesto Fiorentino, Tuscany, the ceramics maker Alessio Sarri has produced several of Sottsass's designs, including the *Indian Memory* series, which he designed in 1972. Some of these pieces were later produced with different colorations by Ceramiche d'Arte San Marco in Nove (Bassano), and have been distributed by Anthologie Quartett since 1987. A few years after the *Indian Memory* series, Sarri also executed some of the Memphis ceramics. He has also produced other pieces by Sottsass in more recent years.

Il Sestante

In November and December 1958, one of Sottsass's first series of Bitossi-produced ceramics was shown at the Il Sestante gallery in Milan, which had just been established by Marisa Scarzella with Lina Matteucci in October that year. The goal of the gallery was to encourage artists and designers to create new kinds of functional objects that would incorporate artisan production. In 1959, the gallery published a catalogue of Sottsass's ceramics that had been made in Montelupo since 1955. Il Sestante put several designs back into production, and continued to make them for a number of years. From 1958 to 1969 Sottsass had an exclusive relationship with the gallery for his ceramics, and it played a critical role in promoting his work until it closed in 1985.

Sèvres (Manufacture Nationale de Sèvres)

In 1994, the Centre Georges Pompidou in Paris presented a collection of fourteen porcelain vases designed by Sottsass for Sèvres, the national porcelain factory of France. Some of these designs had been created in August 1990, while Sottsass was staying on the Aeolian island of Filicudi. The factory, which was originally located in Vincennes near Versailles, was founded in about 1740 and later moved to Sèvres. It first made soft-paste porcelain and later also made hard-paste porcelain. In 1759, King

Fig. 136
Lugalzagesi vase, 2002
Made by Rossi & Arcandi
(Monticello Conte Otto, Italy)
Edition of eight
Sterling silver
14 ½ x 15 x 11 ¼ in. (36.9 x 38 x 28.5 cm)
Galerie Bruno Bischofberger, Zurich

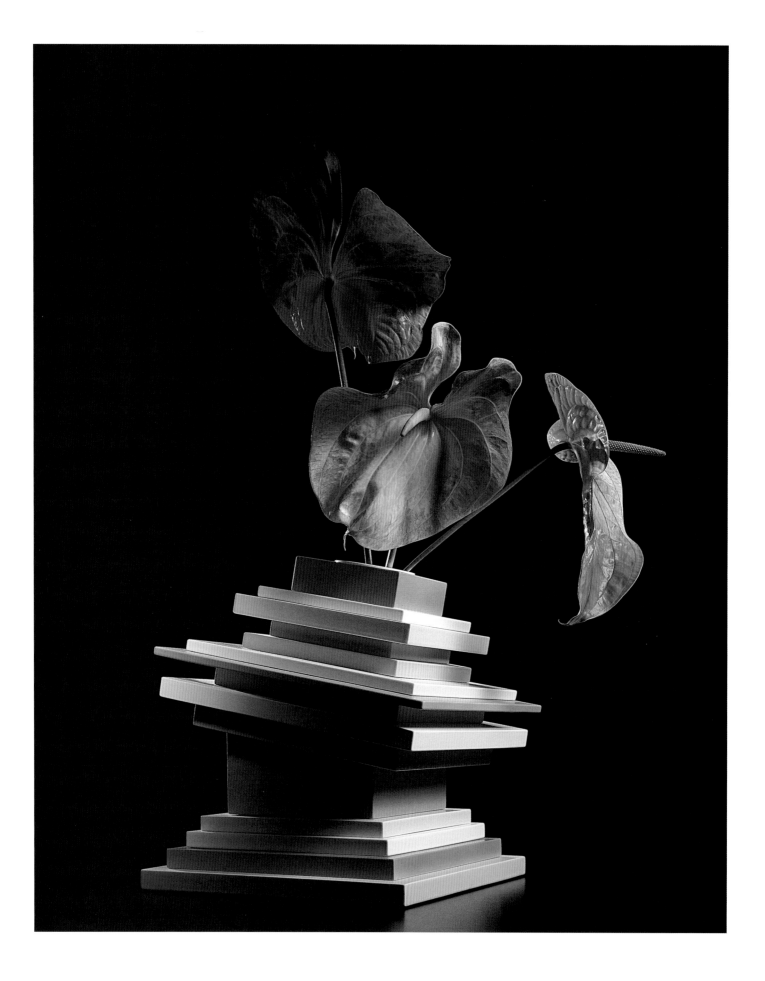

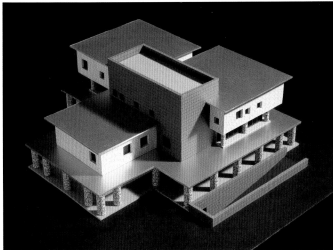

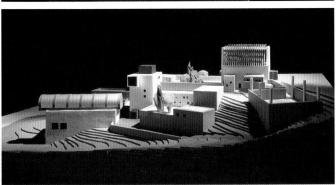

Louis XV's court took it over and began producing cookware and tableware for the royal household. Through the eighteenth and nineteenth centuries, Sèvres became known for its exceptionally fine ceramics. With a reputation for making traditional patterns and forms, the company started seeking out contemporary designers in the 1960s, and established a design lab in the 1980s to make more experimental projects, such as Sottsass's designs.

Sottsass Associati

On leaving Studio Alchymia in 1980, and shortly before forming Memphis, Sottsass created the design consultancy Sottsass Associati with four eager young partners, Aldo Cibic, Marco Zanini (now managing director), Marco Marabelli, and Matteo Thun. None of them had any money and, according to Zanini, they financed themselves with their first earnings. The firm sought to take on projects that were on a larger scale and more widely distributed than those attempted by Alchymia, but ones that were equally experimental. They focused on industrial, graphic, and interior design, including high-profile commissions to work on Fiorucci and Esprit shops in several European cities, Brionvega televisions, furniture for Knoll, and Milan's Malpensa airport. With the participation of architects Johanna Grawunder, Mike Ryan, and Zanini, who are all partners, Sottsass Associati has also taken on numerous residential architectural commissions and urban planning projects (figs. 138, 139). Today, there are about twenty-five young designers from across the world working in the office.

Studio Alchymia

With its goal to break from tradition and create a new, modern Italian design, Alchymia originally started in 1976 as architect Alessandro Guerriero's studio and gallery in Milan. Guerriero met the designer Alessandro Mendini in 1978, who introduced him to Sottsass and the architect Andrea Branzi. Together with some additional contributors, they came to form Studio Alchymia, with the aim of asserting an experimental form of new design. The radical Studio Alchymia artists challenged the strict, austere Bauhaus principles that dominated modern design internationally. Alchymia presented its first collection in 1979, which was ironically entitled *Bau.Haus*.

Studio Alchymia was known for its unconventional, satirical use of different design languages and kitsch references, and for questioning doctrines of good taste and form. These designers freed themselves from the restraints of industrial design with new concepts for color, form, and surface pattern. They used vernacular, simple materials juxtaposed with high-end, luxury elements in the prototypes they generated. As a workshop they put their own designs into production, but they never became a commercial enterprise.

Fig. 137 (opposite)
Vase from the *Geology* series, 2000
Made by Alessio Sarri (Faenza, Italy)
Edition of twelve
Glazed earthenware
15 ¾ x 16 ⅛ x 15 in. (40 x 41 x 38 cm)
The Gallery Mourmans, Maastricht,
The Netherlands

Fig. 138 (top)
Small multipurpose building, Faenza, Italy, 2003–04
Architects: Sottsass Associati (Milan, Italy); Ettore
Sottsass and Marco Palmieri, principals-in-charge

Fig. 139 (bottom)
Recreational Center, Nanjing, China, 2003–04
Architects: Sottsass Associati (Milan, Italy); Ettore
Sottsass and Marco Palmieri, principals-in-charge

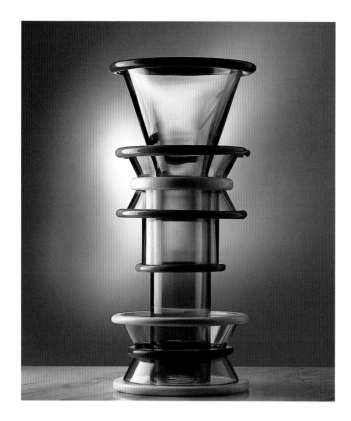

Fig. 140 (above)
Sempre meno capisco (*Less and Less I Understand*) vase, from the *Rovine* (*Ruins*) collection, 1992
Made by Compagnia Vetraria Muranese (Murano, Italy)
Edition of seven
Glass
23 ⅝ x 11 x 11 in. (60 x 28 x 28 cm)
The Gallery Mourmans, Maastricht, The Netherlands

Fig. 141 (opposite top)
5 Betili vase, 1994
Made by Venini (Murano, Italy)
Edition of seven
Glass
19 ¾ x 16 ½ x 16 ½ in. (50 x 42 x 42 cm)
Galerie Bruno Bischofberger, Zurich

Fig. 142 (opposite middle)
Buco nero (*Black Hole*) vase, 1994
Made by Venini (Murano, Italy)
Edition of seven
Glass
18 ½ x 14 ⅛ x 14 ⅛ in. (47 x 36 x 36 cm)
Galerie Bruno Bischofberger, Zurich

Fig. 143 (opposite bottom)
Veniera covered container, 1974
Made by Vistosi (Murano, Italy)
Edition of two hundred fifty
Glass
10 ¼ x 7 ⅞ x 7 ⅞ in. (26 x 20 x 20 cm)
The Gallery Mourmans, Maastricht, The Netherlands

Sottsass left in 1980, and Alessandro Mendini emerged as the leading theorist and spokesperson for the group. Studio Alchymia had dissolved by 1990. Despite its brief existence, the group was important as a precursor to the more commercial Memphis and as a catalyst for many of the design developments of the late twentieth century.

Toso Vetri d'Arte

The Toso family has been involved in various Murano glassmaking endeavors since the nineteenth century. Established by Luigi ("Gigi") Toso in 1980, Toso Vetri d'Arte executed the first and second Memphis glass collections, comprising vases in unusual shapes and vivid colors. Toso probably met Sottsass through his work for the firm Studio Ars Labor Industrie Riunite (SALIR), which Gigi co-directed after his father, a co-founder, retired in 1976. In an introduction written in 1998, Sottsass described Gigi Toso as "a good-natured and patient man" (Marino Barovier, Bruno Bischofberger, and Milco Carboni [eds.], *Sottsass: Glass Works*, Dublin [Links for Publishing] 1998, p. 11)— qualities that were no doubt much needed considering that Sottsass wanted to make his glass designs with glue, a technique that went against time-honored Muranese tradition. In 1990, Toso Vetri d'Arte was bought out by Andrea Boscaro, the owner of Venice's leading furnishings and glass retail establishment, Pauly & C.–CVM (Compagnia Venezia Murano), and reinstated as Compagnia Vetraria Muranese. In 1992, Compagnia Vetraria Muranese made the glass designs for Sottsass's *Ruins* collection for the Design Gallery Milano (fig.**140**).

Nanni Valentini

The ceramic artist and painter Giovanni Battista Valentini, known as Nanni, was one of the artists who executed the *Tantric* series, together with Franco Bucci, at Laboratorio Pesaro. A close friend of Sottsass's since 1957, he was entrusted with making pieces without the designer's personal supervision (unlike most of Sottsass's other ceramic lines). Valentini was born in Sant'Angelo in Vado, Pesaro in 1932. He studied art and ceramics at several Italian schools and academies, including the School of Art in Pesaro. Like Sottsass he was always interested in the dichotomy between fine and applied art, and the balance between the visible and the tactile. He collaborated with artists in Pesaro in the early 1950s and helped develop the artists' collective Laboratorio Pesaro when he moved there in 1962. His work has been shown in many important international exhibitions, and has continued to be influential since his death in 1985.

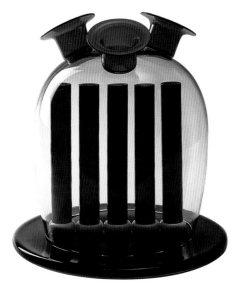

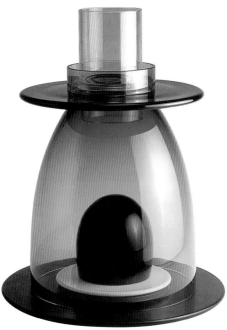

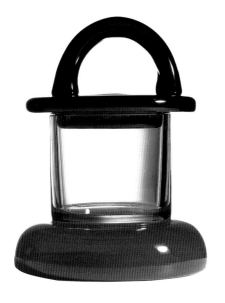

Venini

Known for its traditional yet inventive glass designs, Cappellin-Venini & C., as it was originally known, was established in Murano in 1921 by a Milan lawyer, Paolo Venini, and a Venetian antiques dealer from a family of glassblowers, Giacomo Cappellin. The first artistic director was painter Vittorio Zecchin, who worked with some of the finest Murano glassmakers, including Giovanni Seguso, on Renaissance-inspired designs. In 1925, Venini took sole control and Vetri Soffiati Muranesi Venini & Co was established under the art direction of sculptor Napoleone Martinuzzi. Martinuzzi introduced imaginative, cutting-edge colors and designs that developed the stylistic identity of the company. Paolo Venini became increasingly involved in the art direction, working with such leading designers as architect Carlo Scarpa, who contributed to the company until around 1947. When Venini died, in 1959, his widow and his son-in-law, who was an architect, took over and continued his legacy.

Sottsass started collaborating with the Venini workshop in 1988. The company was compatible with Sottsass because it shared his passion for color, and its glassblowers were open to using old-world methods in the production of modern forms. Venini is constantly researching new color formulas, and produces custom pieces for a number of designers. Venini made Sottsass's glass designs for the Galerie Bruno Bischofberger and The Gallery Mourmans. No longer family-owned since 1986, Venini now belongs to the Italian Luxury Industries group (figs. **141**, **142**).

Vistosi

Luciano Vistosi was the first Murano glassblower that Sottsass worked with, in the 1970s. While the Vistosi company was established in Murano in 1945, by Guglielmo Vistosi, the Vistosi family had been involved in glassmaking since the 1600s. Guglielmo died in 1952 and his brother Oreste took over as business manager. Soon, Luciano and Gino Vistosi, Oreste's sons, began to oversee the glass production. The company grew in the 1950s and Vistosi produced glass with numerous influential designers, including Sottsass, in the 1960s and 1970s. Some of the first glass pieces Sottsass designed—which were executed in 1974, and distributed by Artemide—were influenced by his experiences with ceramics in Tuscany. The Vistosi glass creations were initially statements about returning to the origins of language and simple, primitive signs (fig. **143**). Following Oreste's departure in 1977, and Gino's in 1980, Luciano sold shares of the company to outside partners, one of them being Artemide. After further difficult decisions, Luciano left in 1984 and since then Vistosi has passed through many hands. It is currently owned by Vetrofond.

Chronology

Compiled by Ronald T. Labaco

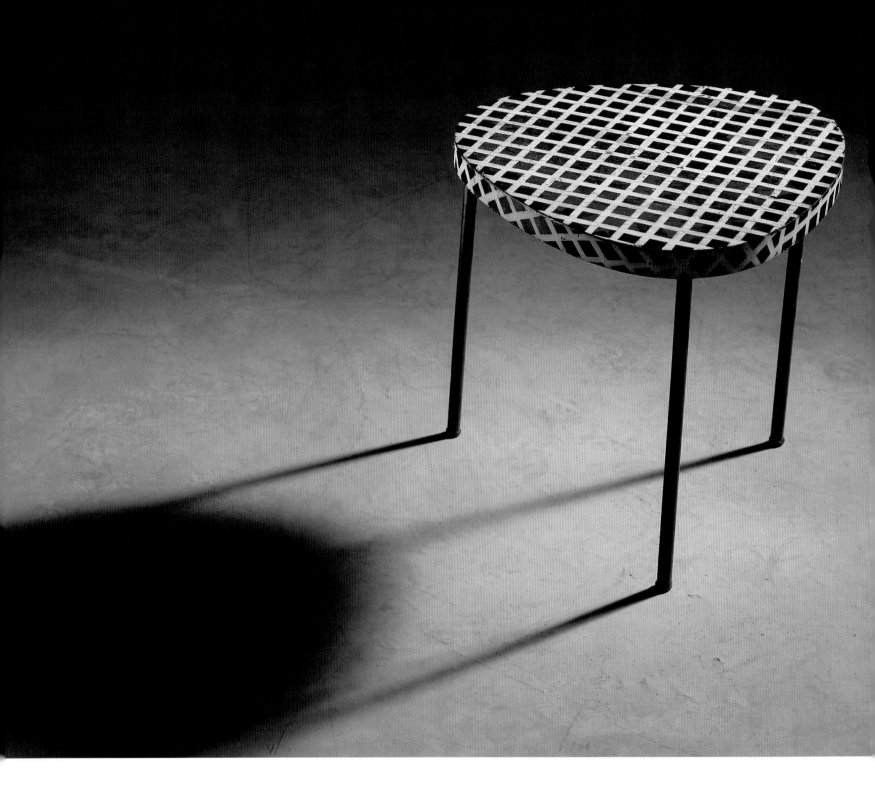

Fig. 144
Side table, 1947
This example made for the House of Dr. Gaita
(Turin, Italy), 1953
Maker unknown
Limited production
Veneered wood, steel, paint, lacquer
17 ½ x 18 ⅛ x 18 ⅛ in. (44.5 x 46 x 46 cm)
The Gallery Mourmans, Maastricht,
The Netherlands

1917
Born on September 14, to Italian architect Ettore Sottsass and Antonia Peintner, in Innsbruck, Austria.

1934
Begins study of architecture at Turin Polytechnic.
Experiments with painting; continues to paint until about 1965.

1936
Visits Paris for a firsthand experience of modern art.

1939
Graduates from Turin Polytechnic.

1939–45
Military service in Montenegro and then internment as a prisoner of war in Sarajevo, Yugoslavia.

1945
Works with Giuseppe Pagano architects, Turin (until 1946).
Collaborates with his father on several architectural projects.

1946
Co-organizes, with Bruno Munari, the first international exhibition of abstract art in Milan.
Begins contributing articles to *Domus* magazine.
Curates craft section for the 1947 Milan Triennale.

1947
Opens own architectural practice, The Studio in Milan.

1948
Receives government-subsidized INA (Instituto Nazionale delle Assicurazione) housing-project commissions; some designs are built between 1951 and 1955, including work in Carmagnola, Meina, and Gozzano.
One-person show in Lugano, Switzerland.

1949
Marries Fernanda Pivano, Italian writer and expert on American literature. They divorce in 1976.

1954
Designs for Raymor, an American retailer and distributor of modern housewares.

1955
First ceramic designs are produced by Bitossi through Raymor. The following year Sottsass begins a close collaborative relationship with Aldo Londi, Bitossi's art director, that results in several important series of ceramics.

1956
Travels to New York, where he works in designer George Nelson's studio for one month.

1957–58
Returns to Milan and assumes position of art director to the furniture company Poltronova, continuing until 1974.
Introduction of *Ceramiche di lava* (*Ceramics of Lava*) by Bitossi, and a series of table and hanging lamps by Arredoluce.
Begins working for Olivetti as consultant designer for the newly created electronic division under Roberto Olivetti (director) and Mario Tchou (engineer); continues until the early 1970s.
Designs the housing for the *Elea 9003* mainframe computer for Olivetti (1957–58). It wins the 1959 Compasso d'Oro award for outstanding Italian industrial design.
Begins designing residential interiors in Milan and elsewhere in Italy.

1959
First of several *Ceramiche di serie* (*Ceramics in Series*) exhibitions at Il Sestante gallery, Milan.

Fig. 145 (top)
Vase from the *Ceramiche di lava*
(*Ceramics of Lava*) series, 1957
Made by Bitossi (Montelupo Fiorentino, Italy)
Unique
Glazed earthenware
12 ⅝ x 6 ¼ x 6 ¼ in. (32 x 16 x 16 cm)
Collection Bischofberger, Zurich

Fig. 146 (bottom)
Ettore Sottsass
c. 1962

1961

Travels to India, Ceylon, Nepal, and
Burma on a three-month tour with
Fernanda Pivano.
Returns to Milan and is diagnosed
with nephritis.

1962

Seeks medical treatment in the United
States, in Palo Alto, California.
After discharge from hospital, travels
with Fernanda Pivano to San Francisco
and meets the "beat" generation poets,
including Allen Ginsberg, Lawrence
Ferlinghetti, Michael McClure, Philip
Whalen, and others, whose work Pivano
has been translating into Italian.

1963

Ceramiche delle tenebre (*Ceramics of
Darkness*) exhibited at Il Sestante
gallery, Milan.
Sottsass and Pivano found the publishing
house East 128, mostly producing books
of poetry.

1964

Offerte a Shiva (*Offerings to Shiva*)
ceramics exhibited at L'Aquilone,
Florence.
Introduction of the *Teckne 3* and *Praxis 48*
electric typewriters, both designed
in collaboration with Hans von Klier,
by Olivetti.

1965

Designs small-scale models for wardrobe
units covered in plastic laminate
(subsequently called *Superboxes*),
later executed in full scale by Poltronova
in 1968.
Designs large-scale ceramic "totems"
(1965–66), shown at the 1967 exhibition
*Menhir, Ziggurat, Stupas, Hydrants and
Gas Pumps* at Galleria Sperone, Milan.

1967

Founds the magazine *Pianeta Fresco* with
Fernanda Pivano and Allen Ginsberg;
the second and final issue is published
in 1968.
Meets the members of Archizoom.

1968

Ceramiche tantriche (*Tantric Ceramics*)
exhibited at Galleria La Nuova Loggia,
Bologna.

1969

One-person exhibition entitled *Miljö för en
ny planet* (*Landscape for a Fresh Planet*),
at the Nationalmuseum Stockholm,
includes monumental ceramic
"environments."
Yantra di terracotta (*Yantras of terra-cotta*)
exhibited at Design Centre gallery,
Milan.

1970

Meets artist Eulalia Grau, who becomes
his companion for the next six years.
The innovative *I mobili grigi* (*The Gray
Furniture*) collection of molded
fiberglass introduced by Poltronova.
Valentine portable typewriter (1969),
designed in collaboration with
Perry A. King, and *Summa 19* electric
calculator (1970) both awarded the
Compasso d'Oro.

1971

Contributes politically provocative
collages and drawings to the Italian
magazine *In*.

Fig. 147
Ring, 1964
Made by Walter De Mario (Milan, Italy)
Unique
Gold
Musée National d'Art Moderne,
Centre Georges Pompidou, Paris

Fig. 148
Chairs, table, and corner cabinets from
I mobili grigi (*The Gray Furniture*) collection, 1970
Made by Poltronova (Agliana, Italy)
Limited production
Painted fiberglass, electric light fixtures

1972

Begins designing tableware for Alessi (later also designs for its subsidiary companies Tendentse and Twergi).

Creates a series of lithographs entitled *Il pianeta come festival* (*The Planet as Festival*) that lightheartedly envisions the architecture of the future.

Innovative "container" furniture system/environment exhibited at the landmark exhibition *Italy: The New Domestic Landscape*, at The Museum of Modern Art, New York.

Designs glass vases for Vistosi (executed 1974) and *Indian Memory* series of ceramics (executed 1987).

1973

Co-founder of the Global Tools group, formed by over thirty advocates of "radical architecture." The group officially dissolves in 1975.

1976

Exhibition of photography series *Design for the Rights of Man* (1973–76), *Design for the Destinies of Man* (1972–76), and *Design for the Necessities of Animals* (1973–74) at the Cooper-Hewitt Museum, New York.

Meets Italian writer Barbara Radice, who becomes his life companion.

Retrospective exhibition organized by the Internationales Design-Zentrum Berlin; exhibition travels to Paris, Barcelona, Jerusalem, and Sydney.

1977

Designs furniture and lamps in collaboration with Andrea Branzi for Croff Casa.

1979

Joins Studio Alchymia design group (founded 1976), where his designs are included in the *Bau.Haus 1* (1979) and *Bau.Haus 2* (1980) collections. He withdraws from the group in 1980.

1980

Founds Sottsass Associati in collaboration with Marco Zanini, Aldo Cibic, Marco Marabelli, and Matteo Thun.

1981

Founds groundbreaking Memphis design group; first show opens in September with great fanfare.

1983–87

Architecture, interior design, and corporate identity for Esprit, including stores in Zurich, Berlin, and Vienna, under the auspices of Sottsass Associati.

1985

Formally withdraws from Memphis.

Fig. 149 (opposite)
***Sherazade* jug, 2001**
Made by Alessi (Crusinallo, Italy)
Vacuum glass, steel, ABS plastic
8 ½ x 8 x 5 ½ in. (21.6 x 20.3 x 14 cm)
LACMA, gift of Alessi

Fig. 150 (top left)
***Il bar Alessi* barware, 1979**
Made by Alessi (Crusinallo, Italy)
Stainless steel, glass
Shaker: 12 ½ x 3 ⅝ x 3 ⅝ in. (31.8 x 9.2 x 9.2 cm); bar strainer: 7 ½ x 3 ⅝ in. (19 x 9.2 cm); stirrer: 10 ¼ in. (26 cm)
LACMA, gift of Alessi

Fig. 151 (bottom left)
Factotum bookcase, 1980
Made by Studio Alchymia (Milan, Italy)
Wood, plastic laminate

Fig. 152 (top)
Beverly sideboard, 1981
Made by Memphis (Milan, Italy)
Wood, plastic laminate, wood veneer,
chromed metal, electric light fixture

Fig. 153 (middle)
Nanon House, Lanaken, Belgium, 1995–98
Architects: Sottsass Associati (Milan, Italy);
Ettore Sottsass and Johanna Grawunder, principals-
in-charge; Oliver Layseca, project architect

Fig. 154
Untitled, 2003 (bottom)
Made by Bottega d'Arte Ceramiche Gatti
di Dante Servadei (Faenza, Italy)
Edition of three
Ceramic, acrylic paint
2 x 13 ⅜ x 13 in. (5 x 34 x 33 cm)
The Gallery Mourmans, Maastricht,
The Netherlands

Fig. 155 (opposite)
Cabinet No. 50, 2003
Made by The Gallery Mourmans
(Maastricht, The Netherlands)
Edition of six
Wood, natural and stained ice birch veneers
66 ⅛ x 65 ¼ x 23 ½ in. (168 x 165.7 x 59.7 cm)
The Gallery Mourmans, Maastricht,
The Netherlands

1987

Returns to limited-edition art gallery
designs with the exhibition of a series
of new furniture at Blum Helman Gallery,
New York.

New focus on architectural commissions,
including Wolf House (1987–89),
Olabuenaga House (1989–97), Zhaoqing
Golf Club and Resort (1994–96), Van
Impe House (1996–98), Jasmine Hill,
Singapore (1996–2000), and Mourmans
House (1996–2001).

1988

Bharata collection of furniture, made by
craftsmen in India, exhibited at Design
Gallery Milano.

1992

Rovine (*Ruins*) collection of furniture,
ceramics, and glass exhibited at Design
Gallery Milano.

1994

Retrospective exhibition at the Centre
Georges Pompidou, Paris.

Introduction of a series of porcelain vases
for Sèvres.

Exotic-wood veneered furniture exhibited
at The Gallery Mourmans, Maastricht,
The Netherlands.

1998

Completion of interior design of Malpensa
2000 Airport (1994–98), Milan.

2003

New series of furniture exhibited at
The Gallery Mourmans, Maastricht,
The Netherlands.

2005

Retrospective exhibition at the Museo
di Arte Moderna e Contemporanea
di Trento e Rovereto, Italy.

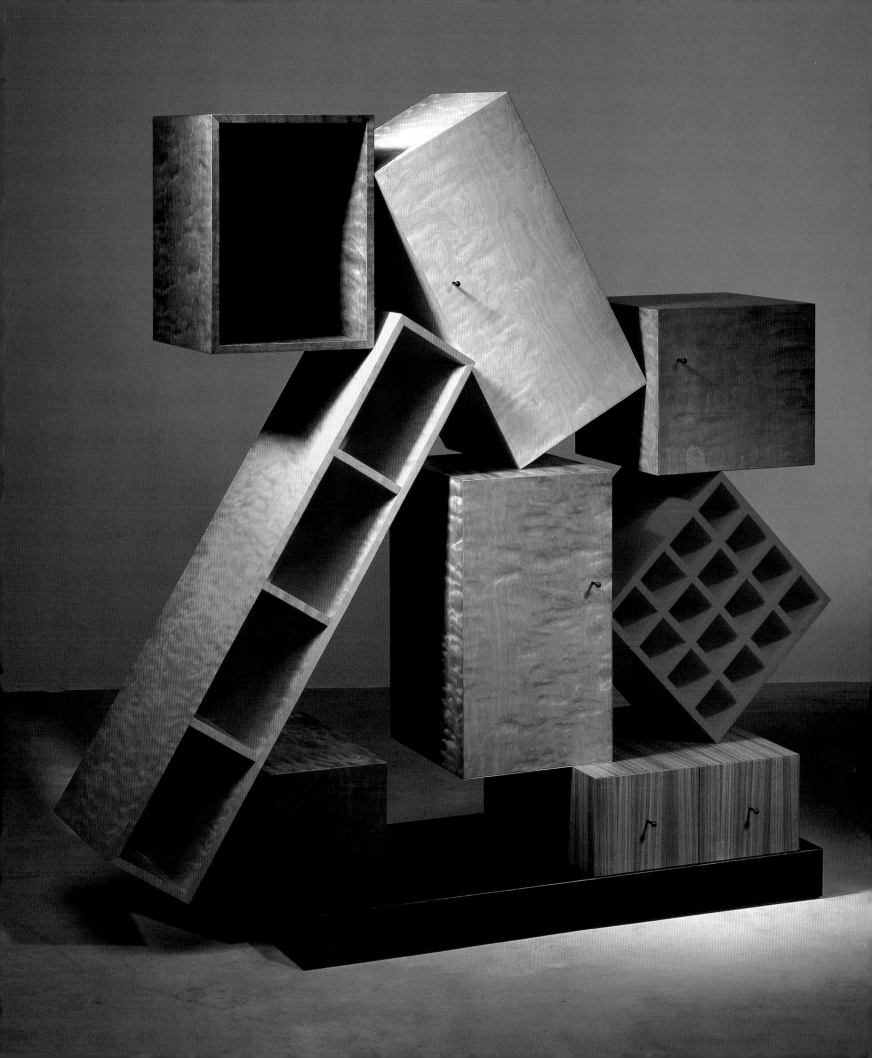

Suggested Reading

Albera, Giovanni, and Nicolas Monti, *Italian Modern: A Design Heritage*, New York (Rizzoli) 1989

Albus, Volker, *13 nach Memphis: Design zwischen Askese und Sinnlichkeit*, New York (Prestel) 1995

Bangert, Albrecht, and Karl Michael Armer, with a foreword by Ettore Sottsass, *80s Style: Designs of the Decade*, New York (Abbeville Press) 1990

Barovier, Marino, Bruno Bischofberger, and Milco Carboni (eds.), *Sottsass: Glass Works*, Dublin (Links for Publishing) 1998

Bischofberger, Bruno (ed.), *Ettore Sottsass: Ceramics*, San Francisco (Chronicle Books) 1996

Brandes, U., *Andrea Branzi, Michele di Lucchi, Ettore Sottsass. Citizen Office: Ideen und Notizien zu einer neuen Bürowelt*, Weil am Rhien (Vitra Design Museum) 1994

Branzi, Andrea, with a foreword by Arata Isozaki, *The Hot House: Italian New Wave Design*, trans. C.H. Evans, Cambridge ma (MIT Press) 1984

Bure, Gilles de, *Ettore Sottsass, Jr.*, Paris (Rivages) 1987

Burney, Jan, *Ettore Sottsass*, Design Heroes, London (Trefoil Publications) 1991

Carboni, Milco, *Ettore Sottsass, adesso però. Reiseerinnerungen*, Stuttgart (Hatje Verlag) 1993

——, *Ettore Sottsass. La darrera oportunitat d'esser avantguarda*, Barcelona (Centre d'Art Santa Monica) 1993

——, *Sottsass e Memphis. Forme e linguaggi del villagio globale*, Rome (J.W. Thompson) 1997

——, *Ettore Sottsass. Esercizi di viaggio*, Turin (Aragno) 2001

——, *Sottsass: 700 Disegni*, Milan (Skira) 2005

Carboni, Milco (ed.), *The Work of Ettore Sottsass and Associates*, New York (Universe Publishing) 1999

Carboni, Milco, and Barbara Radice (eds.), *Ettore Sottsass: metafore*, Milan (Skira) 2002

——, *Scritti, 1946–2001 | Ettore Sottsass*, Vicenza (Neri Pozza Editore) 2002

——, *The Curious Mr. Sottsass: Photographing Design and Desire*, London (Thames and Hudson) 1996

Cucchi, Enzo, *Enzo Cucchi e Ettore Sottsass*, trans. Rodney Stringer and Peter Spring, Milan (Charta) c. 2001

D'Ambrosio, Giovanni, *Ettore Sottsass jr.: nomade, shiva, pop*, Turin (Testo & immagine) 1997

Ettore Sottsass, Paris (Centre Georges Pompidou) 1994

Ettore Sottsass, Milan (Cosmit) 1999

Ettore Sottsass: Drawings over Four Decades, exhib. cat. by Ettore Sottsass, trans. Jeremy Gaines *et al.*, Frankfurt am Main, Ikon, Galerie für Design-Zeichnungen, 1990

Ferrari, Fulvio, *Ettore Sottsass: tutta la ceramica*, Archivi di arti decorative, Turin (Umberto Allemandi) 1996

Ferrari, Fulvio, and Napoleone Ferrari, *Luce*, Turin (Umberto Allemandi) 2002

Höger, Hans, *Ettore Sottsass, Jun.: Designer, Artist, Architect*, Edition Axel Menges, trans. Michael Robinson, Tübingen and Berlin (Wasmuth) 1993

Il design Cartier visto da Ettore Sottsass, exhib. cat., Milan, Palazzo Reale di Milano, 2002

Italy: The New Domestic Landscape, exhib. cat., ed. Emilio Ambasz, Florence, Centro Di, and The Museum of Modern Art, New York, 1972

Kicherer, Sibylle, *Olivetti: A Study of the Corporate Management of Design*, New York (Rizzoli) 1990

Memphis: céramique, argent, verre, 1981–1987, exhib. cat., Marseilles, Musée de Marseille, 1991

Neumann, Claudia, *Design Directory Italy*, New York (Universe) 1999

Oliva, Achille Bonito, *Sottsass*, Annali delle arte/Regione Campania, Naples (Electa Napoli) 2004

Pettena, Gianni, *Sottsass: L'arte del progetto*, Florence (Maschietto y Musolino) 1999

——, *Sottsass e Sottsass: itinerari di architettura*, Turin (Testo & immagine) 2001

Pietro, S.S., *Sottsass Associati: arret sur l'image*, Milan (L'Archivolto) 1993

Radice, Barbara, *Memphis: Research, Experiences, Results, Failures, and Successes of New Design*, New York (Rizzoli) 1984

——, *Ettore Sottsass: Design Metaphors*, New York (Rizzoli) 1988

——, *Ettore Sottsass: A Critical Biography*, trans. Rodney Stringer, New York (Rizzoli) 1993

Radice, Barbara (ed.), *Memphis: The New International Style*, trans. Rodney Stringer, Milan (Electa) 1981

Sottsass, Ettore, *Sottsass: 151 Drawings*, trans. Nobuko Akita and Naomi Miwa, Tokyo (Toto) 1997

Sparke, Penny, *Ettore Sottsass Jnr*, London (Design Council) 1982

——, *Design in Italy: 1870 to the Present*, New York (Abbeville Press) 1988

Stringer, Rodney (trans.), *Sottsass Associati | essays by Ettore Sottsass . . . [et al.]*, New York (Rizzoli) 1988

Picture Credits

Works by Ettore Sottsass illustrated in this book are licensed and copyright-protected under © Ettore Sottsass. Most photographs are reproduced courtesy of the creators and lenders of the materials depicted. For certain artwork and documentary photographs we have been unable to trace copyright holders. We would appreciate notification of additional credits for acknowledgment in future editions.

Jacket front inset, figs. 2, 5, 13–14, 16, 21, 26, 38, 41, 48, 50–51, 53, 93, 114, 117, 119, 124, 128, 131–34, 137, 144,154–55: Photo © Erik and Petra Hesmerg; Courtesy The Gallery Mourmans, Maastricht, The Netherlands

Jacket back inset, figs. 23, 90–91: Photo © Benjamin Yu; Courtesy Sottsass Associati

Jacket background, cover and binding, fig. 59: Courtesy ABET Laminati S.p.A.

Page 2, fig. 64: Photo © Daniele Badolato

Figs. 1, 4, 29, 39, 52, 58, 69, 103, 105, 121–22, 129, 149–50: Photo © 2005 Museum Associates/LACMA

Figs. 3, 111: Photo © Aldo Ballo; Courtesy Sottsass Associati

Figs. 6, 25, 65, 94, 99, 104: Photo courtesy Centro Studi e Archivio della Comunicazione, Università degli Studi di Parma

Figs. 8, 54, 56, 70: Photo © CNAC/MNAM/Dist. Réunion des Musées Nationaux/Art Resource, NY, by Jacques Faujour

Figs. 9, 11–12: Photo by Giorgio Casali, courtesy Università Iuav di Venezia, Archivio Progetti, Fondo Giorgio Casali

Figs. 15, 62–63, 75, 113, 127, 130, 140: Photo © Santi Caleca

Fig. 17: Photo © Ali Elai/Camerarts; Courtesy Barry Friedman Ltd, New York

Fig. 18: Photo by Federico Patellani

Fig. 19, 30, 66: Photo © CNAC/MNAM/Dist. Réunion des Musées Nationaux/Art Resource, NY, by Jean-Claude Planchet. Olivetti S.p.A. All Rights Reserved.

Figs. 20, 36, 67: Photo © CNAC/MNAM/Dist. Réunion des Musées Nationaux/Art Resource, NY, by Jean-Claude Planchet

Fig. 22: Photo © Pino Prina; Courtesy Sottsass Associati

Figs. 24, 37, 71–72, 95, 100, 109, 116, 151: Photo courtesy Sottsass Associati

Figs. 28, 46, 97–98, 147: Photo © CNAC/MNAM/Dist. Réunion des Musées Nationaux/Art Resource, NY, by Georges Meguerditchian

Figs. 31–32, 57: Photo © 2005 Museum Associates/LACMA, Olivetti S.p.A. All Rights Reserved.

Figs. 33, 35, 42, 44–45, 47, 68, 73, 76–80, 83–84, 96, 101–102, 110, 153: Photo © Santi Caleca; Courtesy Sottsass Associati

Figs. 34, 74: Photo by Grey Crawford/Metropolitan Home Magazine; Courtesy Sottsass Associati

Figs. 40, 49: Photo by Tommaso Mangiola; Courtesy Galerie Bruno Bischofberger, Zurich

Figs. 43, 55: Photo © Roland Reiter; Courtesy Galerie Bruno Bischofberger, Zurich

Fig. 60: Courtesy ABET Laminati S.p.A.

Figs. 61, 118: Photo by Atelier Alchymia, Courtesy Sottsass Associati

Figs. 81–82: Photo © Helmut Newton; Courtesy Sottsass Associati

Fig. 85: Photo © Kishin Shinoyama; Courtesy Sottsass Associati

Figs. 86–89: Photo by Johanna Grawunder; Courtesy Sottsass Associati

Fig. 92: Photo © Luca Fregoso; Courtesy Sottsass Associati

Figs. 106, 115: Photo © Ramak Fazel; Courtesy Sottsass Associati

Figs. 107, 138: Photo © Riccardo Bianchi; Courtesy Sottsass Associati

Fig. 108: Photo by Giorgio Casali, Università Iuav di Venezia, Archivio Progetti, Fondo Giorgio Casali

Figs. 112: Photo © Erik and Petra Hesmerg; Courtesy Sottsass Associati

Figs. 120, 135, 152: Photo © Studio Azzurro Fotografia, Gianni Basso and Massimo San Giorgi; Courtesy Sottsass Associati

Fig. 123: Photo © Museo Alessi

Figs. 125–26, 145: Photo © Werner Schnüriger/Roland Reiter; Courtesy Galerie Bruno Bischofberger, Zurich

Fig. 136: Courtesy Galerie Bruno Bischofberger, Zurich/Paolo Curti, Annamaria Gambuzzi & Co., Gallery, Milan

Fig. 139: Photo © Max Rommel; Courtesy Sottsass Associati

Figs. 141–42: Photo by Studio Pointer; Courtesy Sottsass Associati

Fig. 143: Photo by Francesco Barasciutti; Courtesy Galleria Marina Barovier, Venice

Fig. 148: Photo © Alberto Fioravanti; Courtesy Sottsass Associati

Acknowledgments

The idea of commemorating Ettore Sottsass's landmark contributions to architecture and design with an exhibition and book was inspired by Max Palevsky, longtime benefactor of LACMA and the decorative arts, and Wendy Kaplan, Department Head and Curator, Decorative Arts. I am indebted to them both. Wendy Kaplan not only invited me to direct the project but also encouraged creative freedom in shaping it. I thank her for this singular honor and for many personal kindnesses. I also thank her for contributing her remarkable editing skills to this publication.

The selection of objects for exhibition is always a complicated process. In a show about an architect-designer of such versatility and productivity as Ettore Sottsass, whose work spans over sixty-five years, one cannot hope to be inclusive. Therefore, the advice of Mr. Sottsass was invaluable, and his insight into the final checklist was greatly appreciated. Mr. Sottsass also contributed his concept for the exhibition design and I am deeply indebted to his generosity. I thank Barbara Radice for her time, expertise, and advice. At Sottsass Associati, I am grateful for the assistance of Milco Carboni, Marco Palmieri, Massimo Penati, and Laura Persico.

I extend my profound gratitude to the board members of the Decorative Arts Council of LACMA for believing in the importance of this book and for their generous contribution toward its publication: Penny Adams, Richard N. Baum, Lois Boardman, Peter Loughrey, Jane Mackie, Marian Miller, Susan W. Robertson, Anna Silver, Karen Smits, Nan Summerfield, and Kathy Watkins.

Many people at LACMA were instrumental in bringing this project to fruition. I am thankful to Bruce Robertson, Deputy Director of Art Programs, for his unflagging support for the catalogue, and Nancy Thomas, Deputy Director for Art Administration and Collections, for her encouragement.

In the Decorative Arts department Emily Zaiden deserves special recognition for her high degree of personal involvement and professional commitment. Without her scholarly contributions and her exceptional organizational skills this publication would not have been possible. She accomplished this with the assistance of Christel Guarnieri, whose dedication to the project and good humor are greatly appreciated. Christel's extraordinary multi-tasking abilities, irreproachable work ethic, and help with research and the exhibition were invaluable.

This book is greatly indebted to the contributions of a talented team of interns: Lindsey Rossi's unfaltering diligence in securing picture rights and reproductions, Laura Verlaque's organization of illustration captions, and Rebecca Zamora's compilation of the bibliography were essential to its completion. I would also like to thank our volunteers Marilyn Gross and Helen De Gyarfas for their longstanding commitment to the department.

Other departments at LACMA played a crucial role in the realization of this project. My heartfelt thanks go to the following: Exhibition Programs (Irene Martin, Beverley Sabo, Janelle Aieta, Elaine Peterson); Collections Management (Renée Montgomery, Delfin Magpantay, Marsha Rosenberg); Registration (Ted Greenberg, Sandy Davis); Conservation (Mark Gilberg, Don Menveg, Chail Norton); Education (Toby Tannenbaum); Marketing and Communication (Christine Hansen, Gantry Jackson, Jean Oh, Alison Agsten, Brooke Fruchtman); Graphics (Amy McFarland, Katherine Go); Operations and Facilities (Donald Battjes, Arthur Owens, Daniel Forrest); Gallery Services (William Stahl); Art Preparation and Installation (Marilyn Bowes, Jeffrey Haskin, and crew); the staff of the Research Library; and the staff of Protective Services. For successfully interpreting and actualizing Sottsass's exhibition design concept I would like to thank LACMA's exhibition designer, Bernard Kester.

Grateful acknowledgment must also be extended to curators Thomas Michie, Howard Fox, Carol Eliel, Mary Levkoff, and Kaye Spilker at LACMA for their support and collegiality. For their guidance and assistance at the onset of this project, I extend my deepest gratitude to: Craig Miller at the Denver Art Museum, Cara McCarty at the Saint Louis Art Museum, Nina Stritzler-Levine at The Bard Graduate Center, David Hanks, Peter and

Contributors

Shannon Loughrey at LA Modern Auctions, James Zemaitis at Sotheby's, John Geresi, and William Rudolph at the Philadelphia Museum of Art.

Many thanks are also due to the authors who have contributed a high level of scholarship to this catalogue: Penny Sparke, Dennis Doordan, James Steele, and Emily Zaiden.

The generosity of the lenders in Europe and the United States has been extraordinary, together with the efforts and courtesies of their staff: The Gallery Mourmans, Maastricht, The Netherlands (Ernest Mourmans, Brigitte Ploemen, Marian Lenaerts, Iris Thuwis); Galerie Bruno Bischofberger, Zurich (Bruno Bischofberger, Niklaus Kuenzler, Susanne Daniel); Centre Georges Pompidou, Musée National d'Art Moderne, Paris (Marie-Laure Jousset, Danielle Janton); Max Palevsky, Los Angeles (Barbara McCarthy, Susan Potter); Daniel Ostroff, Santa Fe; Susan and Michael Rich, Los Angeles; Joel Chen, Los Angeles; Barry Friedman Limited, New York (Barry Friedman, Marc Benda, Erika Brandt); Alessi (Antonella De Martino, Hiroko Usui); and the Museo di Arte Moderna e Contemporanea di Trento e Rovereto, Italy (Gabriella Belli, Beatrice Avanzi). For their guidance and counsel in the preparation of this book at LACMA, I would like to thank: Stephanie Emerson, former Director of Publications; Cheryle Robertson, Rights and Reproductions Coordinator; Nola Butler, Codirector of Publications; and Erika Caswell, former Publications Coordinator. For superbly attending to all of our photographic needs my appreciation goes out to Peter Brenner and Steven Oliver. At Merrell Publishers, I express my gratitude to Hugh Merrell, Julian Honer, Nicola Bailey, Michelle Draycott, Anthea Snow, and Paul Shinn. John Morgan merits special recognition for his inspired book design.

Last but not least I would like to thank Carol Alarcon, Sean Irvin, and my family for their support and encouragement over the course of this project.

Dennis P. Doordan is Chairman of the Department of Art, Art History, and Design at the University of Notre Dame, Indiana. He has contributed essays to many exhibition catalogues and is the author of *Building Modern Italy: Italian Architecture, 1914–1936* (1988) and *Twentieth-Century Architecture* (2002).

Ronald T. Labaco is Assistant Curator of Decorative Arts at Los Angeles County Museum of Art. He has lectured and written on twentieth-century design, including the articles "'The Playful Search for Beauty': Eva Zeisel's Life in Design" (2000) and "Serving Modern to America: The Museum Dinnerware Collaboration" (2004).

Penny Sparke is Dean of the Faculty of Art, Design and Music and Professor of Design History at Kingston University, London. Her books include *Italian Design: 1870 to the Present* (1988), *As Long as It's Pink: The Sexual Politics of Taste* (1995), and *Elsie de Wolfe: The Birth of Modern Interior Decoration* (2005).

James Steele is Associate Professor of Architecture at the University of Southern California, Los Angeles. His books include *Architecture Today* (1997) and *Sustainable Architecture* (forthcoming).

Emily Zaiden was formerly Research Associate for the Decorative Arts department at Los Angeles County Museum of Art, where she worked on the exhibition *The Arts and Crafts Movement in Europe and America, 1880–1920*. She is currently a research editor for *Architectural Digest* and consults for private collectors and institutions in the United States and Italy.

Index

Page numbers in *italic* refer to the illustrations